DISCUSSIONS IN CONTEMPORARY CULTURE

DIA ART FOUNDATION

DISCUSSIONS IN CONTEMPORARY CULTURE

NUMBER ONE

EDITED BY HAL FOSTER

THE NEW PRESS / NEW YORK

Published in the United States by The New Press, New York
Distributed by W. W. Norton & Company, Inc., New York

The New Press was established in 1990 as a not-for-profit alternative to the large, commercial publishing houses currently dominating the book publishing industry. The New Press operates in the public interest rather than for private gain, and is committed to publishing, in innovative ways, works of educational, cultural, and community value that are often deemed insufficiently profitable.

www.thenewpress.com

Printed in the United States of America

9 8 7 6 5 4 3 2 1
ISBN: -1-56584-463-6

CONTRIBUTORS

BENJAMIN H.D. BUCHLOH teaches art history at SUNY Old Westbury; a collection of his essays, *Post-Neo-Avant-Garde*, will soon be published by MIT Press.

JAMES CLIFFORD teaches in the History of Consciousness Program at UC Santa Cruz; he recently coedited *Writing Culture: The Poetics and Politics of Ethnography* (California), and a collection of his essays will soon be published by Harvard University Press.

DOUGLAS CRIMP, coeditor of *October*, is presently at work on an archaeology of the art museum.

THOMAS CROW is a professor of art history at the University of Michigan and author of *Painters and Public Life in Eighteenth-Century Paris* (Yale).

VIRGINIA R. DOMINGUEZ is a professor of anthropology at Duke University and author of *White by Definition: Social Classification in Creole Louisiana* (Rutgers); her *The Significant Self: Toward a Predication of Israeli Society* is forthcoming from University of Wisconsin Press.

MICHEL FEHER, coeditor of *Zone* and author of a book on Georges Bataille, is presently at work on a history of the *femme fatale*.

HAL FOSTER (editor), coeditor of *Zone*, is author of *Recodings: Art, Spectacle, Cultural Politics* and editor of *The Anti-Aesthetic: Essays on Postmodern Culture* (both Bay Press).

MICHAEL FRIED, professor of humanities and art history and director of the Humanities Center at The Johns Hopkins University is author of

Absorption and Theatricality: Painting and Beholder in the Age of Diderot (California) and *Realism, Writing, Disfiguration: On Thomas Eakins and Stephen Crane* (Chicago).

DAN GRAHAM has produced work in a variety of conceptual and situational forms; a collection of his projects and writings from 1970 to 1978 was published by the Nova Scotia College/New York University Presses.

ALICE JARDINE, associate professor of romance languages and literatures at Harvard, is author of *Gynesis: Configurations of Women and Modernity* (Cornell) and coeditor of *Men in Feminism*.

SILVIA KOLBOWSKI has published articles in *Art in America*, *Afterimage* and other journals; her show "Here and There" was seen at Nature Morte Gallery in December 1986.

ROSALIND KRAUSS, coeditor of *October*, is professor of art history at Hunter College and the CUNY Graduate Center; her books include *Passages in Modern Sculpture* and *The Originality of the Avant-Garde and Other Modernist Myths* (both MIT).

BARBARA KRUGER writes a column on television and film for *Artforum*; her work was exhibited in Documenta 8.

CRAIG OWENS has written extensively on contemporary art and theory and has taught at Barnard College and at the University of Virginia.

AIMEE RANKIN is an artist and writer whose project "Ecstasy" was shown at Postmasters Gallery in March 1987.

MARTHA ROSLER teaches photography and media at Rutgers University; she has produced two books, *Service: A Trilogy on Colonialization* and *3 Works* (Nova Scotia), and several video works.

TRINH T. MINH-HA, writer, filmmaker and composer, teaches in the department of cinema at San Francisco State University; her works include the forthcoming book *Woman, Native, Other* and the films *Reassemblage* and *Naked Spaces—Living is Round*.

KRZYSZTOF WODICZKO has produced image projections in New York, London, Bern, Los Angeles and elsewhere; a project of his was included in Documenta 8.

CONTENTS

A NOTE ON THE SERIES

This collection of edited texts and transcripts comes out of a series of six weekly discussions sponsored by the Dia Art Foundation from February 10th to March 17th, 1987. The discussions were the first efforts of the Dia Foundation to establish an ongoing commitment to intellectual discourse for and with a predominantly visual art-oriented audience.

We held the discussions at a Dia Foundation space downtown at 155 Mercer Street in New York's SoHo area and experimented evening to evening with format, stressing as much as possible discourse between discussants and audience, and among the audience itself. Participants were both engaged by the opportunity to converse on certain issues and at times frustrated by the diversity of critical approaches which were brought to bear on the topics. The richness of this diversity, in fact, and the lack of guiding doctrines made the series interactive and provocative, and contributed to its success.

Hal Foster organized the series and edited this collection of related texts. We are grateful to him for his thoughtful selection of topics and panelists and for his careful attention to these texts.

The Dia Art Foundation continues to program events centered on thought and discussion. Many people who attended this first series commented on the general need for broader commitment to organized intellectual forums outside the academy. We hope that this publication will be the first of many documenting events of this kind at the Dia Art Foundation.

Charles Wright
Executive Director, Dia Art Foundation

PREFACE

A preface usually traces a path through a text or sketches a map of its terrain. Both chartings are impossible here because the book is too porous. The reader can enter the field of its discussions at any place, and in fact the desire for *access* propelled the project from the start. Current public forums for intellectual work are limited: There is the academic symposium with its guild audience and the gladitorial panel with its voyeuristic public, with not much in between. Against the hermeticism of the one and the alienation of the other, we envisioned a space where different people might together discuss issues of common interest. Naively I thought the spectacle would be more minimal than it was and the community more readymade than it is, but just as the first can be adapted for productive work the second can only be formed out of its very diversity. We also wanted to address a lack in contemporary publication formats of critical thought: Between a paper delivered in a study group and a tome on a scholarly subject there are few forms not thoroughly determined by the market in which work-in-progress can be presented, tested, developed. Although the strained silences, witty asides and exasperated sighs that punctuated the discussions are mostly lost here, this book is an attempt at a form of critical inquiry where, for the moment at least, we might all be freed from the fetishism of the perfect essay and the paranoia of the armored argument. It remains a commodity, of course; but within such an economy I hope it suggests a more open, more generous exchange.

If the book is porous it is not incoherent. We wanted to engage topics that might cut into and across specific practices (artistic, critical, theoretical, philosophical, historical, political, anthropological), that might

illuminate these discourses individually and relationally in the present. Thus the first two discussions were to focus on contemporary art and the public sphere: the first on the (d)evolution of the public as historical entity and/or imaginary construct; the second on cultural work that intervenes in this sphere and recodes its media. The second two discussions were to outline a genealogy of recent art and criticism; the first in terms of theoretical models of the last twenty years; the second in terms of contemporary critical art. The last two discussions were to consider different orders of the other and of the body: the first in terms of western anthropological representations; the second in terms of historical techniques and technologies. I posed these general topics, often in collaboration with the speakers, certainly with the work of each in mind; but they set the parameters of the papers and discussions. My idea was to triangulate each topic, to have the speakers not so much represent a position as address a problem. What transpired is a different story, a more suggestive one.

For finally the consistency of this book is found not primarily at the manifest level of the stated topics but rather at the latent level of repeated and/or repressed themes. (As Douglas Crimp suggests in these pages, *difference* is a theme at once repeated and repressed, its general value often affirmed even as its specific stakes are often ignored.) These "ideologemes" may demark both the obsessive concerns and the blind spots of contemporary discourse. Certainly they will vary for each reader; for me a partial list includes (1) the definition of public and audience, historical and present; (2) the politics of cultural identity and sexual difference; (3) the current status of criticism and legitimation; (4) the function of deconstruction, historical memory and the imaginary in art and criticism; (5) the problem of representation as a form of appropriation (which Craig Owens relates to "protectionist discourse" and James Clifford to "the salvage paradigm"); and (6) the history of disciplines of the body. But this list is unjust both to the specificity of the debates and to the constellation of ideas produced by the speakers. To take but one example: In the first discussion Thomas Crow insists that discourse must set criteria for art, that without such public pressure art dissipates into a postmodern condition of puerile pluralism, while in the third discussion Benjamin Buchloh attests that criticism is entirely stripped of its function of legitimation and Rosalind Krauss states that criticality is no

longer in the word but only and rarely in the work of art. These are powerful statements, with much truth, but the very intelligence of these texts and discussions suggests that, if conventional (art) criticism is exhausted, there remain many other subjects and methods to explore.

In a few cases the texts are revised (totally with Craig Owens, substantially with Thomas Crow); the others are mostly faithful to the papers delivered in the series. I edited the discussions, providing names of speakers when I could; afterwords were optional. I want to thank Charles Wright for his support of the project, Thatcher Bailey for his production of the book, and Joan Duddy of the Dia Art Foundation for her kind assistance throughout.

<div align="right">

Hal Foster
July 1987

</div>

THE CULTURAL PUBLIC SPHERE

The Birth and Death of the Viewer:
On the Public Function of Art

THOMAS CROW

These Collectors, They Talk About Baudrillard Now[1]

There is a degree of heterogeneity of practice within the confines of the
art world at the moment that is widely taken to be new. Whether this
state of affairs is called postmodern or not (the term has lately been los-
ing its luster), there is a felt loss of that once-dominant tradition of for-
mal abstraction in traditional materials that we call modernist, and the
central position that it once occupied lies empty. As a canon-creating
account of "ambitious" painting since Manet and as a doctrine that
legitimated the color-field painting of the 1960s, it is not widely
mourned. It may, however, be more widely missed than is often
acknowledged. Any dissenting practice depends for its meaning on the
existence—and the strength—of what it opposes. If we grant that pop
art was interesting for its populism or for its irony, it would be because
those qualities could be read against the apparent elitism and humorless
seriousness of high modernism. And the typical pop painting was for-
mally organized sufficiently like contemporaneous abstract painting to
make the comparison count. The various "dematerializing" practices
that appeared later in the same decade similarly depended for their force
on the fetishization that accompanied the modernist cult of the autono-
mous object.

These latter practices, particularly, are the ones we recall when we
lament the loss of a public dimension and commitment for art. Concep-
tual, performance, installation and site-specific art were avenues that
proved to be most open to counterhegemonic voices and movements
toward alternative political communities: women's politics and the cri-
tique of the art commodity generated out of New Left culture found
space there. As we look back, these practices feel as if they constituted a
unity, a resurgent public sphere that seems diminished and marginal

now. It remains, however, very much open to question whether there has been, in statistical terms, any great falling-off in this sort of activity, in numbers of nonpermanent works documented, performed or installed. Kinds of work that in the present contribute to the widespread impression of heterogeneity and incommensurate discourses are precisely those that in retrospect constitute an image of unity and shared purpose. Leaving simple nostalgia aside, one absence being registered in this sense of loss is the bygone unity provided by modernism, that is, by white-male-dominated elitist art and criticism.

I mean by this more than the truism that a common enemy can temporarily reduce consciousness of the divisions between groups. The argument of this paper will be that the perceived unity of modernist practice was, even in its decayed, terminal forms, a survival of the original equation between artistic seriousness and public purpose that took definitive shape during the 18th century. As long as it seemed alive, that latency could be displaced and made manifest through the very act of resistance to modernist hegemony. As long as one saw oneself reflected, albeit negatively, in the mirror of modernism, one's own image was lent a unity that was neither entirely spurious nor entirely ineffective in political terms.

That last sentence combines the terms image and political—a juxtaposition which seems to me necessary for any adequate historical understanding of the public dimensions and possibilities of artistic practice. The Enlightenment conception of the public for art, as it evolved in both France and England, evoked an ideal community that was not limited to the actual collection of viewers and fanciers of art on hand at a given time. "The public" represented a standard against which the various inadequacies of art's actual consumers could be measured and criticized. This public was thus in large part an imaginary entity, its lineaments being drawn equally from the past and from an anticipated future. The public of the Greek *polis*, stated artists, theorists and critics alike, had been ultimately responsible for the exemplary artistic achievements of antiquity. Similarly, the successful revival of the antique during the Renaissance was traced to the encouragement and scrutiny of the circumscribed citizenry of the Italian city-state. It was in English writing particularly, the Academy lectures of Joshua Reynolds, James Barry and Henry Fuseli, that these examples were brought to bear on the modern circumstances of artistic production. How, they were asking, could a comparable "republic of taste" be formed within a large commercial

nation stratified by social class and the division of labor? From Reynolds's *Discourses* forward, their writings represent an effort to describe the ways in which painting could once again enjoy the support of such a sustaining community and reciprocally help define its character.[2]

At its core, then, their conception of the public for art was a political one. The very term vision was used in these aesthetic texts in a way that was directly analogous to the "vision" exercised by the ideal citizen of the commonwealth. Vision in this sense meant to see beyond particular, local contingencies and merely individual interests. According to their civic humanist conception of public life, a gaze that consistently registered what united rather than what divided the members of the political community was a requirement for participation in affairs of state. This assumption led Reynolds to abandon the then-prevailing assumption that painting was fundamentally an art of deception. He substituted for it a "philosophical" aesthetic in which the properly prepared viewer is struck less by the illusory presence of persons and actions in a painting and more by the truth of general propositions extracted from empirical experience. The ability to generalize or abstract from particulars was his principal criterion for inclusion in the republic of taste. Reynolds's prescriptions for the treatment of the human figure call for a renunciation of local and accidental appearances and a corresponding devaluation of direct attention to nature generally. The attention of his ideal viewer would thus remain undivided by base sensory enticements, as the consciousness of the ideal citizen was to be undivided by private, material appetites. The abstract unity of the pictorial composition was to be an inducement to and metaphor for a transcendent unity of mind.

Thus the themes of abstract form, a pictorial unity powerful enough to demand a unified concentration from the viewer, and a position of mastery within the social order were linked long before the advent of 20th-century modernist criticism. That this conjunction should have been repeated in our own time stems from the fact that its original formation coincided with the demarcation within European culture of the separate aesthetic sphere. Painting, as much as any other art form, was made to stand for this sphere, for its possession of distinct criteria of value, and any subsequent attempt to reassert the autonomy or "purity" of painting would not easily escape being marked by the origins of those concepts. Such was the case in the linked arguments for the autonomous values of painting offered by Clement Greenberg and Michael Fried. Neither of course contended that the ideal viewer constructed by their

criticism demonstrated a fitness to rule in his (I use the pronoun advisedly) habits of attention to pictures. Nevertheless, the equation persists between the ability to read an abstract work and a subjective position of undivided mastery and control. In Fried's statement of the autonomy thesis, the successful painting, in its allover activation of the pictorial field, achieves an instantaneous presentness that both responds to and encourages a condition of disinterested self-sufficiency within the viewer, one that transcends the accidents of actual use, setting and conditions of viewing. Should a work rely on these conditions for its effect or meaning, the attention of the unified, centered self will be divided, and the experience of art will descend to a compromised state that Fried has chosen to call theatrical.[3]

The ability to abstract from particulars that Reynolds proposed as a requirement for citizenship in the republic of taste was, it need hardly be said, assumed to be the exclusive possession of a well-born minority. The lower orders, with their minds necessarily fixed on the mundane necessities of earning a living, were by definition excluded. Modernist criticism nowhere makes its exclusions in the explicit terms of social class, but the viewer who is unprepared by education or initiation in the protocols of high art to discover his centered self in an arrangement of pigment on canvas is simply left out of account. The restriction of such experience to an elite minority is no less certain than it was in the 18th century. As Greenberg famously expressed it in "Avant-garde and Kitsch" of 1939, "It is Athene whom we want, formal culture with its infinity of aspects, its luxuriance, its large comprehension."[4]

These elitist assumptions and implications were made abundantly plain in the critiques of modernism heard increasingly in the later 1960s and after, and these remain on that level unanswerable. One further trait, however, that links Reynolds's rationale for abstraction to Greenberg's is their common antipathy to capitalism. The former, along with other 18th-century artist/theorists, saw modern commercial societies as promoting divisive private appetites to the point that any true, sustaining community for the practice of art was in danger of disappearing. His hope was that a properly demanding art could help form an elite able to see beyond the partial, acquisitive interests that blinded the majority. Within that blinkered majority, of course, were included self-interested dealers and connoisseurs of art objects. One of the aims of civic-humanist aesthetics was to resist the habitual consumption of art objects as merely material commodities.

In its formative phase, then, prescriptive abstraction in painting was built on an opposition between community and capital. It involved a critique of capital's corrosive effects on the individual's capacity for thought and scope of imagination. The same opposition is present in Greenberg's early essays. But if Reynolds saw art's elite community as in danger of disappearing, Greenberg saw it as having substantially disappeared. No significant fraction of the directing classes appeared able to resist the counterfeit culture, the "kitsch," that its economic machinery had brought into being. In his view the precapitalist cultural inheritance of the bourgeoisie had simply been merchandised away in so many commodities fashioned in the likeness of once-living art. The bourgeois elites, Greenberg argued, no longer possessed a culture distinct from the debased products of the entertainment industries and hence constituted no adequate public, no adequate community for the serious artist. "Avant-garde and Kitsch" proposes in their place two largely imaginary communities, one in the past and one in the future: the former he found, as we have seen, in the aristocratic orders of the past. The richness and self-consciousness of late-feudal cultural forms hold a place in his thinking similar to that occupied by the antique polis in civic-humanist aesthetics. His other imagined community is a postrevolutionary social order, the prospect of which lends to present-day advanced culture whatever cogency it possesses. As the essay concludes, "Today we look to socialism simply for the preservation of whatever living culture we have right now."[5]

At key moments in its history and prehistory, the modernist aesthetic presupposed a certain kind of supporting community, but that community was as much an imaginary construct as an actual collectivity. Kitsch, as Greenberg conceived it, was the natural product of false communities, those of alienated mass consumption or totalitarian politics. His public space was the standard against which their common debasement of communal aspirations could be measured. In the absence of adequate bourgeois elites, maintaining that space in the sphere of culture would be the task of the avant-garde itself. The demanding nature of its art would be a continual act of resistance to the easy accessibility of manufactured mass culture and manipulative political symbols.

To the degree that this strategy proved to be "the path along which it would be possible to keep culture *moving*,"[6] the one outcome it could not survive was the embrace of the postwar governing elite. The managers of the American economy and state may have seemed weak and

directionless in 1939, unprepared as they had been for the Great Depression and the threat from fascism. But in the decade following the end of the war they were brimming with confidence, and among them were a significant number eager to signal that recovery through the patronage of demanding abstract art. I won't rehearse here the now-familiar history of that recuperation. It will be sufficient to observe that in the presence of a substantial audience made up of established white males, no necessary link could be argued between abstract art and a moral community liberated from the fetters of material appetites. Greenberg simply stopped raising the issue and increasingly posited a modernist viewer who brought no collective aspirations to the canvas.

It was Fried who constructed a late-modernist theory around this detached and isolated viewer. There are moments in his criticism that take to an extreme the ideologically masculine position of self-sufficient mastery and control. These remarks on Morris Louis's late stripe paintings constitute one kind of nightmare for a radical feminist:

> They are wholly abstract embodiments or correlatives of human will or impulse—specifically, the will or impulse to *draw*, to make one's mark, to take possession, in characteristic ways, of a plane surface. [They are] the instantaneous, unmediated realization of the drawing impulse, the will to draw.[7]

There are nevertheless other moments in which there appears an echo of a communal, even a civic-humanist, rationale for abstraction. Near the beginning of the same essay on Louis, Fried remarks that the artist

> appears to have been profoundly serious, and to have respected only those individual men and women whose integrity, discipline and seriousness could stand the test of his own.... The sensuous, subtle, sometimes electrifying color of his finest paintings ought not to numb us to the fact that, for Louis, painting consisted in far more than the production of sensuously pleasing or arresting objects. Rather, it was an enterprise which unless inspired by moral and intellectual passion was doomed to triviality, and unless informed by uncommon powers of moral and intellectual discrimination was doomed to failure.[8]

One of the principal things that makes Fried's early writings compelling today is the intensity of the moral claims present in them. It does not matter greatly that those claims at times seem grandiose, even visionary, in comparison with his direct accounts of individual works (the rest of

the extraordinary Louis essay never quite makes good on that begin-
ning); it is their very excess that is of interest. Modernist criticism
brought into the 1960s a surplus of moral commitment that was the relic
of an earlier dream of art as the focus of an ideal public sphere. The expe-
rience of the best painting and sculpture remained for Fried a kind of
common ground in which one's private, contentious self would be set
aside. If that moral vision remained unfocused in actual application, if it
was not always locatable in the forms of abstract art, one reason was that
its political origins had been repressed. But the compensatory inten-
sification of the language of morality meant that those origins would not
stay repressed. As long as ethics and art remained intertwined in this
way, ethical issues could be re-endowed with political meaning by
others, that is, by artists engaged in those practices that dethroned the
autonomous object.

The presence of moral commitment, however residual, at the center
of the established art world seems very remote from the atmosphere of
the mid-1980s. The successful art of the moment frames its ambitions in
largely private terms. Abstract painting, after a brief vacation, has
returned, but no longer makes any claims to intensify or expand vision.
In its replications of already-existing modernist, or debased modernist,
prototypes, the art of Peter Halley, Philip Taaffe, Ashley Bickerton, Ross
Bleckner and others adds up in fact to a new kind of disabused realism, a
resigned submission to the already existing. What they cannot replicate
is the bond that existed between the earlier forms of abstraction and the
definition of community.

References

1. The title is a quotation from an interview with Peter Nagy by Gary Indi-
 ana, *The Village Voice* (14 April 1987), p. 91.
2. On the subject of civic-humanist aesthetics in the 18th century, see John
 Barrell, *The Political Theory of Painting from Reynolds to Hazlitt: The
 Body of the Public* (New Haven and London: Yale University Press, 1986),
 passim. This is a book that deserves a wide readership among those inter-
 ested in these questions. For further comment, see my review, "A Republic
 of Taste," *London Review of Books* (19 March 1987), pp. 10–12.
3. The most concentrated statement of this position would be Michael Fried,
 "Art and Objecthood," in G. Battcock, ed., *Minimal Art* (New York: E.P.
 Dutton & Co., 1968), pp. 116–47; also see his text in this volume.

4. Clement Greenberg, "Avant-garde and Kitsch," in *The Collected Essays and Criticism*, vol. I, ed. J. O'Brian (Chicago: University of Chicago Press, 1986), p. 19.
5. Ibid., p. 22.
6. Ibid., p. 8.
7. Fried, *Morris Louis* (New York: Abrams, 1971), p. 35.
8. Ibid., p. 10.

The Birth and Death of the Viewer:
On the Public Function of Art

MARTHA ROSLER

These are signs of collective attention: the millions simultaneously watching televised football games or, elsewhere, soccer. In large cities like New York their collective *action* poses a danger—the strain on the water and sewage systems caused by the simultaneous flushing of toilets at half-time. The public taste in this country for rituals of power and competition is much in display recently, most obviously in sports, but also in collective myths of origin, like the recent Statue of Liberty festivities; in celebrations of return, like the heroes' welcome accorded Vietnam vets after ten years' wandering in the desert; in rituals of conquest, like the one blown up with the shuttle *Challenger* over a year ago—all signs, no doubt, of a resurgence of bread-and-circuses as a political mass-management strategy.

Why should this concern artists? In the first of three related articles published in the early 1970s under the title "The Education of the Un-Artist," Allan Kaprow compared the art world to a church in which a ritual of transgression is acted out: "Its sole audience is a roster of the creative and performing professions, watching itself, as if in a mirror, enact a struggle between self-appointed priests and a cadre of equally self-appointed commandos, jokers, guttersnipers and triple agents who seem to be attempting to destroy the priests' church. But everyone knows how it all ends: in church, of course. . . ."[1] Kaprow was distressed over the art world's failure to notice that it had lost its audience to the far more interesting perceptual effects of everyday life. He writes:

> To escape from the traps of art, it is not enough to be against museums or to stop producing marketable objects; the artist of the future must learn how to evade his profession.
>
> Sophistication of consciousness in the arts today (1969) is so great that it is hard not to assert as matters of fact:

that the LM [Lunar Module] mooncraft is patently superior to all
contemporary sculptural efforts;
 that the broadcast verbal exchange between Houston's Manned
Spacecraft Center and Apollo 11 astronauts was better than con-
temporary poetry; . . .

Kaprow goes on to choose these NASA exchanges over electronic music;
"certain remote control video tapes of . . . ghetto families recorded (with
permission) by anthropologists" over underground films; Las Vegas gas
stations over contemporary architecture; "the random, trancelike move-
ments" of supermarket shoppers over modern dance; "the lint under
beds and debris of industrial dumps" over "exhibitions of scattered waste
matter"; and rocket vapor trails over gas art. He concludes the litany
with this: "the Southeast Asian theater of war in Viet Nam, or the trial of
the 'Chicago Eight,' while indefensible, is better than any play"; and
finally asserts "that . . . etc., etc., non-art is more art than Art-art."
 Kaprow derides the politico-social aims of the earlier avant-gardes:
"[S]uch avowedly moralistic [sic] programs appear naive today in the
light of the far greater and more effective value changes brought about
by political, military, economic, technological, educational and adver-
tising pressures. The arts . . . have been poor lessons, except possibly to
artists and their tiny publics." For Kaprow the real meaning of art is the
"ritual escape from culture"; interestingly, technology provides his pro-
posed refuge: "Agencies for the spread of information via the mass
mediums, and for the instigation of social activities, will become the
new channels to insight and communication; not substituting for the
classic 'art experience' . . . but offering former artists compelling ways
of participating in structured processes that can reveal new values,
including the value of fun." His most extended example amounts to the
total surveillance of all by all, in a "global network of simultaneously
transmitting and receiving TV arcades": apparently, a panopticon
guaranteed to make all the world a prison. Artists are to design mega-
panoramas to ransack public experience for private perceptual plea-
sure—though "public" and "private" have no clear meaning here. "The
technological pursuits of today's nonartists [Kaprow does not mean
"the public" but rather his kind of artist] will multiply as industry, gov-
ernment and education provide their resources." What is promised is
not social transformation but symbolic displacement in the interest of a
more powerful aesthetic experience. The control of private pleasure, a
serious issue, is here trivialized as "fun"—an acknowledgment that the

spiritual values and aesthetic understandings which were "supposed" to attend the reception of art, at least until the crises of the 1960s, have disappeared.

Kaprow responds here to professionalization and mass-media-derived trivialization; these twin specters, which have sapped the shared understandings necessary to the formation of publics, are hardly confined to art. For example, Russell Jacoby has described the professionalization (and in this case the medicalization) of Freudian psychoanalysis, with its consequent removal from the common understandings of a literate public. In *The Repression of Psychoanalysis* Jacoby remarks that Freud was awarded not a Nobel Prize in medicine but the Goethe Prize, a literary award, and he comments:

> Freud wrote elegantly for a cultured public . . . a literate and heterogeneous community As psychology transformed itself into a private club open only to medical doctors, its language and substance unavoidably shifted. Exclusively engaged with clinical practice, the doctors ignored the cultural and political implications of analysis.[2]

Jacoby focuses on half the problem, that of professionalization. The other half, the erosion of a "cultured public" and with it the resonance of "cultural and political implications," occupies our attention here.

The isolation and impotence that afflict artists are predictable in a productive system whose social meaning and standing are evaporating and whose venues are being transformed into specialized sites of its supposed adversary, mass culture. It is not that art has shunned mass culture—does anyone still need to be convinced that the two are mutually dependent? Rather, the current perceived crisis of art stems from the apparent swamping of the relative social prestige and significance of elite culture by mass culture, with the consequent evaporation of any dimension of *remove*—whether critical consciousness, aesthetic transcendence or some more spiritualized aim.

In *The Dialectic of Ideology and Technology*, Alvin Gouldner describes the interplay of technology and cultural form as follows:

> Both the cultural apparatus and consciousness industry parallel the schismatic character of the modern consciousness: its highly unstable mixture of cultural pessimism and technological optimism. The cultural apparatus is more likely to be the bearer of the "bad news" concerning—for example—ecological crisis, political corruption,

class bias; while the consciousness industry becomes the purveyors of hope, the professional lookers-on-the-bright-side. The very political impotence and isolation of the cadres of the cultural apparatus ground their pessimism in their own everyday life, while the technicians of the consciousness industry are surrounded by and have use of the most powerful, advanced, and expensive communications hardware, which is the everyday grounding of their own technological optimism. [3]

Gouldner goes on to cite Herbert Gans's remark that "the most interesting phenomenon in America . . . is the political struggle between taste cultures over whose culture is to predominate in the mass media and over whose culture will provide society with its symbols, values, and world view." (Leave it to an American sociologist to interpret these phenomena in terms of "taste cultures," apparently sidestepping the class dimension underlying them.) Yet high culture is, of course, increasingly interpreted in the light of mass-cultural understandings and forms of address: Witness the return to social and political elites of a patrician style like the "Hollywood version"—a style which, following the lead of the Reagan administration, is concocted of dollar signs, the finesse of surgeons both cosmetic and internal, and a touted skill at interpreting opinion-poll-driven scripts. In art and social life the linking of the good, the true and the beautiful is long dissolved, and a generalized cynicism accompanies the crisis of legitimation of the past decades—a crisis incompletely resolved by the recapitalization of both art and politics.

In art such recapitalization is most blatant in blockbuster exhibitions—the face the art world shows its largest public. The message here is neither a sermon of individual spiritual cultivation or an *Ozymandias*-like caveat about the remains of vanished civilizations. The awe of the audience is not intended to be moral; it is *supposed* to be occasioned by the apparent control of time, space and precious resources—an awe of simple accumulation, like Scrooge McDuck in the money vaults. If this sounds like the mind-set of imperialism, what else could it possibly be? (This identification with successful greed is not new to the exhibition-going public in empire states, of course, but the swaddling pieties have fallen away.)

It is inconclusive at best to remark that museums are more and more like shopping malls and apartment-house lobbies, for these spaces are as public or private as any other transitional spaces through which people must pass. Inside the museum the momentary impressions received in

the few seconds of regard budgeted for each static work are often accompanied or prompted by the spoken commentary of a private audio tour that returns the work to the familiar envelope of everyday mediations, with few terms that are not familiar—provided, of course, that you have had the appropriate childhood education.

Noted in passing: A recent *New York Times* article described the migration of East Village galleries to SoHo, a move made partly to hold onto their best artists— "best artists" here presumably being defined as those in most danger of being taken by SoHo galleries. The advantage of the East Village, it was remarked, was the chance to mull over what one had seen during the block or so one had to walk to the next gallery(!). But of course what SoHo lacks in opportunities for such contemplation it makes up for in available cash. The East Village is here treated not as a "scene" but as a staging ground—like the pre-Broadway staging of plays in provincial locales.

Last November, a conference in Minneapolis united the College of Art, the Walker Museum and First Avenue—Prince's club. The title was "Nouvelle Disco: Art in Popular Culture," and participants Henry Geldzahler, Ingrid Sischy, Barbara Kruger, Barbara Rose and others—but not Prince—were supposed to respond to the following: "Patrons of New York's Palladium and Area nightclubs and Minneapolis's own First Avenue step into an unparalleled kaleidoscope of visual arts, performance art, architecture, and entertainment these days. Why are they finding 'high art' in the disco setting? . . . Is a new art form emerging out of this high-tech, high-powered nocturnal environment?" So this was not, as subtitled, a symposium on art in popular culture but on art *in the space of* popular culture.

I am reminded of the crisis of acceptance of "public art" (the flap over Richard Serra's *Tilted Arc* is the best example), in which the passing audience refuses to constitute itself as its public, the body implicated in its discourse. Certainly in the absence of a political public—of even the conception of that space in which political dialogue and decision-making occurs—government-sponsored art can only be perceived as government-imposed art. Since it doesn't have a public—since there can hardly be said *to be* a public—this art cannot be accepted as work chosen by a designated governmental commission that stands for, that represents, *the* public, the public-at-large.

I am thinking also of the billboards a number of us are now favoring as a form of "public address," or of the insertion of video into some

broadcast television slots (a nod here to the problem of paying for these). Billboards and television represent items or events in the transitional spaces I referred to earlier. But at present the out-of-doors neither symbolizes nor necessitates a collectivity, not even the collectivity of the mob. The streets may belong to the people, but it doesn't at present want them. They have been ceded to the homeless, to the representatives of the state and, one guesses, to the "criminal underworld."

It may be only with the relatively circumscribed—but no less important—agitational works which emerge from a specific community and are staged within it that we can speak about the building of a public in art. I am thinking about Loraine Leeson and Peter Dunn's billboards in London's East End, complex montages with historically and politically based agitational messages of and for working-class communities under siege by developers. Artists' billboards must surely stand in contradistinction to these projects, for apparently the artists' billboards perceived to be the most successful are those with the least specificity in relation to their physical locales and, I suspect, those closest to the familiar forms of advertising (from which Leeson and Dunn's differ significantly). For *our* billboards, then, it seems that the art world is still their actual space, no matter where they are physically located. Their viewers may constitute their audience but not their publics.

In contrasting "audience," by which I mean roughly consumers of spectacles, with "public," which refers rather to the space of decision-making, I have come up against a set of questions that approach the topic suggested by our assigned title:

How can there be said to be a public sphere when only my students over forty *ever* articulate a difference between these concepts of audience and public? In general, everyone else sees the audience as a self-chosen subset of a more amorphous entity called the public. In other words, the dimension activity-passivity is attached only to the concept of audience, which has the distinction of willed spectatorship rather than residence in the limbo of nonchoice. And since choice among presented alternatives is how freedom, in our society, is defined. I guess that members of the audience are perceived as free while members of the public are not.

If public sphere and private sphere exist only in a relationship of complementarity, how can there be said to be a private sphere when no one remembers that in the past family members were expected to show at least an outward unity of purpose? And how can there be said to be a public sphere when news is entertainment and history is recounted in

terms of the lives of performers and dates of hit shows? How can there be said to be a private sphere when millions are told simultaneously to insert suppositories in order to gain hemorrhoid relief? And how can there be said to be a public sphere when most of the audience is apparently unconcerned with this simultaneity of address, and even with whether or not the message applies to them?

How can there be said to be a public sphere when schematic diagrams of the operation on the president's penis and lower intestine appear prominently in the mass media? Concomitantly, how can there be said to be a public sphere when the concept of privacy violated by these examples has long since been erased by everyone's apparent longing to appear on TV and thus be inscribed in history?

How can there be said to be a public sphere when the rules of civil behavior—personal, moral and legal—are suspended for celebrities? Concomitantly, how can there be said to be a public sphere when it has become impossible to challenge or criticize representatives of the state except in the most restricted terms circumscribed by a foolish politeness?

Finally, how can there be said to be a private sphere, how can there be said to be a public sphere, when the image of the terrorist, the grisly specter of the death of private and public alike, is put beside me at the family dinner table?

References

1. Allan Kaprow, "The Education of the Un-Artist," *ArtNews*, February 1971. Part II was published in *ArtNews*, May 1972, and Part III in *Art in America*, January–February 1974.
2. Russell Jacoby, *The Repression of Psychoanalysis: Otto Fenichel and the Political Freudians* (New York: Basic Books, 1983), p. 16.
3. Alvin W. Gouldner, *The Dialectic of Ideology and Technology* (New York: Oxford University Press, 1976), pp. 174–175.

The Birth and Death of the Viewer:
On the Public Function of Art

CRAIG OWENS

The Yen for Art

On March 30, 1987—one day before the Reagan administration
announced protectionist trade sanctions against Japan *and* Margaret
Thatcher dispatched one of her trade ministers to Tokyo with the threat
that she might soon take retaliatory action against Japanese banks and
investment firms operating in the City of London—one of the seven
paintings of sunflowers Vincent van Gogh produced in 1888 and '89—
"to decorate a room in his house," as Tom Brokaw reminded us on the
NBC Nightly News—was sold at auction in London to the Yasuda Fire
and Marine Insurance Company of Tokyo for a record 24.75 million
pounds sterling (or 38.9 million dollars, roughly the budget of a *Star
Wars* or, perhaps more appropriately, *The Empire Strikes Back.*)[1] A
manifestation of Japan's need to find outlets for its phenomenal trade
surplus—as a Yasuda spokesman put it to the *New York Times*, "We
have sizeable assets"—this sale affords an excellent opportunity to ana-
lyze the recent penetration of international investment capital into the
art market. Here, however, I will concentrate not on the sale itself, but
on the response it provoked in the western (art) press, which contributed
its own brand of cultural protectionism to the week's activities.

In the April 13 issue of *Time* Robert Hughes—never one to pass up the
opportunity to condemn the marriage of art and commerce, especially
when the opportunity carries a hefty lecture fee (Hughes has been travel-
ing around the country lecturing on "Art and Money" for $3,500 a
shot)—denounced the *Sunflowers* sale as a monument to "the new vul-
garity" of "a new entrepreneurial class that has fixated on 'master-
pieces.' " *Masterpieces* appears in quotation marks because, in Hughes's
opinion, the painting's aesthetic value—what we might call its Hughes
value—has been compromised by popular appeal: "Why such a price for

Sunflowers?" he asks. "It is one of the largest Van Goghs, if not neces-
sarily the best. Thanks to mass reproduction it is exceptionally popular
and famous. Its clones have hung on so many suburban walls over the
decades that it has become the *Mona Lisa* of the vegetable world." What
is more, this particular version of the painting has not worn well. Here is
Hughes's assessment of its "reduced condition": "The high chrome
yellow paint that Van Gogh used was unstable, and it has darkened to
ocher and brown, so that the whole chromatic key of the painting is
gone; the paint surface has turned callused with time and has little of the
vivacity or even the textural beauty one sees in other Van Goghs." In
other words, as it has aged, the painting has become the *Mona Lisa*
of the mineral world—although Hughes does not appear to appreciate
the irony that the world's most expensive work of art should be a
gold painting.

Hughes's dismissal of *Sunflowers* because of its popular appeal does
not, however, prevent him from condemning its sale in the name of the
public: "Private collectors," he writes, "are driving museums out of the
market. . . . No museum in the world can compete with the private sector
for paintings like *Sunflowers*." (One might well ask why they would
want to, given the painting's "reduced condition.") In pitting museums
against the private sector, Hughes not only ignores the recent alliance of
museums and corporate capital (the Whitney Museum's cohabitation
with both Phillip Morris and Equitable being only the most obvious
example); he also presupposes that museums in fact function in the pub-
lic interest. However, the new-found "populism" of such institutions as
the Metropolitan Museum can be attributed only to corporate support,
which has brought with it an emphasis on box-office receipts and on
productivity—hence, the merchandising of everything from signature
scarves to reproductions of fake Egyptian cats. Today, every museum
worth its salt has a director of marketing. It is clear that, at least in the
1980s, museums regard "the public" as a mass of (potential) consumers.

At the conclusion of his diatribe Hughes once again identifies the traf-
fic in paintings as public enemy number one: "The big auction," he
writes, "as transformed by Sotheby's and Christie's, is now the natural
home of all that is most demeaning to the public sense of art. *Sunflowers*
was once alive, and now it is dead—as dead as bullion. . . ." (Thus, to
protect the work of art from private appropriation, Hughes *fetishizes* it,
attributes living or animate properties to it.) However, the *Sunflowers*
case is complicated by the fact that, in its statement to the press about the

acquisition, the Yasuda Fire and Marine Insurance Company also invoked the public. Upon arriving in Japan, the painting will immediately go on public exhibition (in the Sejii Togo Memorial Yasuda Kansai Museum on the 42nd floor of Yasuda's corporate headquarters in Tokyo) as a token of the company's "gratitude to the Japanese people." For it turns out that this acquisition was also a restoration: the painting was purchased to replace another version of *Sunflowers*, one that was on loan from a private Japanese collection to the Yokohama City Art Museum in 1945, when it was destroyed, as the *New York Times* put it, "by fire." (*Firestorm* is more like it.) That the *Times* did not name those responsible for the destruction of the painting is one indication of just how sensitive an issue Yasuda's acquisition of *Sunflowers* is, especially in light of current tensions between Japan and the west.

I cite this episode here to demonstrate how malleable the concept of the public can be. That both Hughes and Yasuda could invoke "the public," one in condemning the sale of the van Gogh, the other in publicizing its acquisition, indicates that "the public" is a discursive formation susceptible to appropriation by the most diverse—indeed, opposed—ideological interests; and that it has little to do with actually existing publics or constituencies.

Hughes's appraisal of the van Gogh suggests that it would have been at home in the "Damaged Goods" exhibition at the New Museum (summer 1986)—a celebration of the return to the object in contemporary art; alternately, a temple to the fetish commodity. Every Saturday afternoon one of the ten invited artists, Andrea Fraser posing as Jane Castleton, a docent, conducted a tour of the museum, beginning in its bookstore/gift shop: "The New Museum started its Docent Program because, well, ah, to tell you the truth, because all museums have one. It's just one of those things that makes a museum a museum.... But the New Museum has other things in common with other museums ... it has a bookstore/gift shop." Walking to a wood panel in one corner of the bookstore/gift shop, Fraser/Castleton pulled it aside: "Over here, conveniently located in the bookstore/gift shop behind this panel is the control board for the Museum's security system. Of course all museums have security systems—owning and exhibiting art, like all valuable property, is a responsibility, and the Museum's first responsibility is to protect the culture it fosters."

In presenting her contributions to the exhibition in the form of a docent's tour, Fraser was situating her practice in the tradition of intel-

lectual critique instituted in the 1970s. But she was also inverting the terms of that critique, at least as they were defined by Peter Bürger in his *Theory of the Avant-Garde*, which calls for a "functional analysis" of works of art, an examination of their "social effect (function), which is the result of the coming together of stimuli emanating from within the work itself and a sociologically definable public within an already existing institutional frame."[2] Unlike Daniel Buren, who investigated the function of the work of art, Fraser focuses on the function of the institution frame itself—specifically, its avowed purpose of protecting cultural artifacts in the name of the public.

"This particular board," Fraser/Castleton continued, calling our attention to the corporate logo affixed to the control panel, "is an Imperial Product—fit to protect the property of emperors, fit to protect an empire, as it were. From this top box, the guards, with a key, can turn the entire system on and off. This panel here receives signals from the perimeter intrusion detection system—a versatile system that can be used on walls, windows, display cases, storage cases, ATMs, safes, vaults and any other material that can be physically compromised. It can pick up the high-frequency shock waves that intruders broadcast as a result of their attempted forced entry, the shock waves produced by hammering, cutting, drilling or the more archaic breaking." Note the sexual subtext here: phrases like "physically compromised" and "forced entry" connote rape, hence the body's vulnerability, hence the need for protection. "And finally," Fraser/Castleton informed us, "this last panel monitors the combination microwave/infrared detector which you probably didn't notice as you walked through the door, although I'm sure it noticed you!" Thus Fraser called attention to one of the subtle inversions of cultural protectionism: while the museum claims to protect works of art in the name of the public, it actually protects them *from* the public. (At the entrance to the exhibition proper, Fraser/Castleton reminded us that works of art must be protected from viewers: "I have to remind you that no one, not even a docent, may touch works of art on display. Touching works will dull the colors and deteriorate paintings because of oils from the skin, and will also wear away the surface of sculptured works. [Shades of *Sunflowers*!] We must remember that these works of art are real and original and can never be replaced.")

The central themes of Fraser's talk—the link between aesthetics and protection—emerged when she praised the artful installation of the

security system: "The Museum's security system was designed by American Security Systems, a company that cares as much about aesthetics as it does about protection—that's their slogan." (In the printed version of the talk, available in the bookstore/gift shop, Fraser adds a footnote: "Really, I didn't make it up!") This link resurfaced when Fraser/Castleton singled out one of Allan McCollum's *Perfect Vehicles*, describing it as a "deer-shaped vessel from Chicama in northern Peru." Quoting from the *Metropolitan Museum Guide*, she continued: "During the 14th and 15th centuries, the Chimu kingdom ruled the north of Peru from its capital at Chan Chan. Its monarchs amassed great wealth and constructed enormous walled compounds from which to protect it. These compounds contained so many objects made of precious metals that during Spanish colonial times they were exploited as mines." And then, citing Noam Chomsky from the catalog of the "Disinformation" exhibition at the Alternative Museum: "Current estimates suggest that there may have been about 80 million Native Americans in Latin America when Columbus 'discovered' the continent. By 1650, 95% of this population had been wiped out. The systematic extermination of Latin America's population continues today in Brazil, Paraguay, and Guatemala.... This vessel was given to the museum by Nelson A. Rockefeller. But, ah, as we discussed earlier in the talk, they care as much about protection as they do about aesthetics...."

If culture is to be protected, is it not precisely from those whose business it is to protect culture? As Fraser points out, the protection of culture is a responsibility claimed by those most deeply implicated in the destruction of indigenous cultures and the social relations of reciprocity and obligation those cultures embody, so that the capitalist social relation—the wage relation—can be imposed. In other words, along with "soul-making," the protection of culture is an ideological alibi for the project of imperialism—an alibi in which we witness an inversion which, I propose, is the hallmark of protectionist discourse. For it is those who stand to benefit most from the destruction of culture who pose as its protectors.

Fraser/Castleton then directed attention to Louise Lawler's *Two Editions* on an adjacent wall: "Notice the two painted squares. Notice how much larger the square on the left is than the square on the right. Well, the square on the left represents the amount the United States and European community spends on military research, while the square on the right represents the amount spent by the same countries on health

research. It costs $590,000 a day to operate one aircraft carrier." If they saved up for 68 days, they could buy a van Gogh.

Which brings me back to Robert Hughes. Comparing the sale of *Sunflowers* with the auction the same week in Geneva of the Duchess of Windsor's jewelry, Hughes again assumes the role of critic-as-art-appraiser: "Most of the jewelry was florid stuff from the 40s and 50s of no sylistic distinction, with some good stones and a few imaginative settings. None of that mattered. Sotheby's had projected a total sale of $7.5 million; the two-day affair fetched $50 million." And then a parenthetical addition, which may well be an editorial interpolation: "(which, in accordance with the Duchess's will, went for the benefit of medical research at Paris's Pasteur Institute.)" Then the unmistakable voice of Robert Hughes resumes: "The well-known bauble collector Elizabeth Taylor phoned in from Los Angeles to pick up a diamond clip for $565,000." (She might, of course, have contributed the sum to the operation of an aircraft carrier for a day.) The juxtaposition in the same paragraph of the Pasteur Institute and Elizabeth Taylor brings to mind private efforts to raise funds for research into the HIV virus in order to compensate for the public sector's scandalous refusal to appropriate adequate funding. Hughes does not mention the fact that the sale of the Duchess's jewels raised $50 million for AIDS research, which makes his verdict on this sale ironically applicable to himself: "One thinks of this event as ugly social comedy [which Hughes obviously does] at one's own risk."

This sudden invocation of "risk" in Hughes's cultural protectionist discourse reminds us that we the public are currently the target of massive publicity campaigns exhorting us to learn how to *protect* ourselves against HIV infection—when, of course, it is the person with the virus who needs to be protected from the public... and not only medically. As our president—an expert in protection—reminds us, celibacy is the best protection. Thus AIDS becomes a weapon in the right's campaign against nonreproductive sexual activity. As in the effort to reinstate prayer in the public schools, in the campaigns against abortion and pornography and "drug abuse," behavior once regarded as private is being redefined as public—as criminal. And this reinscription of the private as public is invariably enacted in the name of *protection*—in the anti-pornography campaign, the protection of women; in the anti-drug campaign, the protection of children; in the anti-abortion campaign, the protection of *unborn* children.

Cultural protectionists like Hughes share the same agenda. When he fetishizes *Sunflowers* as a once-living thing, Hughes sounds like a foetus fetishist. When he observes that the price of a painting is nothing but an index of the collector's desire, adding "and nothing is more manipulable than desire, a fact as well known to auctioneers as to hookers," he not only scapegoats women for prostitution—the word Hughes is searching for here is *pimps*—he also presumes his reader's moral stance on commercial sex. When he speculates on why "the new entrepreneurial class" needs paintings, observing that "art confers an oily sheen of spiritual transcendence and cultural respectability," he adds, "This is why even a soft-porn merchant like Bob Guccione, publisher of *Penthouse* magazine, is now a 'major' collector." Guccione is the only collector Hughes mentions by name in the article. Not only does "oily sheen" read as an anti-Italian slur; here Hughes aligns the cultural protection movement with the anti-pornography movement.

As Barbara Ehrenreich observed on the recent "Policing of Desire" panel sponsored by the Dia Art Foundation (March 1987), the key term in the right's condemnation of our society is *permissiveness*. Now this permissiveness is not an index of immorality or degeneracy, as they would have us believe, but an essential factor in a disaccumulative economy, the extensive regime of postwar capitalism or consumer society—which must promote consumption, expenditure, self-indulgence, the gratification of every desire as our fundamental economic *obligations*. Thus the right, champion of free enterprise, is caught in a contradiction between its economic and its ethical agendas. Instead of recognizing the economic determinants of this contradiction, however, responsibility for the current crisis of capitalism is displaced, as Ehrenreich observed, onto the supposedly irresistible allure of "alternative life styles." But as often as not it is the cultural sphere that is held responsible for permissiveness—and not only film and television, which as instruments of capital are the primary media through which we are daily reminded of our obligation to consume, but also the anarchic, antagonistic, potentially liberating culture of the avant-garde.[3] This is, of course, the argument of Daniel Bell's *The Cultural Contradictions of Capitalism*, and it has lately been taken up by Hilton Kramer and company at *The New Criterion*. Unlike Hughes, these ideologues advocate the transfer of cultural patronage from state-sponsored museums to precisely those private interests traditionally engaged in the protection of culture—a strategy which complements perfectly the privatization of foreign policy by the

Reagan administration. Nevertheless, the terms of the argument remain the same. And the question of who is to define, manipulate and profit from "the public" is, I believe, the central issue of any discussion of the public function of art today.

References

1. This text develops out of the Dia discussion in which I took part (2/10/87); it is not a record of the talk I presented that night.
2. Peter Bürger, *Theory of the Avant-Garde*, trans. Michael Shaw (Minneapolis: University of Minnesota Press, 1984), p. 87.
3. See Jürgen Habermas, "Modernity—An Incomplete Project," in *The Anti-Aesthetic: Essays on Postmodern Culture*, ed. Hal Foster (Seattle: Bay Press, 1983).

The Birth and Death of the Viewer:
On the Public Function of Art

DISCUSSION

AUDIENCE (HAL FOSTER): I have a question for Martha and Craig. Tom suggested an opposition between an imaginary public and actual audiences; the latter, he implied, have effectively balkanized the former. What do you think of this charge of balkanization that he lays on different groups, on groups of difference?

CRAIG OWENS: To an extent that's the question I wanted to ask him too: Do you mean that this balkanization of the public is the doing of postmodernist artists and critics—that it was they who somehow abandoned this great notion of community, this ideal concept of the public?

THOMAS CROW: Not really—nothing quite so moralistic or voluntarist. What I think is actually involved is an aesthetic regression. We come out of a period after 1968 in which the sovereignty of the object was undermined. The formation of a new art public—which would be a microcosm, either actual or anticipatory, of a larger public—seemed to necessitate an end of the craft which had constituted art as traditionally conceived. Yet this challenging of the hegemonic (white, male) cultural sphere was proposed in the name of precisely those discarded craft practices—painting and sculpture, colorful handmade things. The result was a balkanization of art practices, a balkanization of art audiences.

Now in the other moments I discussed—Reynolds in the 18th century, Greenberg et al. in the 1930s—the art object was also dethroned for the simple reason that it was perceived to be no good. Then it was up to discourse to say what was required—to construct a public informed enough to demand good art. Today, in the hegemony of postmodernism, discourse seems only to follow practice, which is to say that it heeds only the needs and interests of special groups. In art that reduces down to the needs and desires of certain artists and patrons—to

the point now where work is often legitimated by the simple assertion of the artist.

AUDIENCE: You leave out the fact that today artists play critic and vice versa—that these are interchangeable roles.

MARTHA ROSLER: Are you saying this characterizes the current moment?

AUDIENCE: Oh yes, definitely.

C. O.: We could ask for examples. Tom spoke about the moment of the late '60s and early '70s when artists did function on multiple fronts in multiple roles—a moment when the professional division of labor within the art world was overcome. It seems to me that now everybody's back in place: the artists make the objects, the critics write about them, the dealers sell them and the historians write history. That's a shift since the shift of the late '60s.

AUDIENCE (DAN GRAHAM): There was a magazine called *Artforum* where artists worked as writers, where an artist—Ed Ruscha—designed the layout . . .

C. O.: You're speaking in the past tense, Dan. Now there is a magazine called *Artforum* in the center of which are visual projects by visual artists, with texts in the editorial section by writers. The general pattern is clear.

M. R.: I wonder why so many people agreed that there was a shift in roles? I mean, the older folks—from the early '70s—didn't; but how can the rest of you see this at work in the present moment?

AUDIENCE: You yourself are an example; so are Barbara Kruger, Louise Lawler, Hans Haacke, Victor Burgin, Krzysztof Wodiczko . . .

M. R.: Do you know what generation they are?

AUDIENCE: Most are under forty.

M. R.: Most of them are not under forty. It makes a tremendous difference because they are not the present generation of artists.

T. C.: Their activity is a continuation of this previous shift.

C. O.: Right. Those practices were formed in a particular moment—they come out of the late '60s and early '70s. They are also all involved in

a theorization of the viewer. You mentioned Hans Haacke: Well, the private appropriation of the public sphere—of the public function of art—is the very subject of his work, and the conceptual dematerializing of the art object that Tom mentioned is part of its strategy.

Today the situation is very different. Recently in a graduate sculpture studio I met this woman who made these nice paper things that hang between plexiglass, and I asked her, evasively, what they were about. She replied, "I'm trying to establish a different relationship to the buyer of my work." Now it used to be called the viewer. . . . This is the discourse today: in most new works of art the function of public address is eliminated. Instead of the modernist you-don't-have-to-own-it-to-get-it there's a direct relationship posed to the patron, and the work is that relationship. This "position" stands in strong opposition to late '60s/early '70s practice. If there is a loss of the public function of the work of art, it happened not then but in the present.

M. R.: Tom, I'm shocked by your suggestion that it was somehow groups like women who dragged the discourse away from the pursuit of some imaginary high public.

T. C.: I don't agree with your characterization of my statement. There can be no objection made to the political argument with decayed modernism which came from feminists as well as from others, and I am in total agreement with it. But a price was paid; the work of artists like Judy Chicago was one of the prices.

M. R.: No. No matter what you think of her work, Judy Chicago invented the idea of a productive community in the modern art world where people could get together as a relational group and generate art. It was the most valuable contribution, and it involved not only a community but a pedagogy—the necessity not only of building a public (in much the way you described) but also of representing the unrepresented, of posing the questions that urban life and class division had obscured. That's how I see her work and its resonance.

T. C.: Your point's well taken.

AUDIENCE: Donna Haraway, in an article called "Manifesto for Cyborgs," a feminist article, talks about images of identity. For example, she uses the term "women of color" and argues that it was set up in opposition to a pair of other terms—of blacks who are never women and women who are never black. In other words, she suggests a flexible

notion of identity whereby one can take on an attribute in order to clarify a situation. Now my claim is that the public does this all the time—it's built into the culture. It is flexible and unstable by nature—like the lady from Kansas City who is thrilled by graffiti in New York but who would hate it in her hometown, or the little girl who plays with a Rambo doll while listening to Tina Turner sing "We Don't Need Another Hero." Given such constant shifts, if we set up a model of an ideal public, we may impose a false unity rather than empower large, random audiences to create their own formations.

M. R.: I think you have a problematic opposition there between a totalizing notion of the public and a looming, buzzing chaos of different audiences.

T. C.: I hear something else: You're objecting to my notion that we could map out this missing public when the actual situation far exceeds our happy constructions. You're arguing that if these actual audiences were empowered they would have the art they want. Is that how it runs? Well, I think we've been through this. We've had lots of forms of rich nonelite, nonsanctioned culture valorized and empowered—we've seen it happen. You brought up graffiti—well, graffiti got empowered. To what effect? To effects that are thoroughly reactionary—that obstruct thinking about the conditions under which the form was originally produced, about why its images are borrowed, stereotyped, sexist and violent, about why it is such a big hit with the new patron class (that is, until last year or so).

AUDIENCE: Graffiti was appropriated, not empowered. In many ways it was disempowered.

T. C.: But what was so great about it in the first place? It was mainly made by adolescents...

AUDIENCE: You already put down women because they rejected certain forms of art; now you put down graffiti because it's made by kids.

T. C.: No, that's not the point. Let me clarify. All these groups—women, Puerto Ricans, whatever others—they're not all the same: there are arguments among women, arguments among urban ethnics, and those arguments are where the politics are. Defining them as audiences strictly in terms of gender, ethnicity or region is precisely the conceptual problem. In fact, the artificial definition of communities that are divided

among themselves is the conceptual disease of the whole left postmodernist moment. One result is that stereotypical art often gets undeserved attention at the expense of art produced by members of groups with greater claims. Under current conditions of kitsch, regressed art will always win out—discourse does nothing to stop it. I don't mind treading on these difficult issues of gender, race and so on (I think my political credentials are pretty OK) because they should be raised in these very terms.

AUDIENCE: Definitions by gender, race and region are not the problem for these groups; the problem is that the power elite, the white, male power elite, does not allow their voices.

T. C.: Of course. I agree with you.

AUDIENCE: I want to get back to the question of community, empowerment and graffiti.

M. R.: You think graffiti is about empowerment?

AUDIENCE: Yes. It gives unrepresented people a chance to speak.

M. R.: Do you want to hear another view? When we talk about graffiti art, we talk about a simulacrum (even if it is produced by the same people who produced graffiti): it is a symbolic representation, on center stage, of the other as tamed entertainer—it's like a minstrel show. Now its original counterfunction should not be ignored: it did open up places within a closed system to people of color, of other classes. But to see it as liberatory as such or as directly representative of specific communities now is to be satisfied, as Tom said, with a stereotype. And the problem with such stereotypes is that they are always unidimsenional—unitary sides rather than bearers of complex meaning. I somehow feel I'm with Tom on this point.

AUDIENCE (DEBORAH DRIER): What is this ideal art that is supposed to serve us? Extrapolating your historical examples toward the present, what is this ideal community to which we should address our writing or our art?

T. C.: I have a good pedigree of pessimism on this score in the people I cited in my talk. They couldn't point to much and didn't try; yet their discourse proved to be extraordinarily productive for later practice. (For example, even in the decayed modernism of the late '50s and early '60s

there's an echo of a politically constructed subject as imagined in the
'30s.) In the '30s and in the 18th century no valid artistic practice could
be conceived; their models were entirely retrospective, and only an
heroic transformation of the audience through discourse could promise
(and a very iffy promise it was) the emergence of an art which would
stand on equal terms with the great art of the past. I think we're in a
similar position today. I can't offer prescriptions; I can only point to the
list of names posed earlier—artists who keep these issues alive in a much
narrower subpublic than their kind of practice once had.

AUDIENCE: You talk about the '30s and the '60s with no mention of the
dissent in the culture at large—like the Communist Party of the '30s and
the New Left movements of the '60s. That has everything to do with the
possibilities of a new public. Right now there's no left movement, or it's
very hard to find. It's so small and marginalized that few new voices
come out of it.

T. C.: Your point's valid. It's part of the closing in of political culture, of
the imagination of political alternatives, of the construction of collective
political opposition—of the very bases of the 20th-century imagination
of community.

M. R.: There's nothing wrong with a little utopianism. The problem
begins when you let the media define your agenda: if you allow represen-
tations of political culture to stand for political culture you're defeated
before you begin. But your particular point is very important: often only
artists of a certain generation—most of whom come out of left move-
ments or the counterculture in general—are allowed to speak for the left
vision in art. I think this is a serious problem, one that every artist—no
matter where he or she stands in the political spectrum—should resent
and struggle against.

AUDIENCE: I want to go back to Tom's contrast between ideal publics
and actual, ideological communities. I wonder whether in fact all those
moments—late 18th century, the '30s and the '60s—are not moments
when there are falls from grace, falls from a past ideal that never actually
existed. After all, there were always oppositional practices, oppositional
publics.

T. C.: I agree. But when we talk about a public in any strong sense it's
got to be lasting. If art can create a public, as artists in the 18th century
believed it could and as theorists in the '30s hoped it might, it can only

come of a long-term commitment, and it has to be built socially on all fronts—not just on a temporary group. The art world has communitarian strains, but they have been sorely tested of late, and the cash nexus has replaced other kinds of feelings that once seemed more powerful. Unfortunately, that's a feeling I think we all share.

Strategies of Public Address:
Which Media, Which Publics?

DOUGLAS CRIMP

The subject of this discussion— "Strategies of Public Address: Which Mediums? Which Publics?"—seems to me to assume that another question has already been answered. It seems to take for granted that we know what we are strategizing about, what we want to address to *the* or *a* public with this or that medium. And for reasons that became clear to me last week, I don't think we can make that assumption. I think we have to ask, before we ask anything else, what exactly is at stake. These sessions were intended to be genuine discussions, in which something of the spectacle of speaking in public would be overcome, so that the strategy of public address used here would not be one we are accustomed to in the art world, but would instead be a situation where we could get down to work on issues that concern us. The first session was profoundly alienating for me, and I was led to think more seriously about that alienation through an even more intensified experience of it when I acted as a respondent at a session of the College Art Association in Boston two days later. In that instance I tried to raise the issue of the real political stakes in a session on art museums by introducing Louis Althusser's theory of ideology. At the moment when I began quoting Althusser to the effect that the Ideological State Apparatuses may not be only the *stake* but also the *site* of struggle, a great number of people simply got up and left. After hearing a number of more or less traditional art-historical analyses of art museums, the audience responded to my attempt to raise the stakes, as it were, by saying in effect, "This does not concern me."

So it is this question of stakes, of what really does concern us, that I want to raise here, because it seems to me that in the first discussion it was simply assumed that we all shared the same political stakes, which at the time were rarely specified or concretized. In addition, many of us in the audience registered our sense of alienation only negatively, saying with our silence once again, "This does not concern me."

What *was* concretized somewhat last week revolved around Tom
Crow's implicit blaming of the current market domination of art on a
balkanization of political struggle that issued from the New Left in the
1960s, which seems to me blaming the victim with a vengeance. But this
also led me to think about a particular one of those balkanized states,
the one from which I felt my own specific isolation and alienation, and
the one in which I have a particularly urgent stake: the intensification of
isolation and oppression of gay people. The kind of response that Crow
met from women last week, very eloquently articulated by Martha
Rosler for example, rarely comes from gay people, who almost never feel
empowered to speak, to speak, that is, *as* gay people, from within a
developed discourse of their own; and this is as true in the art world as
anywhere else. As Guy Hocquenghem wrote fifteen years ago, "The
power of oblivion generated by social mechanisms with respect to the
homosexual drive is such as to arouse the immediate answer: this prob-
lem does not concern me."

I don't think it should be necessary to illustrate the truth of this state-
ment, the fact that gay issues are the most marginal of political issues.
"This problem does not concern me" is in fact the very way that homo-
sexuality is framed for discussion. Within the left, even where political
struggles are theorized through the very balkanization that Crow was
speaking of, gay struggles are mentioned only phatically, usually as the
final word in a phrase like "blacks, women and gays." It is a kind of ritual
nod, which rarely goes further, and sometimes doesn't even go that far.
When *Social Text* produced its special issue on the "Sixties without
Apology," it contained what was called a "very partial" chronology of
political events of the '60s. It was very partial indeed. For the year 1969
fifteen events were listed, including the release of Dennis Hopper's *Easy
Rider*. The Stonewall riots were omitted.

I don't think that we can begin, then, by assuming that we know what
the stakes are for all of us in this room. There was a button that people in
the gay movement used to wear that said, "How dare you assume I'm
heterosexual." And I guess that's what I would like to say to Tom Crow:
How dare you assume that my stakes are the same as yours. But Crow
would undoubtedly be unperturbed, claiming confidently, as he did last
week, that his political credentials are in order. But although Crow did
say that, and many of us were shocked by it, I think that we should
understand this as voicing a position of self-satisfaction that is not
Crow's alone, but that of an established and powerful left discourse

within academia. This discourse generally claims, as Crow did, to support all those movements of the '60s that led to balkanization. But what form does this support take other than that of simple tolerance? Pasolini said that "tolerance is always and purely nominal." And he continued,

I do not know a single example of real tolerance. That is because real tolerance would be a contradiction in terms. The fact that someone is "tolerated" is the same as saying that he is "condemned." Indeed tolerance is a more refined form of condemnation. In fact they tell the "tolerated" person to do what he wishes, that he has every right to follow his own nature, that the fact that he belongs to a minority does not in the least mean inferiority, etc. But his "difference"—or better, his "crime of being different"—remains the same both with regard to those who have decided to tolerate him and those who have decided to condemn him. No majority will ever be able to banish from its consciousness the feeling of the "difference" of minorities. I shall always be eternally, inevitably conscious of this.[1]

Pasolini would not be conscious of it much longer, since only a few months after he wrote this he was brutally murdered for his difference.

Two years ago the New Museum organized the show titled "Difference: On Representation and Sexuality," a show in which Barbara Kruger's work was included, and during the opening of which Krzysztof Wodiczko projected images of chains and padlocks onto the Astor Building, which houses the New Museum. A great deal of animosity was generated around that show; all of us tended to take and defend positions, with the result that constructive discussion of the issues the show raised was foreclosed. The very urgency of inscribing a discourse of sexual difference within the museum tended to be lost in the controversy over how that should be done. This is not to say that those differences were not important, only that they constituted the terms of a debate that we never had. On one occasion Constance Penley suggested that we might think about the meaning of Krzysztof's projection during the show's opening. I think she intended for us to consider the relation between two distinct strategies of public address: on the one hand, confronting the institution from within with the stakes of sexual difference, on the other, confronting the institution from without with the stakes of art-world complicity in gentrification and homelessness. Is there a way

to mediate between these two strategies? The question is neither conten-
tious nor idle, for it resolves itself into the absolutely crucial problem of
mediation between the politics of class and those of sexual difference.
Since two of the participants in that event are on this panel, this question
of mediation is one that might be productively raised here.

But I want to complicate this question somewhat further by insisting
on a point I tried to make at the time. Just before the "Difference" show,
Chantal Akerman, whose *Je Tu Il Elle* was included in the show's film
and video section, withdrew that same film from the gay film festival,
saying that she did not want to be ghettoized in such a context. Her deci-
sion to do so is one that I respect, because no one should be denied the
right to refuse an identity imposed by others, especially when that iden-
tity can have dire consequences. Nevertheless, her decision raised the
issue for me, as for others, of the absence of homosexuality from the
discussion of sexual difference within the exhibition's catalog. In his
notes for the "Homo Video" show recently at the New Museum, curator
Bill Olander makes reference once again to that absence, saying that with
regard to homosexuality the "Difference" show was a "stunning failure."
Now it must be said that any attempt to dismantle patriarchy, any insis-
tence on sexual difference, implicitly benefits gay people. But the rele-
vant word here is "implicitly." How, we have to ask, does this implicit
inclusion of us in the discourse differ from the presumption that women
are included in the universal "he"? How does the presumption of desire
as heterosexual differ from the presumption of subjectivity as male? So I
think that Bill's insistence upon the fact that the word "homosexual"
never appears in the texts for "Difference" cannot be easily dismissed.

One of the videos shown in "Homo Video" was *The AIDS Show:
Artists Involved with Death and Survival*, a made-for-television tape
documenting a theatrical review staged by Theater Rhinoceros to
give a collective voice to the San Francisco gay community's response
to AIDS. The vignettes documented in the tape are actually those of
the second, updated version of *The AIDS Show*, whose title was *Un-
finished Business*.

Now I'm not sure how many people noticed the fact that *The New
AIDS Show* and Hans Haacke's exhibition at the New Museum (concur-
rent with "Homo Video") had exactly the same title, "Unfinished Busi-
ness," because I'm not sure how many people saw both, or would have
been aware of the particular ironies of this conjunction. My impression
from the several times that I visited both shows was that there was very

little sharing of audience. But one thing is clear: there was no mediation between these two shows. The reviews of the Haacke show, which appeared in the mainstream press, never mentioned the presence in the same museum of "Homo Video," and the reviews of "Homo Video," which with only one exception appeared in the gay press, did not mention the Haacke show.

It is easy to see the reason for this: The journalistic response to Haacke's show treated the issues raised by his "Unfinished Business" within the context of the individual artist's body of work—in other words, business as usual. Political issues became secondary to the aesthetic strategies of the producer. Perhaps this was most obvious in the fact that of the essays in the Haacke catalog one was always singled out for mention: the one written by the famous art-world personality, Leo Steinberg, who sought to position Haacke aesthetically rather than politically. The essay by Rosalyn Deutsche, which dealt not with Haacke the artist but with the political stake of one of his works, was ignored. Thus, when it is an individual's practice that is at stake, rather than the political stakes of that practice, broader political questions are foreclosed. Such a broader question might be, "What is the relation between the political stakes of Haacke's 'Unfinished Business' and those of that other unfinished business back there where the pink triangle was painted on the wall?"

A favorable review of the "Homo Video" show in the *Native*, a gay newspaper whose politics are very undeveloped, stated that "to see these tapes in a museum environment forces the viewer, regardless of his or her sexual preference, to consider them as Art [written with a capital A]: personal, unique expressions that portray human experience in any, some, or many of its possibilities." This statement can only demonstrate that the writer has been entirely unaffected by the way in which the Haacke exhibition problematizes just such a view. Did he not bother to look at and think about the Haacke show? If not, was this because he thought Haacke's work did not concern him? And might he not, in fact, have been justified in thinking that?

One of the accusations that has been made against the gay movement is that it is a single-issue movement that ignores other forms of political oppression. This is a *real* danger of balkanization. But we must remember that it is the result, in this case, of a very painful history within the gay movement, whose attempts to form a coalition with other left movements were usually met with one form or another of the response: "This

problem does not concern me." And I don't detect anything in Haacke's work that might give gay people the sense that there is anything here in this regard but business as usual. (I want to add here that my sensitivity to the way in which Haacke's work embodies a "theological" notion of the political—a politics which takes no account of sexual difference—came largely from conversations with women, especially Rosalyn Deutsche, whose assessment of the real political stakes of Haacke's work includes a concern that it not be positioned as an exemplary political practice. There is, of course, no question of any single artist addressing every aspect of politics, but neither should any politics be so privileged as to marginalize others.)

If Haacke's work itself did not directly address issues specific to the gay public of "Homo Video," neither did the New Museum attempt any form of mediation between these two shows. I don't want to sound as if I'm coming down on the New Museum. If it becomes the focus of political discussion that's because it's one of the few institutions that provides the space for political ideas in the first place. But I wonder what might have been achieved, for example, if the two curators, Brian Wallis and Bill Olander, had strategized together about the possibility of confronting Hans Haacke's "Unfinished Business" with "Homo Video" 's unfinished business. How might Benjamin Buchloh's lecture on Haacke at Cooper Union have been *different* if he had been asked to talk about "Homo Video" as well? I know this might sound like an absurd proposal. But its absurdity should tell us something of the degree of our differences.

I want now to raise some questions more specific to "Homo Video," with regard not to the individual tapes but to their intended public. Some of these are suggested by *The AIDS Show*, not the video but the theatrical review it documents, the strategies of its public address. *The AIDS Show* was intended to be performed at locations in San Francisco to provide gay people with a collective experience that might counter their sense of isolation, their fear that whatever they had achieved of community was threatened with destruction as a result of the AIDS epidemic. This desire to rebuild the gay community, to empower it in response to crisis, seems to me the most important fact of *The AIDS Show*. It is this that it seems to me is missing from "Homo Video," and precisely because, as the *Native* reviewer said, in this space the tapes are seen as works of art.

I don't want to come down on Bill Olander here either. I feel only soli-

darity with what he's done. But what he's done raises important questions which are essential to our topic of discussion. These questions might already have been partially answered if Bill himself did not have to work in isolation, if his own enterprise were in some sense collective.

Here then are a series of simple, concrete problems that this show suggested to me, and that I think might provide us with a model for a discussion of other mediums and other publics. First, it seems to me, given a very difficult history of relations between gay men and lesbians, where gay men very often presume to speak for homosexuality as a whole, shouldn't this show have been done in collaboration with a lesbian cocurator? Second, could this have been something more or other than an exhibition, an occasion for discussion of issues raised by the tapes, for example? Third, who is the intended public for this show? If its primary public is gay, should we not consider all those gay people who do not go to museums? Are there possibilities for showing these tapes in places where gay people would feel comfortable discussing them: in the gay community center, for example; in community groups such as Men of all Colors Together or Salsa Soul Sisters; in bars and clubs that are equipped with video monitors? And these questions pertain to the production of the work as well. For whom, and for what venues, are these tapes made? Clearly, some are for cable TV, others for gay film and video festivals; but if the tapes are made for the gay community, how have they taken account of where that community is to be found, or how it is to be constructed?

Cultural work would obviously be very different if it were conceived within, addressed to and constitutive of collectivities. But this is something that artists alone cannot be expected to produce. Rather, all of us who sense that our stakes are shared would have to invent procedures for working together. In the process our sense of isolation might be overcome, our overspecialization broken down. And strategies of public address—which mediums? which publics?—would be decided in the process of that collective work. This might sound utopian, but it seems to me less utopian than thinking we can answer these questions as isolated individuals.

Reference

1. Pier Paolo Pasolini, "Genneriello," in *Lutheran Letters*, trans. Stuart Hood (Manchester: Carcanet Mill Press, and Dublin: Raven Art Press, 1983), pp. 21–22.

Strategies of Public Address:
Which Media, Which Publics?

BARBARA KRUGER

These are the words which were spoken on the night of the panel. Noth-
ing has been altered to make me sound better, more formidable, more
correct or more intelligent for the printed posterity which this book
might guarantee. —B. K.

"Love" is entangled with the question of woman's complicity; it
may be the bribe which has persuaded her to agree to her own
exclusion. It may be historically necessary to be momentarily blind
to father-love; it may be politically effective to defend—tightly,
unlucidly—against its inducements, in order for a "relation
between the sexes," in order to rediscover some feminine desire,
some desire for a masculine body that does not respect the Father's
law.
 —Jane Gallop
 The Daughter's Seduction: Feminism and Psychoanalysis

Artists engaged in sexual representation (representation *as* sexual)
come in at precisely this point, calling up the sexual component of
the image, drawing out an emphasis that exists *in potentia* in the
various instances they inherit and of which they form a part. Their
move is not therefore one of (moral) corrective. They draw on the
tendencies they also seek to displace, and clearly belong, for exam-
ple, within the context of that postmodernism which demands that
reference, in its problematised form, re-enter the frame. But the
emphasis on sexuality produces specific effects. First, it adds to the
concept of cultural artifact or stereotype the political imperative of
feminism which holds the image accountable for the reproduction
of norms. Secondly, to this feminist demand for scrutiny of the
image, it adds the idea of a sexuality which goes beyond the issue of

content to take in the parameters of visual form (not just what we see but how we see—visual space as more than the domain of simple recognition). The image therefore submits to the sexual reference, but only in so far as reference itself is questioned by the work of the image. And the aesthetics of pure form are implicated in the less pure pleasures of looking, but these in turn are part of an aesthetically extraneous political space. The arena is simultaneously that of aesthetics and sexuality, and art and sexual politics. The link between sexuality and the image produces a particular dialogue which cannot be covered adequately by the familiar opposition between the formal operations of the image and a politics exerted from outside.

—Jacqueline Rose
Sexuality in the Field of Vision

You are walking down the street but nothing is familiar. You are a child who swallowed her parents too soon: a brat, a blank subject. You are the violence of mourning objects which you no longer want. You are the end of desire. You would not be this nothing if it wasn't for courtliness. In other words, religion, morality and ideology are the purification and repression of your nothing. In other words, romance is a memory of nothing that won't take no for an answer and fills the hole with something called metaphor, which is used by writers so they won't be frightened to death: to nothing. You ransack authority by stealing the words of others, but you are a sloppy copyist because fidelity would make you less of a nothing. You say you are an unbeloved infidel. When you are the most nothing, you say "I want you inside of me." And when you are even more nothing, you say "Hit me harder so I won't feel it." As a kind of formal exercise you become a murderer without a corpse, a lover without an object, a corpse without a murderer. Your quick-change artistry is a crafty dance of guises: coverups for that which you know best: nothing. And all the books, sex, movies, charm bracelets and dope in the world can't cover up this nothing. And you know this very well since you are a librarian, a whore, a director, a jeweler and a dealer. Who's selling what to whom? Supply and demand mean nothing. People talk and you don't listen. Explicits are unimportant as they lessen the weight of meaninglessness to the lascivious reductions of gossip. You prefer to engage the in-between, the composite which skews the notion of a constituted majority, questioning it as a vehicle for even that most exalted of daddy voices, the theorist. He hesitantly places his hand on your belly as if he

were confronting the gelatinously unpleasant threat of a jelly-fish and decrees you a kind of molecular hodge-podge, a desire-breaching minority. You turn to him slowly and say "Goo-goo." He swoons at the absencelike presence of what he calls your naive practices: "the banality of the everyday, the apoliticalness of sexuality, your insignificantly petty wiles, your petty perversions." You are his "asocial universe which refuses to enter into the dialectic of representation" and contradicts utter nothingness and death with only the neutrality of a respirator or a rhythm machine. Goo-goo. But you are not really nothing: more like something not recognized as a thing, which, like the culture which produced it, is an accumulation of death in life. A veritable map and vessel of deterioration which fills your writing like a warm hand slipping into a mitten on a crisp autumn day. And like the exile who asks not "Who am I?" but "Where am I?" the motor of your continuance is exclusion: from desire, from the sound of your own voice and from the contractual agreements foisted upon you by the law. Order in the court, the monkey wants to speak. He talks so sweet and strong, I have to take a nap. Goo-goo.

Strategies of Public Address:
Which Media, Which Publics?

KRZYSZTOF WODICZKO

Before I attempt to characterize briefly the strategies of public art today in light of public practices of the avant-garde of the past, I must express my critical detachment from what is generally called "art in public places." This bureaucratic-aesthetic form of public legitimation may allude to the idea of public art as a social practice but in fact has very little to do with it. Such a "movement" wants first to protect the autonomy of art (bureaucratic aestheticism), isolating artistic practice from critical public issues, and then to impose this purified practice on the public domain (bureaucratic exhibitionism) as proof of its accountability. Such work functions at best as liberal urban decoration.

To believe that the city can be affected by open-air public art galleries or enriched by outdoor curatorial adventures (through state and corporate purchases, lendings and displays) is to commit an ultimate philosophical and political error. For, since the 18th century at least, the city has operated as a grand aesthetic curatorial project, a monstrous public art gallery for massive exhibitions, permanent and temporary, of environmental architectural "installations"; monumental "sculpture gardens"; official and unofficial murals and graffiti; gigantic "media shows"; street, underground and interior "performances"; spectacular social and political "happenings"; state and real-estate "land art projects"; economic events, actions and evictions (the newest form of exhibited art); etc., etc. To attempt to "enrich" this powerful, dynamic art gallery (the city public domain) with "artistic art" collections or commissions—all in the name of the public—is to decorate the city with a pseudocreativity irrelevant to urban space and experience alike; it is also to contaminate this space and experience with the most pretentious and patronizing bureaucratic-aesthetic environmental pollution. Such beautification is uglification; such humanization provokes alienation; and the noble idea of public access is likely be received as private excess.

The aim of critical public art is neither a happy self-exhibition nor a passive collaboration with the grand gallery of the city, its ideological theater and architectural-social system. Rather, it is an engagement in strategic challenges to the city structures and mediums that mediate our everyday perception of the world: an engagement through aesthetic-critical interruptions, infiltrations and appropriations that question the symbolic, psychopolitical and economic operations of the city.

To further clarify my position on public art, I must also express my critical detachment from the apocalyptic visions of urban design and environment suggested by Jean Baudrillard in terms of "cyberblitz" and "hyperreality": however brilliant his metaphorical-critical constructs may be, they cannot account for the complexity of symbolic, social and economic life in the contemporary public domain.

For Baudrillard the Bauhaus proposed "the dissociation of every complex subject-object relation into simple, analytic, rational elements that can be recombined in functional ensembles and which then take on status as the environment."[1] Today, however, we are beyond even this: "[W]hen the still almost artisanal functionalism of the Bauhaus is surpassed in the cybernetic and mathematical design of the environment . . . we are beyond the object and its function. . . . Nothing retains the place of the critical, regressive-transgressive discourse of Dada and of surrealism." And yet this total vision omits the powerful symbolic articulation of two economically related but distinct zones in the contemporary city: state architecture and real-estate architecture. The two work in tandem: state architecture appears solid, symbolically full, rooted in sacred historic ground, while real-estate architecture develops freely, appropriating, destroying, redeveloping, etc. A monstrous evicting agency, this architecture imposes the bodies of the homeless onto the "bodies"—the structures and sculptures—of state architecture, especially in those ideological graveyards of heroic "history" usually located in downtown areas.

Now in the current attempts to revitalize—to gentrify—the downtowns, cities legally protect these graveyards as meaningful ideological theater, not as places of "cyberblitz" where "the end of signification" has been reached. In this regard Marc Guillaume is only partially correct when he states that the contemporary downtown is just a "signal system" for touristic consumption:

> The obsession with patrimony, the conservation of a few scattered
> centers, some monuments and museographic remains, are just such

attempts [to compensate for the loss of social representation in urban architecture]. Nonetheless, they are all in vain. These efforts do not make a memory; in fact they have nothing to do with the subtle art of memory. What remains are merely the stereotypical signs of the city, a global signal system consumed by tourists.[2]

And yet it is still possible to establish a critical dialogue with state and real-estate architecture or even, as described by Guillaume, with monuments to pseudomemory. Not only is it still possible, it is urgently needed—that is, if we are to continue the unfinished business of the situationist urban project:

People will still be obliged for a long time to accept the era of reified cities. But the attitude with which they accept it can be changed immediately. We must spread skepticism toward those bleak, brightly colored kindergartens, the new dormitory cities of both East and West. Only a mass awakening will pose the question of a conscious construction of the urban milieu . . .

The basic practice of the theory of unitary urbanism will be the transcription of the whole theoretical lie of urbanism, detourned [diverted, appropriated] for the purpose of de-alienation: we constantly have to defend ourselves from the poetry of the bards of conditioning—to jam their messages, to turn their songs inside out.[3]

Of course, the situationist project of intervention now requires critical evaluation; some of its methods and aims seem too utopian, totalitarian, naive or full of avant-garde aestheticism to be accepted today. In this respect we can learn much from past and present avant-garde practices, which I will schematize below in terms of their relationships to: the cultural system of art and its institutions; the larger system of culture and its institutions; the system of "everyday life"; and mass or public spectacle and the city.

HISTORIC AVANT GARDE (1910–1940s): futurism, dada, suprematism, constructivism, surrealism. Artistic interventions against art and its institutions; critical and self-critical manifestations of the rejection of its cultural system. Discovery of direct public address: e.g., futurist synthetic theater, evenings, actions and manifestoes. Discovery of media art; discovery of critical public art as contestation. Roots of situationist aestheticism (rejected by new avant-garde as well as by engaged and neo avant-gardes).

SOCIALLY ENGAGED AVANT-GARDE (1920–1930s): Brecht, Grosz, Tatlin, Lissitzky, Vertov, Alexsandr Bogdanov, Varvara Stepanova, Lynbov Popova, Galina and Olga Chichagova, Heartfield, etc. Critical-affirmative action on culture and its institutions; critical transformation of the institutions of the cultural system of art. Engagement in mass publications, design, education systems, film (Kino-Pravda, Kino-Oko), opera, radio, theater ("epic" form, "estrangement" technique), agit-prop, proletcult, spectacles, Novy Lef (Sergei Tretiakov's affirmative intervention). Roots of present affirmative interest in media cultural programs and public domain; also roots of situationist interruption and *détournement*.

CRITICAL NEO-AVANT-GARDE (1960–1970s): Daniel Buren, support-surface artists, Hans Haacke, etc. (Missing reference: British pop art.) Critical-affirmative action on art and its institutions; critical and self-critical manipulation of its cultural system. Artistic attack on art as myth of bourgeois culture; critical exposure of structural ideological links between institutions of bourgeois art and culture—politics, ethics, philosophy, etc. Critical infiltration of museums as official public spectacle, but no significant attempts to enter mass spectacle, popular culture, public design.

SITUATIONIST CULTURAL AVANT-GARDE AS REVOLUTIONARY FORCE (1960-70s): Henri Lefebvre, Situationist International, Guy Debord, etc. (Missing references: Fluxus, punk rock). Cultural revolutionary intervention in everyday life and its institutions (environment, popular media, etc.); critical and self-critical abandonment of art as cultural system and of avant-garde art as specialized procedure. Public intervention against spectacle; tendency toward alternative spectacle. Creation of situations "concretely and deliberately constructed by the collective organization of a unitary ambience and game of events"; manipulation of popular culture against mass culture. Organization of *dérive* (drift), urban wanderings to contest modern structures, dominant architecture, city planning (surrealist tactics). Influence of postmarxist cultural studies and sociology; the city as "rediscovered and magnified" festival to overcome conflict between everyday life and festivity. Attack on passive reception of the city: "Our first task is to enable people to stop identifying with their surroundings and with model patterns of behavior."

PRESENT CRITICAL PUBLIC ART: NEW AVANT-GARDE AS "INTELLIGENCE": Barbara Kruger, Dara Birnbaum, Alfredo Jarr, Dennis

Adams, Dan Graham, etc; also Public Art Fund (New York), Public Access (Toronto), Art Angels Trust (London), etc. Critical-affirmative action on everyday life and its institutions (education, design, environment, spectacle and mass media, etc.); critical transformation of culture from within. Critical collaboration with institutions of mass and public media, design and education in order to raise consciousness (or critical unconscious) regarding urban experience: to win time and space in information, advertising, billboards, lightboards, subways, public monuments and buildings, television cable and public channels, etc. Address to passive viewer, alienated city-dweller. Continuous influence of cultural studies enhanced by feminist critique of representation.

References

1. Jean Baudrillard, "Design and Environment or How Political Economy Escalates into Cyberblitz," in *For a Critique of the Political Economy of the Sign* (St. Louis: Telos Press, 1981), pp. 185–203.
2. Marc Guillaume, in *Zone* 1/2 (1986), p. 439.
3. See *Situationist International Anthology*, ed. Ken Knabb (Berkeley: Bureau of Public Secrets, 1981).

Strategies of Public Address:
Which Media, Which Publics?

DISCUSSION

DOUGLAS CRIMP: To begin with, since the name Jean Baudrillard has entered the discussion, I have a comment, one that might be relevant to some of the things we have said.

During the student demonstrations in Paris last November, a rightwing editorial writer for *Le Figaro* named Louis Pauwels characterized the students as suffering from *SIDA mental* (mental AIDS). It was duly noted that this was a vicious remark by, among many others, Baudrillard in an article titled "Glorious Aphasia" in *Libération*'s special wrap-up issue on the demonstrations. But after ritualistically condemning the remark as a moral insult, Baudrillard went on to ask, essentially, why not take the characterization seriously? Were the student demonstrations not after all manifestations of a society that had no real defenses left? For even though these students had organized collectively to effect political change, and even though they had at least stopped Chirac's government from its insidious reform of the universities, Baudrillard wanted to dismiss the events as weak, soft, flaccid, the mere simulacrum of the events of May '68. For from Baudrillard's current perspective, collective political action is theoretically impossible.

Such a perspective gives us nothing but an excuse for quietism, and it is therefore a perspective that I think we should leave to the neo-geo boys and other cynical theorists of the latest art-world gadgets. I think we should look to the gains made by collective political events rather than cynically dismissing those events (for this, the recent television documentary on the civil rights movement, "Eyes on the Prize," is a welcome antidote). So, rejecting fashionable art-world cynicism, the questions I want to pose are: What are the specific issues we want to address? What are the audiences we want to address? And how do we do it?

Maybe, since Bill Olander and Brian Wallis are here, they could tell us

what kind of exchanges—or lack of exchanges—occurred in relation to the two shows they curated at the New Museum ["Homo Video" and "Hans Haacke: Unfinished Business," respectively, December 12, 1986–February 15, 1987].

AUDIENCE (BILL OLANDER): I knew my reference to the "Difference" show as a "stunning failure" would come back to haunt me; nevertheless, it did figure in my desire to program "Homo Video." Somewhat naively I believed the audience of the Haacke exhibition would be interested in issues related to gay men and lesbians, and I think the portion of people that crossed over was greater than you imagine, Douglas. But the museum itself did not set up any interaction between the two shows. It was discussed but not really acted upon.

D. C.: In the late '60s, given the art practices of the time, museums were forced to think about the use of spaces other than their own. Museums today might again consider programming outside their spaces or forming direct relationships to actual communities.

BARBARA KRUGER: There are some institutions that attempt this. The Institute of Contemporary Art in London is developing a program to engage other spaces, to network outside its institutional site. Krzysztof listed many places where all one would need is a video monitor or a billboard. Any number of forms could work.

AUDIENCE (HAL FOSTER): It seems to me it's a question not so much of sites as of common ground. Take the example of gay cultural practice and feminist cultural practice: where is the ground on which they might be mediated today? In his statement Douglas provided two examples of nonmediation at the New Museum: Krzysztof's projection and the "Difference" show, the Haacke exhibition and the gay video program. What forms of mediation might there be between such events?

B. K.: If you couple work then you have to think about mediation. If you put out work individually in different sites, or in a thematic group of images or tapes, that's not the same kind of mediation.

AUDIENCE: Why make these distinctions? The point is that artists have the ability to transcend cultural norms.

B. K.: That's an open question, not a definite point: Can artists engage in a social relation and do cultural work and not be defined in some way by cultural norms?

AUDIENCE: Sure.

B. K.: Oh sure. The surety with which you say "Sure" is the very surety with which most people don't include others in their sureties.

D. C.: I'd like to ask Krzysztof a question. On the one hand, you talk about interventions that are almost guerrilla acts—interventions that respond to particular situations and particular audiences. On the other hand, you talk about the necessity of working with bureaucracies, which of course operate very slowly. How do you reconcile these two situations? How can you work with institutional support and use a fast tactic?

KRZYSZTOF WODICZKO: A very good question. But there are strategies that engage bureaucracy and still retain flexibility. One such maneuver is called, in military terminology, a "wing attack": you engage your enemy in a frontal exchange of fire while part of your force penetrates a different section of the battleline. Then, too, you don't always need bureaucratic permission or support. There are, for example, acts which won't even be noticed; after all, bureaucracy doesn't work at night. The question is: How long can you play this game? And one answer may be: Well, you must travel, change places. But there is another possibility: You could work with people who also want to act in the public domain; you could coordinate different negotiations with institutions and agencies.

B. K.: Krzysztof, my sense is that in Poland you have to negotiate different bureaucratic channels—to become savvy in certain seductions and retrievals. Yet this also comes in handy here. Obviously the constructs of control and repression are very different, yet one still has to negotiate the loopholes in order to make anything present.

K. W.: But there are also good bureaucrats, and some people are genuinely interested in public art—at least on occasion. One must understand that part of the legitimation of the entire bureaucratic system is "service," readiness to respond to public demand. It's just somewhere beyond the romantic clouds.

B. K.: Right. That suggests working with cultural norms—as opposed to the practice of the great avant-garde artist, mediator between God and public, who scoffs at cultural norms and only responds to hurricanes of inspirational zeal.

HAL FOSTER: You seem to agree, but in fact your positions are very dif-

ferent. In his statement Krzysztof alluded to the idea of the social as a place of cyberblitz where everything is mediated whether it wants to be or not, whereas in their statements Douglas and Barbara considered the social in terms of very specific groups that are not mediated at all.

B. K.: I don't think I did that, Hal.

HAL FOSTER: It seemed to me that the thrust—

B. K.: "Thrust"?!

HAL FOSTER: OK, the gist—the gist of your statement was that there was no feminine spectator as yet, that this culture did not allow for one. This was an important theoretical position of many feminists in the '70s; but is it still strictly the case? Can you historicize the absence—or the appearance—of a feminine subject in patriarchy?

B. K.: I'm not starting from the originary zero. The idea of the female is a process of becoming: it is more a verb or in the verbal than it is a noun or in a fixed state. There's this mania for categorization—to categorize a singular thing that is feminism. But there is a multiplicity of feminisms, and a multiplicity of ways to embody the multiplicity. I see feminism as a horizontal site of many positions—which is *not* to say we are in a "postfeminist" period.

AUDIENCE: That multiplicity is the very reason for alternative spaces.

AUDIENCE: I'm sorry: Whenever I hear the term "alternative spaces" I think of safety valves for the dissatisfactions of people within our culture. I'd rather see those spaces as revolutionary planning committees. For example, Krzysztof seems to know his way around bureaucracy. I think there's a need for a school to teach that to people here.

K. W.: I would like to be taken for who I am, not necessarily from where I am. Not everything about me is Polish or Solidarite. There are certain myths—North American middle-class myths—about Eastern European intellectuals, and I wouldn't like to serve as an example in such a myth. The problems of public space, of bureaucracy, of effective work on issues of social importance—these are as difficult here as anywhere, and Europe is not necessarily a more enlightened place for this kind of activity.

As for alternative spaces, initiate such activity! But do not necessarily marginalize them as alternative to the market, to that which is incorpo-

rated. In some cases that might be more reactionary than progressive.

AUDIENCE: You talked about what we might do as artists, but I want to know whom do we do it for?

AUDIENCE: You mean, whom do we do it *to*!

AUDIENCE: How do we address the audience that we intend? How do we not end up with the same old audience that art's usually made for? How do we shift the audience?

AUDIENCE: And where do we do this?

AUDIENCE (SILVIA KOLBOWSKI): Wait a moment. Who are *we*? I don't think we can presume that all of us here have the same stakes.

About a year ago on the steps of the Met I saw a mime perform. Within ten minutes he had gathered about 200 people; that's actually very common—the ability to galvanize an audience when what is presented is not politically threatening. We talk about work for a specific audience that is already receptive, but we need to think about galvanizing audiences that are not receptive.

D. C.: But why not consider work in relation to the concerns of specific audiences? If you make a political statement about gay issues, it could threaten nongay people, but it could also galvanize the gay community, or at least promote a solidification of concerns. Obviously the gay community is ridden with problems—problems between gay men and women, of racism, of the same class divisions as elsewhere; even more particular problems like the greater percentage of black and Hispanic men who have AIDS and the lesser support systems that most of them have. But those are things that certain sectors of the gay community need and want to address. So it seems to me that there are all kinds of work to be done within certain communities, and it is simply irrelevant how it might be received in other communities.

SILVIA KOLBOWSKI: I understand; my point had more to do with oppositional practices. When we talk about oppositional practices we mostly talk about logistical strategies—how to find the right space, how to gain access, etc. My point is that we must also examine the position from which we do these things.

AUDIENCE (DONNA DE SALVO): I'd like to follow up on this issue of the public sphere. How can museums today engage an audience which is not

just the traditional art audience but also the person who works in a factory, the person who's a secretary—all the tremendously different types that make up society? How can museums engage these audiences without presenting watered-down culture?

D. C.: I would say, first, that in most cases museums have no interest in those other audiences; and second, that when they do it can be very productive, as the example of "Homo Video" suggests. Suddenly the New Museum had a whole gay audience, most of whom, I would venture to say, had never been to the New Museum before. So if you target particular communities, you can engage them—it can happen.

B. K.: We should think about this notion of watered-down culture—this idea that as soon as production gets pulled away from the institution, its power and money, it becomes watered-down. It's a literal description: As the opposite of "rich," "watered-down" suggests a loss of wealth, of value. But it's not necessarily the case...

D. C.: In fact, it can be proven not to be the case by Krzysztof's work, which is the opposite of watered-down. For example, his projection of missile and chain images during the 1985 New Year's Eve celebration in the Grand Army Plaza in Brooklyn—this had a large working-class black and Hispanic audience, and it generated a great deal of interesting exchange. So here's a cultural practice, far more provocative than usual museum work, in a public space that galvanizes an audience.

B. K.: Right. Making images that are effective in promoting displacement and change—that's a fluid operation which can happen in any number of different locations. Museums are just one kind of space.

AUDIENCE (JAMES WELSH): But it's not difficult to imagine a company like Philip Morris promoting such public locations in order to diversify its own sites.

AUDIENCE (ABIGAIL SOLOMON-GODEAU): I want to address Barbara with a comment she recently made in an *ArtNews* interview [February 1987]. You were quoted to the effect that there's nothing outside the market—not a piece of lint, not a cardigan, not a coffee table. In view of our rather amorphous discussion of oppositional practices and alternative audiences and different forms of address I think it's important to address this notion that "there's nothing outside the market." I want to lay this on the table.

B. K.: Basically what I meant is this: The fact that we survive by exchange means that our lives are encompassed by a market that is erratic, virulent, horrendously pervasive. To ignore this, to argue that there's a way around it, is the privilege of a person with an inheritance or a tenured job. I'm not being facetious, Abigail; I'm just trying to be in the world. Because if my work is not tested by this reality—by the labor and exchange conditions of the market—then it might be politically correct, but I'd be deluded. My parents traded their labor for money; they spent their lives as commodities within a workplace. I, too, see my work in a construct supported by market machinations. Now this is a site-specific discourse, but nothing I know in New York is outside the market, not even, not especially, people who can't get jobs. After all, just because something—some person, some art—doesn't sell, doesn't mean it's not a commodity. Unfortunately, all these issues—of the market, of feminism—are still defined in vertical, hierarchical terms of class and color.

D. C.: Barbara, let me cut in here with an example. The "Homo Video" program included some television spots made by the Gay Men's Health Crisis for the purpose of educating people about AIDS. They worked totally in relation to the market: They were made slickly, it cost a lot to put them on TV—and they said precisely nothing. They said "Get the facts." OK, obviously, but what are the facts? As with everything else under Reagan, AIDS education is to be left to the market, and it's going to come in the form of condom commercials. And you know what they'll say: "You don't have to be gay to get AIDS."... It may be true that the market pervades every aspect of life in late capitalism—I think it is true—but one has to consider ways in which to deal with this situation. One can't simply use it as an alibi; one has to go on to the next step.

B. K.: Absolutely. One should become aware of all the machinations of the market. And they are everywhere—in every exchange, every conversation. Every deal we make, every face we kiss, involves a politic—a politic which is constituted within the strictures of the marketplace. To say that one is located outside it—I simply don't live that life.

ABIGAIL SOLOMON-GODEAU: The terms of your response made my question sound like an accusation: "How dare you sell your work?" That's not the issue. Nor was I implying that there are practices totally outside the system of commodification. Rather, I wanted to suggest that there's a whole range of possible responses to this condition. Insofar as

these discussions are to do with the notion of oppositional practice and the question of audience and public sphere, I don't think that's a point that can be easily dismissed as naive.

D. C.: Can I lay another one on you?

B. K.: Yeah, sure, I'm getting paid for it.

D. C.: It's a question about specificity. It's clear you're not interested in specifying meanings—but how far does one want to let the meaning of a work slip? I have in mind a specific piece of yours and a specific response to it; it's the one which reads "You construct intricate rituals which allow you to touch the skin of other men." The critic who wrote about this work said that it alluded to the idea that physical contact has become a social ceremony. Now I see this work instead as a complication of the cliché about latent homosexuality as producing authoritarianism. Now even though this writer and I come from essentially the same class and social world, we have opposite responses to the work. This suggests to me that there's a problem of specificity about what you really want to elicit from a spectator.

B. K.: I don't like to fix the meanings of my work, which in any case can't be the image of every spectator's perfection. I do believe, when I watch the conglomeration of theatrics played out by men in spheres of diplomacy and warfare, that the world is run by the intricate rituals of such brotherhoods. But I also believe that, as many people have said, gender is biologically defined and sexuality is socially constructed. It's one thing that makes me an optimist, because the way we are in the world as sexual beings can be altered—malevolences can be changed slowly, incrementally. In any case, we all speak through some kind of libidinal space, and for all I know your reading of this work might have to do with your relationship to this other writer. After all, very often artists are conduits between different textual producers.

D. C.: But as a textual producer yourself, Barbara . . .

B. K.: Yes, I know, and I try to avoid it. My textual work is also very informed by my work as an artist, so it's give and take. But I do try to be responsible for as many slippages as possible within readings of my work—even as I also try not to destroy difference.

1967/1987:
GENEALOGIES OF ART AND THEORY

Theories of Art after Minimalism and Pop

MICHAEL FRIED

When I was asked to participate in this discussion, it was suggested that I begin with a few words about my essay "Art and Objecthood," which I wrote almost exactly twenty years ago. Since that time "Art and Objecthood" has been the focus of a great deal of discussion, most of it hostile, which in view of the dominant trends of the art world during the past two decades makes perfect sense, but more than a little of it uncomprehending, which I regret. So I want to make just a few remarks about the original motivation of "Art and Objecthood."

When I wrote it in early 1967 it was the culmination of a series of essays on recent developments in what has come to be called color-field painting, plus the sculpture of Anthony Caro—a body of work that seemed to me then, and continues to do so today, the most important and distinguished painting and sculpture of our time. "Art and Objecthood" also originated in (and expressed) my strong negative response to minimalism, that is, to the work of Donald Judd, Robert Morris, Carl Andre, Tony Smith, et al., a point that no doubt seems obvious to anyone who has even glanced at the essay, but which I make explicit in order to emphasize the fact that the response came first and that certain arguments that I marshaled against the work—specifically, the charge that literalist art was and is essentially theatrical—were developed only as I tried to find adequate terms for what I saw and felt. More precisely, they were developed to try to account for two related observations: first, that there really was a significant, a fundamental, difference between minimalist pieces on the one hand and the art of the painters and sculptors I most admired on the other; and second, that when you encountered minimalist work you characteristically entered an extraordinarily

charged mise-en-scène (Morris and Andre were real masters of this). It was as though their work, their *installations*, infallibly offered one a kind of "heightened" experience, and I wanted to understand the nature of this surefire, and therefore to my mind essentially *in*artistic, effect. So I found myself developing a contrast between the radically abstract and antitheatrical art of the figures I admired and what I came to describe as the nominally abstract but in fact literalist and theatrical art of the minimalists—distinctions that, plainly hierarchized as they are, nevertheless were meant to acknowledge that the latter exerted a powerful, if in the end disputable, claim on our attention.

These were part of a series of oppositions that the essay attempts to set in place—between "presentness" and "presence," instantaneousness and duration, abstraction and objecthood, and so on. Of course we have today, thanks in part to deconstruction, a healthy suspicion of oppositional thinking in its various forms. But we need to remember that the minimalists themselves saw their work as directly opposed to the abstract painting and sculpture that preceded them, or at least as going beyond that painting and sculpture in decisive respects; which is to say that one aspect of the strategy of "Art and Objecthood" was to offer a redescription of their work and indeed of their theoretical statements that would undercut the specific claims they had been making on their own behalf. In any case, I continue to be struck by the extent to which hostile responses to "Art and Objecthood" tend not to be deconstructive in approach but rather to attack my "positive" terms in the interests of my "negative" ones, so that on the whole the disputes have continued to take place within the conceptual space the essay established twenty years ago.[1]

Another motivation for writing "Art and Objecthood" as well as "Shape as Form," the essay on Frank Stella that preceded it, might be characterized as at once historical and theoretical. As anyone familiar with my essays on abstract painting and sculpture is aware, I was deeply influenced throughout the 1960s by the art criticism of Clement Greenberg, who by now is universally recognized as the foremost writer on contemporary art of the post-1940 period. But by 1966 I had become unpersuaded by his theorization of the way modernism works (as put forward, for example, in essays like "Modernist Painting" and "After Abstract Expressionism"), in particular by his notion that modernism in the arts involved a process of *reduction* according to which dispensable conventions were progressively discarded until in the end one arrived at

a kind of timeless, irreducible core (in painting, flatness and the delim-
itation of flatness). The implication of this account was that such a core
had been the essence of painting all along, a view that seemed to me
ahistorical, and I wanted to find an alternative theoretical model that on
the one hand would not dissolve into mere relativism and on the other
would not lead to what I will call the wrong sort of essentialism. The
conceptual matrix on the basis of which I tried to do this was the philos-
ophy of the later Wittgenstein, and my thinking about these issues was
mediated for me by my friendship with the philosopher Stanley Cavell.
I've rehearsed some of these arguments fairly recently (in a special issue
of *Critical Inquiry* [September 1982] on "The Politics of Interpreta-
tion"), so I won't repeat them here. My point is simply that all this was
also part of what I was trying to do in "Shape as Form" and "Art and
Objecthood," and that the relation of both essays to Greenberg's ideas is
therefore a little more complex than is usually recognized by commen-
tators who are content to label us both unregenerate formalists.

Another point worth stressing is that "Art and Objecthood"'s case
against theatricality is limited to the contemporary situation. The essay's
claim is that what it calls theater is *now* the enemy of art; and what I
want to insist on here is that while that may be wrong, the word "now"
can't be overlooked. I was precisely not attacking earlier art that might
be considered overtly theatrical but rather was proposing that contem-
porary work that didn't understand itself to be theatrical was in effect
merely that.

The whole question is further complicated by the fact that the issue of
theatricality defined as a pejorative term implying the wrong sort of con-
sciousness of an audience originally arose around the middle of the 18th
century in France (a point I had been made aware of since teaching
Diderot's theory and criticism for the first time in 1966). I have subse-
quently done a lot of historical work aimed at establishing that the
attempt to defeat the theatrical was a central impulse of a major tradition
within French painting between, say, Greuze and Manet. (I'm currently
completing a book on Courbet that shows how that issue is at the heart
of his realism, which I hope seems a surprising assertion.) All this leads
to greater complexities than I can begin to deal with here. But at the very
least it means that the antitheatrical arguments of "Art and Objecthood"
belong to a larger historical field than that of abstraction versus mini-
malist art in 1967, a field I am still exploring with a sense of discovery.
Indeed, part of the interest "Art and Objecthood" still has for me is that

more than any other of my early essays it represents a link between the
art criticism I had been writing since the early 1960s and the art history I
would soon go on to write.

Reference

1. An impressive example of a recent essay that *is* deconstructive in its treat-
 ment of these issues is Stephen Melville's "Notes on the Reemergence of
 Allegory, the Forgetting of Modernism, the Necessity of Rhetoric, and the
 Conditions of Publicity in Art and Criticism" in *October* 19; see also the
 first chapter of his *Philosophy Beside Itself: On Deconstruction and Mod-
 ernism* (Minneapolis: University of Minnesota Press, 1986).

Theories of Art after Minimalism and Pop

ROSALIND KRAUSS

The letter I received late last fall gave as the title of our discussion "1967/1987: Theories of Art after Minimalism and Pop," before it went on to sketch what Hal projected as the conversational and constructive nature of the evening's exchange.

"1967/1987," I must admit, continued to have a particular resonance for me, long after it had vanished from the official title of our proceedings. For while '67/'87 brackets, with a certain directness and innocence, the simple chronological span of the past twenty years, it seems to propose as well a relation between its two terms, a kind of logic of onset and culmination or of threshold and arrival. Something, it seemed, had happened in 1967 that had ushered in this era of afterness to which we were to address ourselves, this world that had opened up "after minimalism and pop." "1967," I wondered ... but not for very long; for 1967 was the date of Michael Fried's "Art and Objecthood," an essay which I supposed was intended to function as a kind of subtext for our discussion insofar as its arguments have often been seen as having driven a theoretical wedge into '60s discourse on art, somehow dividing that period into a *before* and an *after*.

That we might have been convened to talk—with no matter how wide a range—about a single text struck me as an extremely useful idea, a tactic that might indeed transform what we have all come to regard as the alienating medium of the symposium-as-spectacle into a genuine discussion during which some real work might be done. That the text to inaugurate this discussion about afterness—after minimalism and pop— might be "Art and Objecthood" was also welcome since I realized that the terms of this text provide the most complete object-lesson of what it

is that I want to say tonight: namely, that we are deluding ourselves if we think that we are dealing with a period of art that succeeds or comes after pop. For as far as we are concerned there has been no "after pop"; its terms, no matter how third-hand, no matter how degraded and sad, have been rehearsed and re-rehearsed throughout almost everything that has happened within dominant aesthetic practice in the past two decades.

With its warnings about the consequences of theatricality, "Art and Objecthood" might be seen as having predicted all this; but that is not the object-lesson I have in mind. What I want to focus on is the curious way it has become clear, from the vantage of 1987, that the very art that "Art and Objecthood" was concerted to defend was strangely complicit with the very terms of its supposed antithesis, which is to say, everything that was theatrical in the art of the '60s, by which its author meant not only minimalism but also pop.

This linking of postpainterly abstraction—specifically painting such as Kenneth Noland's or Frank Stella's or Larry Poons's—to aspects of pop art already operates as the hinge of Leo Steinberg's argument in his 1972 essay "Other Criteria." *Design technology* is Steinberg's term for the rules behind the production of Noland's targets and chevrons and stripes. It is the world of commercial emblems and corporate logos generated from within a serial expansion, which speaks mainly about repetition and mass production, that identified these works in Steinberg's eyes as more than just the distant relatives of Andy Warhol, Roy Lichtenstein and Jasper Johns. Across the discursive barrier we might regard "Art and Objecthood" as having erected, Steinberg saw the joining of hands of aesthetic siblings.

Steinberg's analysis was very brief—like a stinkbomb thrown in passing into the world of "Art and Objecthood." It can be deepened, however, in the following ways. "Art and Objecthood" sees its favored artists—Noland/Stella/Anthony Caro/Jules Olitski—as securing their work's relation to Art (capital A) by locating it within the domain of the virtual. In describing this domain, this virtuality, "Art and Objecthood" is content to quote the Greenbergian dictum about the aesthetic value of "rendering substance entirely optical" and to agree with the goal of this newly abstracted form of illusionism, namely "that matter is incorporeal, weightless, and exists only optically like a mirage." To this notion of mirage, achieved by the pulverization or extreme attenuation of matter, "Art and Objecthood" added its own concept of the medium of

shape, which argued for the special importance of the pulverization of edge, the setting up of the illusion that one cannot secure the experience of distinct objects because one cannot locate their contours.

The last place that "Art and Objecthood" would look for these effects is in the world of pop art, and yet in Warhol's screen paintings (just to take one example), with their grainy overlays of Day-Glo color separations carefully slid off-register, we encounter a treatment of pictorial surface that constantly ingests or eradicates the objects it supposedly proffers, forcing them to hover in an unlocatable nonspace. And we realize that here indeed is just that production of virtuality—of the field rendered optical "like a mirage"—facilitated by the mediumization of shape. The effulgence of Warhol's surfaces, their floating fields of acrid, smarting color, or the glassy passages of matter stretched beyond comprehensible shape in James Rosenquist's pictorial compartments, or the open, weightless suspensions of Lichtenstein's Ben-Day dots—these constitute in their own way a parallel opticality.

But the issue is not just the morphological similarities that exist between pop and postpainterly abstraction, once we remove the superficial distinction that one practice is figurative while the other is not; rather, it is the way the phenomenological goals of the two map onto one another that is significant. And it is this question of the goal of the experience that "Art and Objecthood" addresses most fully. That goal is to produce the illusion in the viewer that he is not there—an illusion that is set up in reciprocity with the status of the work as mirage: It is not there and so consequently he is not there—a reciprocity of absence that the author of "Art and Objecthood" would go on to call in other contexts a "supreme fiction."

But clearly this not-being-there must be qualified, for we are not talking about total absence: no painting in an empty room. The mirage is there in its insistent condition as anti-matter, as nonphysicality, as the fiction of nonpresence. So the viewer is there in a mirror condition, abstracted from his bodily presence and reorganized as the noncorporeal vehicle of a single stratum of sensory experience—a visual track that is magically, illusionistically unsupported by a body, a track that is allegorized, moreover, as pure cognition. What we have here, then, is not exactly a situation of nonpresence but one of abstract presence, the viewer floating in front of the work as pure optical ray.

Now it can be argued that this very abstract presence, this disembodied viewer as pure desiring subject, as subject whose disembodiment

is, moreover, guaranteed by its sense of total mirroring dependency on what is not itself—that this is precisely the subject constructed by the field of pop and the world into which it wants to engage, the world of media and the solicitation of advertising. And this indeed is what I will want to maintain. But it will also be sensed that this very situation, with its disembodiment, its constitution of the subject as a function of the image, its setting the stage for the occlusion of the subject through the mechanism of identification with the object—that this repeats as well the terms of the Lacanian Imaginary, particularly from the early period of his working out the concept of the mirror stage. And this reading is also important if we are to explore the deeply dependent and alienated condition of the viewing subject as that is constituted by pop and all its avatars.

The Lacanian Imaginary has another function within what I am suggesting about "Art and Objecthood," a function we could think of as strategic. For it helps us to get some kind of leverage on that internal rift, that deep condition of contradiction, that works way under the surface of the argument. For "Art and Objecthood" simultaneously sets up two subjects, two beholders for the work of art, which, since they seem to occur within the same moment of thought, are presented as being synonymous, as two representatives of the same beholder. Now the theorization of the Imaginary can show us that these are not the same beholder, not two forms of the same subject, but two different subjects pointing in two different directions and doing two different kinds of work.

I have already spoken about the optical subject, the one called the beholder, who is given as reified vision and whom I have associated with the Imaginary. But the other subject of "Art and Objecthood" is constituted along a different axis, before being slid over the first one to try to create a seeming consonance. This latter is a subject that is developed in relation to the term *theater* and is defined merely as the function of a binary set of terms: the theatrical as opposed to the nontheatrical. It is the subject about whom the most it could be said is that, in his condition within the nontheatrical, he is not part of the audience.

Now theater and theatricality are precisely what is never defined in the pages of "Art and Objecthood," or in the one definition that *is* ventured we are told that theater is what lies *between* the arts, a definition that specifies theater as a nothing, an emptiness, a void. Theater is thus an empty term whose role it is to set up a system founded upon the opposi-

tion between itself and another term. This is not of course a neutral, unloaded opposition, a simple *a* versus *b*; rather it is one that is vectored along an axis of good and bad: Theater as the empty, unlocatable, amorphous member of the pair is bad, while the nontheatrical rises within the pair to be coded as good.

This polarization of terms, one of which (the one that describes one's own position) is good, while the other (the one used for someone else's) is bad, and the role that this polarization into a system of binaries plays in the very constitution of a self—this ethical scheme is what Nietzsche's genealogies alerted us to. "Slave ethics," he said, "begins by saying *no* to an 'outside,' an 'other,' a nonself, and that *no* is its creative act." It is this strategy of controlling the hierarchy or ethical vector of terms that Derrida came to call logocentrism, a notion that was very quickly expanded to phallogocentrism. And by now the analysis of the way this strategy operates to produce the fiction of the centered subject has become familiar.

The two subjects that occupy the theoretical space of "Art and Objecthood" can thus be analyzed into (1) a subject alienated in vision, which I have described as the fundamentally pop and Imaginary subject shared by the conditions of virtuality of postpainterly abstraction, and (2) a nontheatrical subject that is laboring to recenter itself through the operations of a symbolic, moralized order of language. It is this act of recentering, moreover, that creates within the author of "Art and Objecthood" the experience of the liberating, self-realizing capacities of the condition of abstract- or non-presence, creating this at the same time as it operates as a blind spot about what nonpresence actually describes. It is the second subject that works both to retotalize the divided logic of "Art and Objecthood" and to recuperate or rewrite the other, Imaginary, decentered subject in the register of self-presence.

And what of minimalism in all of this? For minimalism was, after all, the major target of "Art and Objecthood."

Well, minimalism certainly was, as "Art and Objecthood" objected, the '60s art of the bodied, the corporeal, subject. The bodily specificity of that subject, the fact that it had a front and a back, that its experience was affected by the vagaries of ambient light, that its very corporeal density both guaranteed and was made possible by the interconnectedness of all its sensory fields so that an abstracted visuality could make no more sense than an abstracted tactility—all of this was choreographed and mobilized by minimalist art. That corporeal condition, which within '60s minimalism was still directed at a body-in-general within a

rather generalized sense of space-at-large—that condition became ever more particularized in work that has followed in the '70s and '80s. The gendered body, the specificity of site in relation to its political and institutional dimensions—these forms of resistance to abstract spectatordom have been, and are now, where one looks for whatever is critical, which is to say non-Imaginary, nonspecular, in contemporary production. All the rest, we would have to say, is pure pop.

Theories of Art after Minimalism and Pop

BENJAMIN H.D. BUCHLOH

Periodizing Critics

There is a certain ironic opportunity in this lineup of three critics of the same generation who are on the one hand so different in their historical orientations and affiliations and on the other hand clearly united by their indifference toward most of the work currently celebrated by the art market and the mainstream art institutions. When I say "opportunity" I do not mean that of a showdown or spectacle; rather I mean an opportunity to reflect on the current role and function of the critic in aesthetic practice.

From the vantage of a younger artist, the interests represented by the three of us are probably equally remote and unattractive. For example, the historical range of Michael Fried's work as a critic—inasmuch as it is relevant or tangential to recent and contemporary art—originates in discussions about Jackson Pollock, Morris Louis and David Smith, and leads via Jules Olitski, Anthony Caro and Kenneth Noland only as close to the present as Frank Stella's work allows. In 1965 Fried attempted in "Three American Painters" to deploy Stella as a last bastion against the onslaught of minimalist aesthetics, but—alas—he did so in vain. By 1967, the time of "Art and Objecthood," Stella was already one of the key figures of the minimalist generation, actively pursuing the project of completing and transcending the formalism of New York School art. Ironically, it was Stella, Fried's last ally, who had actually initiated the emerging aesthetics of minimalism.

If Stella was the historical figure with whom Fried's critical interests in contemporary art came to a halt—apparently since he could not redeem the Greenbergian legacy through his work—Stella was also the figure who, along with Robert Rauschenberg and Jasper Johns, provided

the point from which Rosalind Krauss would embark on her critique of
the Greenbergian and Friedian legacy. This would make her the central
critic of the generation of minimalist and postminimalist artists (her
work on Sol LeWitt, Robert Morris and Richard Serra attests to this);
and in the course of this development she would reintroduce the
unnameable "other" tradition descending from Marcel Duchamp that
had been banished from history by Greenberg and Fried.

I assume that the decision to invite me to participate in this discussion
was at least partially motivated by the fact that the artists with whose
work I have been actively involved as a critic and editor were precisely
those postminimalist and conceptual artists, emerging around 1968,
whom Krauss in turn overlooked in her *Passages in Modern Sculpture*
(1977). In most cases these artists—Michael Asher, Marcel Brood-
thaers, Daniel Buren, Dan Graham, Hans Haacke, Lawrence Weiner,
etc.—actually abandoned the traditional categories, materials and pro-
cedures of artistic production.

It is commonplace by now that, as much as we might learn from the
actual construction of a historical text, we might learn more from the
omissions and repressions of those elements of history which would oth-
erwise perturb this construction—its positing of a linear system, a dis-
cursive critical apparatus, a complete historical canon. What unites the
three critics before you is precisely our continual devotion to such an
order and canon, even though it is obviously a rather different one in
each instance. Inasmuch as it reaffirms—with only occasional excep-
tions—male white supremacy in visual high culture, the critical canon to
which we all adhere is hegemonic and monocentric. Furthermore, this
canon inadvertently confirms—despite all claims to the contrary—the
construction of individual oeuvres and authors, and it continues to posit
and celebrate individual achievement over collaborative endeavor. We
are also united as critics in our almost complete devotion to high culture
and our refusal to understand art production, the exclusive object of our
studies, as the dialectical counterpart of mass-cultural and ideological
formations—formations from which the work of high art continues to
promise if not redemption then at least escape.

This limitation might result from professional specialization and the
general compartmentalization of intellectual labor, or it might result
from the historian's role-casting. In any case, we have consistently and
almost completely avoided any critical involvement with the dark

underside of modernism, the mass-cultural and ideological apparatus. Indeed, for the most part, we three critics have avoided mass-cultural and ideological phenomena, and their determining impact on high-cultural production, with the same compulsive fear with which mass-cultural historians have avoided the structures and complexities of contemporary high-cultural objects. This is all the more astonishing since many of the objects of our study—especially pop and minimalism, their predecessors in dadaism and constructivism and their followers in the art of the mid-to-late '70s (which makes up one segment of the conflictual postmodern contingent)—programmatically foreground the conflict between high and mass culture and insist on the transformation of its historical dialectic.

Furthermore, the practices of these three critics are and remain—despite occasional slander by paranoid conservative critics—relatively depoliticized and apolitical. The depoliticization is due to an imposed condition which defines our practice as one which transcends concrete political issues; the apoliticalness is due to a self-imposed condition of passivity and complacency within academic specializations where devotion to discursive detail and scholarly exactitude has displaced the urgency of an activist and interventionist conception of critical practice.

This attitude stands once again in manifest opposition to the actual and implicit claims made by radical art practice after pop and minimalism. In this practice the specificity of site and audience relations supplanted the minimalist stress on the specificity of materials, and the essentially collaborative nature of aesthetic experience was emphasized and expanded—this in a belated recognition of Duchamp's theory of the "creative act" and of Walter Benjamin's theory of the transformation of the passive contemplative spectator into an active collaborator. Finally, art after minimalism and pop also provided visual high culture with models of a rigorous and systematic institutional and discursive critique—a critique which had emerged previously in critical theory and structuralist and poststructuralist discourse but which is still relatively undeveloped in art criticism.

Yet there is a paradox in this description of the conditions of criticism, for the actual situation of the critic in the '80s is dramatically different from that of the critic in the '60s and '70s. At the same time that affiliation with institutional (academic) power has distanced critical practice from the concrete projects of the aesthetic practices with which it was once engaged, mainstream art in the '80s has become oriented to com-

pletely other value systems which exclude the world of the scholarly or
political intellectual of the '60s. In the '60s it was still one of the func-
tions of serious academic criticism to form the artistic canons and crite-
ria with which the mediation between artistic practices and cultural
institutions—and thereby the cultural legitimation of the ideological
state apparatus—could be accomplished. Since then criticism has lost
even this function: it has been disenfranchised, especially in regard to its
capacity to legitimate.

For the most part artists themselves have assumed the role of legit-
imist; and this with the near-unanimous enthusiasm of all concerned,
for instead of contestation of the dominant cultural and ideological
apparatus they deliver valorization and institutional affirmation. It is
therefore no longer required of the critic to provide reasonable dis-
course, empirical proof of artistic competence or historical parameters
of evaluation and criteria of quality by which legitimation might be
gained. With the collapse of high art production into the culture indus-
try, the traditional functions of the critic to identify and control, to
measure and validate transgression and deviance, to contain rupture and
contestation have become obsolete. This fact alone, beyond the control
of criticism, has further separated it from all other practices of academic
and intellectual production.

In short, the merger between avant-garde culture and culture industry
has initiated among curators and collectors, dealers and artists a new
awareness: namely, that management and control, validation and affir-
mation can just as well be performed from within the ranks of the given
institutions and their networks of support, in particular the museum and
the market. It is now a generally accepted and approved fact that inde-
pendent criticism can be locked into an academic ghetto and that the
management of aesthetic consciousness need not be affected or troubled
by the absence of this once-independent force. Just as Greenberg's
attacks on mass-cultural formations in the late '30s hardly endangered
those formations, so too a ghettoized contemporary critic today poses
little threat to the already confirmed institutional and economic consent
regarding high-cultural production—e.g., that David Salle and Eric
Fischl are the key artists of the Reagan era. Criteria of evaluation are
currently established outside any relevant critical practice, and no criti-
cal contestation could even begin to trouble a curator's conviction or a
journalist's strategy to link the names of those artists with that of Manet.

One of the very preconditions of the successful operation of the cur-

rent discourse of institutional and economic power is thus that it be able to sever all links with the reality principle of history, and that meaning and history be constructed according to the topical needs of the moment. Today, under prevailing conditions of cultural anomie and amnesia, traditionalist (not to say reactionary) definitions of cultural production can be asserted all the more readily since all contradictory evidence can be repressed. Given such conditions, it would be quixotic—to say the least—to engage in a criticism of Michael Fried's life-long defense of Caro, Noland and Olitski as the most important artists of the second half of the 20th century, and to confront his canon formation with my own supposedly superior one of the late '60s (even though the historical and artistic bankruptcy of an artist like Caro has become once again more than evident, most glaringly in his new figurative bronze odalisques and welded bronze collages). It would be all the more comical to oppose this aesthetic of medium-specific modernism and its inherent transcendental experience to the late-'60s aesthetic of radical immanence—of contextuality and contingency, of site specificity and institutional and discursive critique. For at this point in the late '80s it is difficult to make an argument for the progressive political implications of such postminimalist practices by simple contrast to the obviously conservative implications of Fried's aesthetic of autonomy. It is difficult because this generation of postminimalist artists, whom Fried attempted to discredit as "theatrical," now receives and accepts commissions for public monumental sculpture from both conservative governments and corporate real-estate speculators. For instance, in Berlin the earth mounds that Joseph Beuys installed in a museum only a few years ago are now (posthumously) cast in bronze. And in Brussels Daniel Buren's once-subversive demarcations underscoring the institutional and discursive constitution of vision are now transformed from one of the most pointed critiques of formalist aesthetics into a mere architectural decoration of marble slabs for the lounge of the Royal Family at the Opera House.

This, then, is clearly not the moment for smug remarks and triumphant self-satisfaction regarding the work of the various generations of artists with whom we as critics have been, and still are, identified. At least for the time being, the defeat of the critic's function seems complete: On the one hand, such artists have mostly abandoned the radical premises for which they once stood; on the other hand, the critic as fourth voice among author, market and institution has been silenced.

Indeed, the apogee of anomie and cynicism has recently been reached by a member of the new generation of critics: Even as this person provides catalog and art journalism copy and manages the art investment services of a major bank and its corporate and private art portfolios, he claims that it was precisely the work of postminimalist and conceptual artists, Daniel Buren and Hans Haacke in particular, that provided the theoretical and artistic justification for these newly defined functions of the "critical" profession. Faced with such hypocrisy, the critic might best define his or her practice, especially in regard to the legacies of pop and minimalism and their successors, as an act of countermemory, one which opposes such facile and falsifying "rediscoveries" of '60s practice in the present.

But it is not in acts of countermemory alone that the concepts of institutional critique and site specificity, the transformation of audience relationships and models of participation will be rescued as the critical challenge against which all contemporary claims are to be judged. Since that legacy cannot be salvaged in acts of academic preservation and canon-formation, it is another function of criticism at this moment to support and expand knowledge of those artistic practices of resistance and opposition which are currently developed by artists outside the view of the hegemonic market and of institutional attention. With marginal audiences and peripheral support it is these practices that are developing the radical oppositional potential that the work of the late '60s contained.

DISCUSSION

MICHAEL FRIED: I'm grateful for the opportunity to speak to these issues. They are important to me but are hard to get right, and there are historical reasons why this is so. I want to speak first to the whole question of "opticality," the realm of the purely visual. This is not a wildly gripping topic today, but Rosalind and Benjamin are right—it was significant in the late '50s and '60s. Its prime locus was the criticism of Greenberg, in particular the essay "The New Sculpture" [1948/58]—the idea of sculpture existing purely optically like a mirage. Now when you start out as a critic or an artist you start from the previous work that you respect, and you inevitably accept a number of its working terms. For me "opticality" was one such term. It was important in Greenberg's writing, my initial take on art was very strongly shaped by his writing, and "opticality" in my early essays figured importantly, especially in relation to what is now called color-field painting.

But by the time I wrote "Art and Objecthood" [1967] "opticality" played a very small role. My attack on minimalism in "Art and Objecthood" was not made in the name of the optical versus the literal. I saw minimalism as an attempt to hypostatize a certain notion of the object—a kind of abstracted object. That is what I meant by "literalism," and its dominant mode of effect was what I called "theatrical." Its counterterm in radical abstraction—in the truly pictorial or the truly sculptural (as in the work of Caro which, yes, I continue to admire)—was not a notion of opticality. In the essay I made this explicit in relation to Caro. As early as 1963, when I wrote an essay for his first major exhibition at the Whitechapel Gallery in London, what interested me was the syntactic nature of his art. I had first seen a couple of abstract Caros in his

garden in London in 1961 when I was twenty-two years old—*Midday*, the sculpture that now sits forlornly in the sculpture garden at the Museum of Modern Art, and then another piece called *Sculpture 7*. And I had this instant access of conviction that Caro was a great artist.

I was familiar with Tony Smith, but there was something else in my response to Caro. I was already interested in Merleau-Ponty, philosopher of the body, and Caro's sculptures worked off the body in a way—very abstract and moving—that was related to phenomenology. In one of Merleau-Ponty's confused but wonderful essays, "Indirect Language and the Voices of Silence," he quotes Saussure on linguistic value construed as an effect of difference—that the power of language to signify does not lie in any of its positive terms but in the difference between its terms. This seemed to me stunningly apposite to the effect of Caro's sculpture. The sense in which it seemed fundamentally not like an object had to do less with any miragelike opticality than with its radically differential nature. I first made this point about syntax in '63; then Greenberg picked up on it in a piece in which he talked about relationality, on what he called a "radical unlikeness to nature"; and then I picked up on that in "Art and Objecthood"—what it would mean to think of art syntactically. Thus the argument was being moved into a realm of signification, ultimately Saussurean but mediated by Merleau-Ponty.

So what there isn't in "Art and Objecthood" is a reification of opticality; what there is in the text is some other kind of notion that has to do with relation and syntax—the way sculptures like Caro's are formed and how that is different from the syntax of ordinary objects, which is the syntax hypostatized, reified and projected by minimalism. That's the difference—not opticality versus object, but a radically syntactic or differential art versus the projection of objecthood.

BENJAMIN BUCHLOH: Can I insert one single question? How can you claim Merleau-Ponty for Caro when Merleau-Ponty is the central philosopher for minimalist art? How can that be historically explained when you don't recognize his importance for minimalism?

M. F.: But I do, I do—that's the beauty of it! It's not just that Caro had not read Merleau-Ponty...

B. B.: But that's interesting enough: Caro hadn't while Robert Morris had.

M. F.: Minimalism and the art I championed—they represent two anti-

thetical responses to the same history . . . except it then turns out to be a different history because art history isn't just objectively given. Anyway, they are two radically different readings of much the same history. Of course, Pollock was important for both sets of artists. In fact, what fascinated me about the minimalists was that they read Greenberg, valued the same recent art, but saw in it a development that projected literalness. When minimalists looked at the transition from Pollock to Kenneth Noland to Frank Stella they saw art becoming a unitary thing, no longer a matter of part-by-part construction. This is what fascinated me; it was as if the minimalists were the ones who really believed the Greenbergian reduction—that there was a timeless essence to art that was progressively revealed. And in their reading the timeless essence turned out to be not just the delimited flat surface of painting but the literal properties of the support. They then projected a further "insight"—that the support itself is a limited, compromised form of literalness. So why not go all the way and isolate, hypostatize and project literalness as such—go beyond painting and sculpture altogether and simply make things like primary objects? If literalness was behind the entire development of modernism, if it was the motor that made it run, why not just go after it directly? That was the logic of the minimalists.

B. B.: It was one motor.

M. F.: Yes, one motor. For them.

B. B.: It was not the motor of the readymade paradigm; in fact, it was precisely the contestation of literalness which the readymade paradigm proposed. Maybe that was one of the problems the paradigm caused you in 1963 when you were first confronted with it.

M. F.: Yet how much—or, as I would want to say, how little, how very, vanishingly little—did the readymade paradigm function in the discourse of Judd, Morris et al.? In your retrospect, which is an intensely interpretative retrospect (and I don't say that to knock it because it's all we have), you can inscribe a relation to Duchamp into history, but it'd be hard to document in certain ways at the time—among the minimalists, I mean. Anyway, part of the interest of my project, part of my argument with Greenberg's reductionist, essentialist reading of the development of modernist art, was precisely this case history in minimalism of what happened if one thought in those terms.

That Merleau-Ponty and the body should be important to the mini-

malists makes perfect sense to me, and my reading of their art was certainly open to Merleau-Ponty. There are references to him in what I wrote. What bothered me about their art was not that it was keyed in some sense to the body but that its relation to the body was surefire. Those things were machines for producing surefire effect. And my aesthetic to this day is against an art of surefire effect. When a work seems surefire it is essentially uninteresting; I admit to that bias. This is partly what Benjamin meant when he talked about a transcendental aesthetic, and it's one of the many points on which we disagree.

One of the very important issues for me then was the issue of shape. In "Shape as Form" and in "Art and Objecthood" I did not argue for an optical notion of shape versus a literal notion of shape; I did not argue for what Rosalind called "a pulverizing of shape." I wanted to describe and define a notion of shape that would be pictorial—but not in some ahistorical sense. For there took place in painting in the years 1965–67 an extraordinary effort to deal with the problem of shape. Increasingly, shape as such—not just the depicted shape in the picture but even the literal shape of the picture—did not compel conviction in the way that shape previously had, and I was tracking various strategies by which advanced painting had tried to reestablish shape as a vehicle, a medium of conviction. It could not be achieved by sheer opticality. In fact, one reason I underestimated Noland's *Narrow Diamonds* (those rather pinpointy diamonds about two feet wide and eight feet high) is that their effect seemed to me then too sheerly optical.

This relates to one other point I want to make. It's true: The meaning of Stella's art, its historical significance as it evolves through the '60s, is a very complicated issue. He and I go back a long way, and I did put him together with Noland and Olitski in my "Three American Painters" of 1965. And yet Benjamin is certainly right: Stella is of a different generation from Noland and Olitski; his art will have a different historical valence from theirs. Nevertheless, I don't think it can simply be said that even or especially as late as 1967 Stella's art was unequivocally on the side of minimalism and literalness. 1966 was the year of Stella's eccentric polygons; against the background of the aluminum pictures and the metallic stripes it is strongly arguable that they represented a turning toward painting, toward the problems of painting, in particular this investigation of shape, as opposed to a move into minimalism. That was my argument in "Shape as Form."

MODERATOR (HAL FOSTER): Rosalind, do you feel that Michael has

responded to your question that his model of a disembodied beholder might be exemplified not in the viewer of a Caro or an Olitski but in the subject projected by pop, the subject constructed by the media? That to me is an hypothesis that might collapse certain distinctions between pop and postpainterly abstraction, between mass culture and high art, that for many of us structure the art, indeed the culture, of the '60s.

ROSALIND KRAUSS: I have two things to say about Michael's response, but then I have a question to address to Benjamin. Michael, I purposely steered clear of the notion of opticality—I don't think I used it except to quote Greenberg. I did use the term "mirage," but only because it locates the work in relationship to the idea of illusion, of fiction—the aspiration toward an experience of belief or, let's say, of the suspension of disbelief. That, I think, is what is at issue not only in "Art and Objecthood" but in all your subsequent work. I know that opticality is not the term that is contrasted with literalness in your initial argument. Instead your counterterm is "presentness," by which you were calling for an experience of intense, abstract presence in relation to the work—an experience which is allegorized as one of pure cognition, a tremendously instantaneous moment in which one gets the point of the work both instantaneously and forever so that this explosion of "getting it" is supposed to lift one out of the temporal altogether. Now that model is very hard to reconcile with the Saussurean model of meaning, with its notion of meaning based on difference, on the absence of positive terms. I don't see how you can square that differential model with your notion of instantaneous plenitude. So when you say that Saussure was secretly cooking away in your argument about the experience of art like Caro's—well, I simply don't have a flash of recognition there.

I don't want to abandon the discussion of "Art and Objecthood"—it does help us center the issues—but I do have a question for Benjamin. I agree with a lot of what you said, and yet there's a moment when I don't get it. On the one hand, you talk about the ghettoization of the critic (in the academy, for example) and the fact that the critic no longer does what he or she used to do—set the criteria of quality, affirm certain works over others, usher new art into the preserve of the museum. And on the other hand, you talk about this other group, these dumb curators who today do whatever they want. To me that separation overlooks the fact that, in the last ten years or so, the critic has had an incredible amount of power in setting the terms through which artistic practice is supported theoretically and therefore grounded aesthetically—to the

point now where a lot of artists attempt to situate their work, to establish its importance, simply by capturing certain critical positions or terms in the way a chessplayer might capture a rook. This is related, I think, to the evacuation of the critical project that you discussed. Theory thinks it gains the possibility of resistance in critical practice, but it is often recuperated and evacuated by the worst—the most trivial—artistic practice. And this seems to me a different issue from the ghettoization of the critic; it's about the creation of a discourse or pseudodiscourse that is very unresistant to absorption by certain types of art. What do you think about this in relation to the problem of criticism that you brought up?

B. B.: I think it adds to the problem; I don't think it contradicts it. But it seems a minor issue in comparison to the one that you addressed, Michael. Perhaps I can make a statement that relates to both problems.

I think the function of critical practice can be analyzed historically; that's one of the reasons why your writings, Michael, have fascinated me. I don't mean to personalize the argument, but in terms of a "tropics" of art discourse, of its formation, it is enigmatic to me why at that moment in time [1963–67]—against all the evidence of actual artistic practices, against all the evidence of actual history that preceded or accompanied those practices—you felt compelled to engage in yet another round of historical, aesthetic and theoretical legitimation of American-type modernism, when clearly it had been contested for at least ten years, contested on the grounds of a gradual recognition of avant-garde practices in other cultures that had existed prior to American-type modernism and that had been repressed by it. American-type modernism was clearly contested in the reception process proposed by the work of Rauschenberg and Johns from 1951 onwards—work which of course was the great threat to your own project and that continues to meet with your complete rejection. And it was also clearly contested in the work of the artists with whom you were involved, perhaps even in Stella's black paintings of 1959, but certainly in the work of his close friend Carl Andre. Andre would not have allowed such a reading of their work, given the historical circumstances, given the claims they made. That is what is so fascinating, so enigmatic: What was the agenda, what was the need, to save American-type formalism from its obvious decline? Was Caro the great rescuer of this ailing tradition because in addition to everything else he was its European extension and so could confirm its imperial success?

There's also the wonderful conflict which Rosalind pointed out (and

which maybe you should address again) between your critical awareness—your claim that Merleau-Pontyan phenomenology and Saussurean linguistics formed the basis of your perception—and Caro's work which does not seem to offer those terms or to warrant or justify that reading at all, while the work of Andre or Morris cannot be discussed, cannot be seen, except in those very terms within which, again, it was actually constituted. Those are the questions I would like to ask.

M. F.: They're very good questions. Rosalind and I have known each other a long time (with various hiatuses along the way). Benjamin and I don't know each other well, and I suppose one of the things that strikes me, Benjamin, is your very positivist mode of argument—so that you will say "against all the evidence of actual artistic practices," "against all the evidence of actual history." That feels so massive and so totalizing—and to me it is simply wrong. It's one thing to say, "Look, from our retrospect today one can see these forces stirring that can now be construed to be in fundamental opposition to those other forces." It's quite another thing to say, "How could you possibly repress or minimize that awareness at the time?"

AUDIENCE (DOUGLAS CRIMP): But you still hold to the same position, so you can say "for now" too, right? You have the same retrospective view that Benjamin has, and yet you still hold out for Caro and Poons.

M. F.: Of course I hold out for Caro and Poons; that's neither here nor there. What this discussion shouldn't come down to is who I think are the best artists in the world. Look, Benjamin and I disagree fundamentally; this has emerged before. We disagree fundamentally about the value of Caro's art then and now. And this in many ways will determine the sorts of things each of us has to say. One thing I really respect about Benjamin, one thing that makes our discussions go deep, is that they turn on differences in judgment, differences in taste. If you believe as I do that Caro is a major sculptor—is, along with David Smith, the best sculptor of the postwar period—then the kinds of questions that Benjamin asked don't arise. My conviction was that this stuff was tremendously important, ditto the painting. That is why a phrase like "against all the evidence" sounds unhistorical to me: for me the evidence was running the other way. I don't want to make a countermove and say it is self-evident that all the evidence works my way. What has to be recognized is that this is a contested field—even now, even if I'm the only one contesting it. I still believe I'm right, and certainly then it didn't require extraordinary

bad faith or historical blindness to believe that this art was truly impor-
tant—which I did and do.

R. K.: Michael and I started writing in 1961–62, so our sensibilities were
formed in 1958–60. That is ancient history, but that is so. Well, what
was the evidence then? Pollock, for one, and we certainly didn't think of
Pollock as degenerate, that he reflected the obvious collapse of Ameri-
can modernism. Same with Newman, who was painting some of his
very great paintings at the time. So where was the evidence in the late
'50s of this obvious collapse? And I must say, in support of Michael, that
in 1961 or '62 he wrote a very elaborate, very persuasive argument for the
importance of Johns. So I agree with him, Benjamin: I don't exactly
understand what your question is.

B. B.: OK, let me correct one thing. I did not talk about the "degenerate"
conditions of American art—that should be clarified. I did talk about
increasing evidence of the decline of American-type formalism as a criti-
cal construction—that's a different thing altogether. The evidence was
not primarily critical theory; it was the evidence of the work, and the
statements of the artists, from Rauschenberg's work in the early '50s and
Johns's work in the mid-'50s to Stella's work out of Johns's in the late
'50s. In the face of such work, statements that define pictorial experience
in terms of opticality would seem to be no longer possible. When Stella
emphasized that he used a housepainter's brush and laid on paint as an
object, it would seem difficult, already in the context of his black paint-
ings, to continue to read and discuss his art in terms of virtual space or
opticality—when precisely every step he took then was involved in the
opposite project, the opposite agenda. So, again, I was not talking
about the degeneration of American art; I was talking about the de-
cline of American-type formalism—its linguistic, ideological and criti-
cal apparatus.

M. F.: Benjamin, Rosalind didn't misrepresent what you said. You were
scathing about the art.

B. B.: No, I was not. Absolutely not. I was trying to clarify the historical
definitions, the historical needs, the historical determinations of Ameri-
can-type formalism—that's what interests me. "Scathing" is not the issue
(except perhaps for Caro).

M. F.: I still think your analysis is tainted by a kind of positivism—I
mean the idea that it ought not to have been possible to support certain

art of the time because certain other art was stirring, or that "American-type formalism" was already in manifest decline. When Rosalind and I entered the field of art criticism just a short time apart, the most interesting critical work by far was Greenberg's. Now you want to say, in retrospect, that that discourse ought to have appeared discredited to us—but it just didn't seem discredited to the most serious people involved in art criticism at the time. Just as an historical fact that has a certain force.

B. B.: Does that mean we will never be able to historicize that discourse?

M. F.: No, I want to historicize it. But you can't historicize it if you treat it as inexplicable—as a piece of insanity or error. Benjamin, that's how you present it: You find it inconceivable that anyone could have thought that way. That's not historically productive. It may be that Stella's relation to all these issues was more ambiguous or ambivalent than my criticism had it; but I was claiming his paintings for a development I believed in. In a sense Carl Andre and I were fighting for his soul, and Andre and I represented very different things. Andre appeared to me as a very bright person but a very alien form of intelligence—I come clean about this. But the point is that these were issues to fight over, so that if we historicize that moment now we have to see it as a conflictual time, a time when different possibilities were entertained, when the same body of work was seen in different ways, when the future—our now—was in doubt, when you entered the debate in an active way and you fought for what you saw as the truth.

B. B.: Was Andre alien because he knew about Rodchenko and Malevich and Duchamp, because he put their practices into the critical discussion of artistic production around 1959? Why was he alien?

M. F.: That wasn't why. I know you want it to come out that way, but that wasn't it. Andre represented an early form of the belief that if you got a whole lot of identical objects (let's say squares) and put one here and here and here and here, then that was a work of art, that was gripping and compelling. Carl was a very early advocate—even in his poems—of that type of thing, and I was and am committed to an altogether different aesthetic.

HAL FOSTER: Let's open up the conversation to the audience; but first let me say one thing. I titled this discussion "Theories of Art *after* Minimalism and Pop." It interests me that the moment of minimalism and pop is still so obsessive—not only for participants but also for onlookers

of other generations. It really does seem to be an historical crux. But I am also struck by a generational difference, a theoretical difference, and Rosalind pointed to it when she underscored the importance of belief for critics like Michael. There's a line in "Art and Objecthood" to the effect that painting must compel conviction. Now a primary motive of the innovative art of my generation is precisely that it *not* compel conviction—that it trouble conviction, that it demystify belief: that it not be what it seems to be. That to me is a real difference.

AUDIENCE (JOHN KNIGHT): Michael, maybe rather than wrong your position was simply incomplete. Were you aware of this other position, of this other agenda?

M. F.: Of what other agenda?

JOHN KNIGHT: Of the information or the tradition that legitimated someone like Andre, that you seemed not to find important enough to address.

R. K.: He's asking: Were you aware of constructivism? Were you aware of Duchamp?

M. F.: Yes, I was aware of Duchamp; he just didn't interest me a lot. Duchamp certainly seemed important for Rauschenberg and Johns, but he didn't strike me as relevant to the work that attracted me. I knew as little as one could about Rodchenko and Russian constructivism.

JOHN KNIGHT: Why don't you talk about your position now?

M. F.: What do you think would happen if I did?

JOHN KNIGHT: It would bring us up to date, and it might give us an archaeological figure of your criticism.

R. K.: I think one way to talk about it now might be to talk about your work since then. In your historical work there continues to be this notion that art is governed by "the primordial convention" that paintings are made to be beheld ...

M. F.: But that beholder doesn't necessarily hypostatize pure visuality ...

R. K.: It just means that there's this person and this object and this relationship between them which evolved with this "primordial convention" that paintings are made to be beheld. But all that is put into question at certain moments. There are models which take into account different

conditions—historical changes in the mode of production of art. Think of Walter Benjamin on mechanical reproduction—on how it changes not only the function of the work of art (the fading of aura) but also its relation to its viewer. Your idea of the "primordial convention" that paintings are made to be beheld is ahistorical; it does not pay attention to this whole other proposition, one instance of which is the writing of Benjamin. Is that bringing your discourse up to date?

M. F.: "Primordial convention": Remember, though it says "primordial," it also says "convention." But I'd prefer not to get into this (there's a good discussion of its complexities in the article by Stephen Melville I mentioned in my opening remarks). As for Walter Benjamin, I read him, I care about him, I admire him—but "The Work of Art in the Age of Mechanical Reproduction" is not the sacred text that it's often taken to be. In fact, it's deeply problematic—this idea that a "fading of aura" can be taken as an historical fact or an historical given. The tradition of paintings that I am moved to write about is one in which this issue of beholding arises with a vengeance in France around the middle of the 18th century and is worked out in a continuum that I've tracked historically. (Incidentally, this beholding can implicate the body deeply, as I hope my work on Courbet has shown.) It is only for this particular tradition of painting that the "primordial convention" that paintings are made to be beheld emerges as a productive problem. Is that formulation historical enough?

This is not to say that other critical methods are useless or empty, but for me notions of (let's say) commodification are not particularly helpful—I'm interested in another set of issues, another set of problems. That's why I work on certain artists and not on others. But it's true: I find it very hard to see a figure like Rauschenberg as world-historical in the way that lots of people, lots of serious people, do. I'm not saying it's categorically absurd; I just don't see it that way.

R. K.: What's at issue in the question I raised or rephrased is this: On one hand you write history and on the other hand you assume a nonhistorical position; on the one hand you talk about the historical nature of the argument based in certain French painting and on the other hand . . .

M. F.: I talk about my conviction in certain contemporary work.

R. K.: But this same history has produced models of art—of its relationship to its audience—that are not based on this "primordial conven-

tion" of beholding. Why doesn't this factor into your discussion? I raised Benjamin, the mode of mechanical reproduction in art, because of his importance and availability, but there are other models—like my own work on the indexical nature of Duchamp's work and '70s art. In such indexical art the issue of beholding is postponed. And there are many, many other models in which the same thing holds true. We simply don't have to invoke this idea of the beholder.

M. F.: But I've never argued that this idea is so total or global that anyone who doesn't talk in these terms should be drummed out of court. Look, I see myself not as a sheriff but as an outlaw! And certainly I don't regard other models as invalid or idiotic.

AUDIENCE: What about Rauschenberg then? You seemed to dismiss his work completely—regardless of what other serious people think.

M. F.: The fact that I grant that other people are serious doesn't mean that I have to agree with them.

AUDIENCE (MARTHA ROSLER): I was interested that Benjamin evaded Rosalind's assertion—which I find problematic—that critics now set the terms or parameters within which artists make their work.

R. K.: I didn't say all artists; I was specifically thinking of the use of Baudrillard by an artist like Peter Halley.

MARTHA ROSLER: Do you want to date the phenomenon to a certain period? Because it seems to me exactly coterminous with the evacuation of criticism that Benjamin discussed.

R. K.: Right. I was asking Benjamin to deal it into his model.

MARTHA ROSLER: I'd like to hear it too.

B. B.: Again, I think this complements and confirms my own argument. The phenomenon is coterminous: it emerges at the very moment the complete isolation and dismissal of criticism as an independent practice is historically confirmed. So they are two halves of the same problem.

MARTHA ROSLER: It didn't sound like that. There seemed to be a contradiction between what you said and what Rosalind said. I agree with you—they're parts of the same problem. But Rosalind seemed to grant criticism a power to effect practice—to see criticism as independent, not impotent.

R. K.: No. What I meant was that criticism had vehiculated a certain argument in relation to which a certain type of art has been made. We can talk about it as a post- "Pictures" production, a production that wants to legitimate itself by reference to certain poststructuralist ideas. The result is that criticism that thought it was on the high road of theory has in fact become deeply implicated in this activity: it has justified it, given it enough chitchat, enough high-flown language to make its claims. And I abhor this. So my point is that critics are both powerless and powerful in a perverse way, in a way that I don't think we quite understand. That's what I wanted Benjamin to address.

MARTHA ROSLER: Is that so different from Jules Olitski being floated on chitchat?

R. K.: Jules Olitski, as far as I know, did not issue statements about his work. The phenomenon I have in mind concerns a discourse, validated in an extraordinary way by academic institutions, that the art world has now picked up on. It's not the same relationship of artist and critic; it's a change of real quality. And I agree with Benjamin that Michael and I belonged, at least in the '60s, to a totally different practice. Critics like us from the '60s must seem like mastodons . . .

HAL FOSTER: And critics like me from the '80s must seem like the Jetsons. Now I don't want to defend art made out of a shallow reading of theory . . .

M. F.: Go ahead, be bold, Hal!

HAL FOSTER: But it does seem to me, Rosalind, that there *is* art after pop that is not totally within its charms. And it does seem to me, Benjamin, that the critical function has *not* totally collapsed. To say so with such finality is not exactly dialectical; it would not allow a critic like you—or me—to even see the problem, let alone argue against it.

R. K.: Hal, at this point the work that has the strongest critical function is made by artists: real criticism is located there. Nobody's responsible for this. But somehow the power of authentic speech has passed from the written word at the moment. That's not to say it might not come back, but I don't think it's there anymore.

AUDIENCE (PERRY ANDERSON): Michael, in your initial remarks on the context in which you wrote "Art and Objecthood" you explained that you feel now that you were intellectually too close to Greenberg at the

time, and you went on to set up your points of modification. But there is a separate question which I don't think you have yet fully addressed: Has anything happened in painting or sculpture in the last twenty years to cause you to repent, to revise—or in any way to extend—your position? I hope that's not an unfair question.

M. F.: I don't take it as that at all. Of course "Art and Objecthood" is not an essay I could write in the same way today, but I haven't changed my mind about minimalist art and I continue to hold certain other artists in high esteem. And yet two things since then have problematized the essay—at least two things—but "problematize" is not to say "invalidate." One is that, boy, was I right about art moving towards theater! There's a sense in which everything new in art since then has happened in the space between the arts, the space I characterized as theater. In fact, the whole area of theatricality has been explicitly colonized in ways that are very diverse, often very interesting, in many cases powerful; so that the opposition between good art and theatrical art and the meeting of specific arts in the theatrical space between the arts has been enormously complicated by practice. I could no longer reify the distinction, though I'm glad I wrote what I wrote then, and in some sense I stand by it even now as it's written. On the one hand, I haven't been moved or convinced by all this theatrical work; on the other hand, I recognize—I think—that it's not subject to blanket dismissal. I certainly recognized then that there's an intertwining of the theatrical and the nontheatrical, and that the art that I championed as nontheatrical was itself staged in certain ways, but when one writes polemically certain subtleties get lost. The second thing that has emerged I mentioned before: the rise of a deconstructive way of thinking about art, a new kind of theoretical discourse.

But to answer your question: I can't say that the last twenty years have seen the production of a vast amount of painting and sculpture by artists other than the ones I supported then and have continued to be associated with that seems to me equal to the best work made in the 20th century.

AUDIENCE (IRVING SANDLER): Let me ask this of both Michael and Rosalind. Your writings were considered in the '60s as formalist. What do you think is still salvageable, still useful, from that tradition?

R. K.: Irving, how could you ask that of me? I've made a whole career of repudiating formalism! . . . A certain commitment to looking carefully at works of art—that's possibly salvageable. But the terms, the things that

get discourse going—like the ones we've discussed tonight—they do not seem to be salvageable. We have to come up with different terms; that's why I brought up the questions of reproduction, replication, etc.

M. F.: I've never been happy with the notion of formalism; let's say instead criticism that is medium-specific. Insofar as any art operates in a mode that can be persuasively understood as medium-specific, then powerful aspects of that criticism will be relevant. We are now in a time when medium-specificity is radically called into question in many different ways; this is part of the troubling of conviction Hal alluded to. And, yes, my criticism did arise out of a conviction in a particular kind of medium-specific tradition. But there are interesting questions that get opened up here. For example, Laurie Anderson's work seems interesting to me, yet one of the things that serious criticism has to deal with is: interesting as what? Whatever else it does, criticism has to identify and characterize the phenomena it discusses. If one presses that, one might enlarge or loosen the notion of medium; and one will most likely discover an ongoing enterprise that has some kind of history, some kind of traditionality—even if only proleptically. And then one will discover oneself working, whether one likes it or not, in terms that can be laid alongside those of criticism of the '50s and '60s.

AUDIENCE (ANDREW ROSS): I have a 1987 question for Benjamin. When you talk about the disempowerment of art criticism today, I assume you refer exclusively to radical art criticism. Because there's obviously no shortage of hired hands, of company men and women, who work to legitimate artists (perish the thought there might even be some in this room!). After all, legitimation comes largely after the fact: it's a continuing process, not a single creative act. I also assume that you want that power to legitimate back—for you cannot contest unless you have such power. And so my question is: What would you do with that power now? And what does it suggest about the intimacy between criticism and the will to power itself?

B. B.: I was aware that my statement might be taken in this way; in fact, I deliberately constructed it to invite this reading. It was neither a personal complaint about a loss of power, nor was it a claim for a future restoration of power; it was an attempt to describe the historical transformations of critical activities in the period under discussion. Michael's writing "Three American Painters" in '65 and "Art and Objecthood" in '67, or Rosalind's writing "Notes on the Index" in '76 or '77—these are historical instances

of an independent discursive practice with which institutions then engaged. I mention this not in nostalgic mourning but as a simple marking of critical functions that no longer exist. I have no anticipation of restoration, and I totally agree with what Rosalind said: Critical practice at the moment resides in aesthetic practice itself. It may reside in other domains, too, like mass-culture studies, but it's not operative in high-culture art criticism anymore. And in my statement I wanted to imply that Michael Fried's critical model in the '60s might be one place where the collapse of this historical function begins to become visible. This is an issue we haven't successfully discussed yet. Why did you stop writing criticism in 1967? Why was "Art and Objecthood" the conclusion of your critical project? After that essay it was Manet, then Courbet and now Eakins. I think you arrested in time at the very moment when it became clear that this project—the project of legitimating the hegemony of American-type formalism—could not be fulfilled, could not even be rescued. So in spite of your claim I still say certain historical conditions can be quoted, can be introduced into the discussion, and if that makes me a positivist so be it. That was the connection I wanted to establish.

M. F.: I'll respond to this briefly—it's helpful, it's clarifying. The problem that I faced after "Art and Objecthood" was not the collapse of a critical project, if by that you mean "formalism"; it was that, having set up terms I believed in and having championed artists I believed in, I would be writing my fifth article on Caro, my sixth article on Noland, my seventh article on Louis. Whereas all this interesting historical work had opened up—and I didn't know how it would turn out. If the tradition I had championed had proved tremendously productive of major new talents after those years, then I would have been moved to write. And I did go on to write a few short pieces, about Poons, for example. There continues to be new art I greatly admire, but it tends to be made by a relatively small group of people, and the terms within which it operates are essentially ones laid down by Caro, Noland, Olitski and Poons—all artists about whom I've had a say. Maybe you'll feel that this is a sufficiently devastating acknowledgment in its own right.

Afterword

MICHAEL FRIED: Two brief points. First, in view of my remarks at the close of the discussion period, it should also be stated very plainly that

almost all the best painting and sculpture I know by younger artists today belongs to the tradition "Art and Objecthood" supports and that the indifference of the gallery scene to that work is nothing less than a scandal.

Second, looking over the transcript of the discussion, I was struck by a remark of Rosalind's that I let go by but want to respond to here—I mean her statement that she doesn't see how I can square a differential model of language derived from Saussure with an emphasis on instantaneously "getting the point" of Caro's art. But of course there's no contradiction whatsoever: Saussure's model doesn't deny that we experientially grasp the meaning of a word or a sentence in a flash (such a denial would be absurd), but rather that the instantaneous intelligibility that characterizes actual discourse is everywhere underwritten, made possible, by a differential structure that in a certain sense—that of Derrida's *différance*—implies a notion of temporal deferral. But it's a very special notion of deferral and can't simply be equated with the assertion that understanding a statement, or for that matter a painting or a sculpture, takes time. More broadly, the question is what follows for a consideration of these issues from Derrida's radicalization of Saussure; what surely doesn't follow from it, I suggest, is the conclusion that differential structures can only yield effects of deferral or indeed lack of plenitude, which seems to be what Rosalind has in mind. Incidentally, rereading "Art and Objecthood" I see that I speak there about Caro's sculpture in relation to the body in ways that might have reminded Benjamin of Merleau-Ponty.

Legacies of Critical Practice in the 1980s

DAN GRAHAM

It is extraordinary to be in this room illuminated by the work of Dan Flavin, always a favorite artist of mine and an inspiration both in his art and in his writing; he was also the first to appreciate my writing.

In the first Dia discussion the question of artist/writers came up. It is from this position of artist/writer that I and the other two panel members speak. Our topic is strategy for the '80s—which, it is assumed, is different from strategy in the '70s or the '60s. My strategy has evolved from the '60s idea of art as a phenomenology of the present-time/presence of things, to an involvement in structuralism; from there to deconstruction, and within the last five years to a rejection of deconstruction in favor of a concern with historical memory. (This evolution is evident in my "minimal" sculpture/pavilions, for instance, in my "Rock My Religion" video, and in various articles such as "Gordon Matta-Clark" and "Theater, Cinema, Power.") I believe now that the task of the artist is in part to resuscitate the just-past—that period in time made amnesiac by commodity culture—and to apply it as an "anti-aphrodisiac" (Walter Benjamin's phrase). The Rolling Stones's song "Yesterday's Papers"— "Who wants yesterday's papers? Who wants yesterday's girl? No one in the world"—makes this anti-aphrodisiac aspect of the just-past clear.

According to Benjamin, "progress," the 19th-century scientific and ultimately capitalistic myth, is expressed in commodities, fashion goods which "produce a sense of eternal newness."[1] This makes progress a mythical goal, never to be reached, for there is always the new and it is always superceded by the next new. For Benjamin, then, progress is actually a state of stasis.[2] And yet it is this very stasis that makes the recovery of the just-past potentially subversive.

In the plan for his *Passagen-Werk*, the project about 19th-century Paris on which he worked from 1927 to 1942, Benjamin wished to demonstrate that for his generation slightly out-of-date—just-past—objects of mass culture possessed a latent revolutionary power, a notion he developed from surrealism. (The 19th-century consumer arcades and the crystal palaces of the universal expositions functioned for Benjamin in a similar way; they were "dream houses" that induced a "time space/time dream.") He wanted his arcades writings to serve as a dialectical "fairy tale": "to reverse the myth of the late 19th century created by constant newness and induced amnesia of the recent past, which undermined the historical meaning of the past in favor of the present and fantasized future of the commodity dream (progress)." Such a fairy tale might effect this, he thought, "by changing what adults saw as newness into the archaic and mythical." As a consequence, each generation of children might see remnants of the just-past not only as archaic but as endowed with a mythical capability to restore the past. For Benjamin this was one way in which "the commodity dream" might be broken.

Benjamin's goal was to restore historical memory in opposition to historicism, or the idea that everything we know about the past is dependent upon the interpretation of the fashion of the present. In historicism there's no real past, only an overlay of interpretations or a simulation of the "past." Benjamin opposed this idea with the notion of an actual though hidden past, mostly eradicated from consciousness but briefly available in moments of dreams, hallucinations, stoppages, etc.

In proposing this idea Benjamin had to dispute Marx's rejection of memory while saving his "theological" premises. In his 19th-century context Marx had wished to shed the ideological shackles of memory for an empirical approach to history:

> The social revolution of the 19th century cannot draw ... from the past, but only from the future. It cannot begin before it has stripped off all superstition in regard to the past. Earlier revolutions required reminiscences of past world history so as to hide from themselves their own content. In order to achieve its own object the revolution of the 19th century must let the dead bury the dead.[3]

For Benjamin, on the contrary, bourgeois ideology was maintained by the notion of progress, a notion supported by an empirical, "scientific" ideology of "objective," historical progress. In opposition to this ideology of progress, he proposed a recuperation of historical memory.

Without a redemption of past oppression, Benjamin felt, Marxism could only fall into the dominant rationalism of capitalist society:

> The past carries with it a temporal index by which it is referred to redemption. There is a secret agreement between past generations and the present one.... Like every generation that preceded us, we have been endowed with a weak Messianic power, a power to which the past has a claim ... nothing that has ever happened should be regarded as lost for history.... [The oppressed] have a retroactive force and [their struggle] will constantly call into question every victory, past and present, of the rulers.... To articulate the past historically does not mean to recognize it "the way it really was" (Ranke). It means to seize hold of a memory as it flashes up at a moment of danger.... Only that historian will have the gift of fanning the spark of hope in the past who is firmly convinced that even the dead will not be safe from the enemy if he wins.[4]

The work of Gordon Matta-Clark is good recent example of how one can cut away and reveal the just-past. "There is a kind of complexity," Gordon once said, "which comes from taking an otherwise completely normal, conventional (albeit anonymous) situation and redefining it, retranslating it into overlapping and multiple readings of conditions past and present." With his cuts into and removals from existing architecture, Matta-Clark intended his work to function as a kind of urban agit-prop—like the 1968 acts of the Paris situationists, who saw their temporary spectacles as public "cuts" in the otherwise seamless urban fabric. "By undoing a building," he argued, "[I open] a state of enclosure which had been preconditioned not only by physical necessity but by the industry that proliferates suburban and urban boxes as a pretext for insuring a passive, isolated consumer."[5]

Paradoxically, Matta-Clark's cuts are still a form of architecture, one that uses "gaps, void places that were not developed" or that were covered over as contradictions in architectural and bureaucratic logic. His work thus exposes the private integration of compartmental living space, revealing how the family copes with the imposed social structure of its container. Matta-Clark's cuts demonstrate this constructional imposition, along with our adaption to its concealed order, in the form of "sculpture." In this way his art works to open up both the unconscious and historical memory.

References

1. Walter Benjamin, quoted in Susan Buck-Morss, "Benjamin's *Passagen-Werk*: Redeeming Mass Culture for the Revolution," *New German Critique* 29 (Spring/Summer 1983), pp. 211–240. Unless otherwise noted, all other Benjamin quotations are from this source.
2. For the relation of this to recent architectural debates, see my "Not Post-Modernism: History As Against Historicism, European Archetypal Vernacular in Relation to American Commercial Vernacular; and the City as Opposed to the Individual Building," *Artforum*, December 1981.
3. Karl Marx, source unknown.
4. Benjamin, "Theses on the Philosophy of History," in *Illuminations*, ed. Hannah Arendt (New York: Schocken Books, 1969), pp. 254–255.
5. Gordon Matta-Clark, *Avalanche*, December 1974. For more on Matta-Clark see my essay in *Parachute*, Summer 1985.

Legacies of Critical Practice in the 1980s

AIMEE RANKIN

The Legacy of the Real,
or the Limits of Representation

One morning years ago, in that twilit state between awareness and dreams, I experienced a peculiar flashback. It appeared as though on a movie screen inside my head, a short film, but one which also produced physical sensations. The image was of a section of a room, and I was able to note certain things: an unusual pattern of tiles on the floor, the flowered fabric seat of a chair, the coiled black snake of a telephone cord—but that knowledge came from outside the memory, which itself fixed on the identity of nothing. From the occasionally adjusted pressure on my body from belly to breast, and the rough texture which assaulted my cheek and chin, I was able to deduce my position: being carried by someone, my front against them, my head held over their shoulder.

Everything in the world was swaying up and down, so that my field of vision shifted like a kaleidoscope of light and color. From my vantage point outside this scenario I realized that it was the walking movement of the person who held me that produced this strange phenomenon. What was remarkable about this memory was that there was no spatial distinction made between the objects in the room: I saw the chair and the shadow of the chair as the same, embedded in the wash of light and color of the surrounding scene, which acknowledged no perspective because there was in fact no distance. Further, the hands of the person who held me were not perceived as part of a separate being: since I had not learned to recognize myself in the isolation of my own identity, I had yet to comprehend that most fundamental definition of difference, my physical separation from others and from the sensate field of my surroundings. I was being carried into bed, and the screen of my dream went dark for a while as I slept. Then, as I lay in the darkness, I was awakened by the

touch of hands, which undressed me and knowingly explored my little body, provoking in me for the first time the waves of pleasure which I would always associate with this barely remembered past, in the temporary impression of the loss of the limiting outlines of the edge of my own body.

When I awoke from the dream, shaken by its extraordinarily vivid images, I phoned my mother. I described the details of the room I had seen to her, especially the unusual pattern of tiles, and asked her if we had ever lived in such a place. "Of course," she said, "but we moved from there when you were three months old." The primordial plenitude of this world before difference is so powerful that most of us have repressed any knowledge of the entire prelinguistic portion of our lives. Yet the submerged traces of its intensity will always haunt the edges of our minds, fueling the phantasmatic structures of our dreams and desires.

The subject of my talk is the *real*, the forgotten presence against which all representation is always doomed to fail. As Marvin Gaye and Tammi Terrell know:

Ain't nothin' like the real thing, baby.
Ain't nothin' like the real thing.
No no.
Ain't nothin' like the real thing, baby.
Ain't nothing' like the real thing.
Oh honey,
I've got your picture hanging on the wall
but it can't see
or come to me
when I call your name.
I realize it's just a picture
in a frame.
Oooooh
I read your letters
when you're not here
but they don't move me
they don't groove me
like when I hear
your sweet voice
whispering in my ear . . .

According to Lacan, who has defined this concept the most convinc-

ingly, the real as the undifferentiated state of pure sensation outside the
order of sense is that mythic point of origin which underpins subjec-
tivity. There are three terms in this schema: the *imaginary*, which is "the
dimension of images, conscious and unconscious, perceived or imag-
ined; the *symbolic*, which refers to signifiers defined as differential ele-
ments, in themselves without meaning, which acquire value only in their
mutual relations;"[1] and the *real*, "that before which the imaginary
falters, over which the symbolic stumbles—that which is refractory and
resistant. It is in this sense that the term [describes] that which is lacking
in the symbolic order, the ineliminable residue of all articulation, the
foreclosed element which may be approached but never grasped: the
umbilical cord of the symbolic."[2] Like any umbilical cord, this one leads
us where? Straight back to the mother's body, the original site of that all-
encompassing plenitude against which the subject must struggle to
emerge. Underlying the assumptions of psychoanalytic theory is an
acknowledgement of the mother's terrible power, her functional
omnipotence in the eyes of the infant for whom she will be the first
definable entity. In Lacan's description of the mirror phase as founding
moment in the infant's recognition of his or her identity, it is the mother's
look which sets up this specular circuit—a fact often lost on certain fem-
inists who have theorized the masculinity of the gaze.

Language is the code of repression which breaks the bonds to the
maternal body, predicated as it is on its structuring principle of difference
which allows the subject to separate him or herself as such. The signify-
ing function of the father appears precisely to countermand the mother's
power, in the hierarchy of oppositional terms which privileges the phal-
lus at the expense of that other, now seen only as its lack. This binary
model of separation, which will banish the other underground and
extinguish forever the force of the real, is the source of that wound which
all of us carry: the repressed residue of that primordial state which holds
for us such horror and *jouissance*. For this wound we have a word:
desire, which Lacan calls "the mark of the iron of the signifier on the
shoulder of the speaking subject."[3] The violence of this operation, in
which the subject exists an an effect of the symbolic, is stated literally
in *Écrits*: " ... the symbol manifests itself first of all as the murder of
the thing, and this death constitutes in the subject the eternalization of
his desire."[4]

The implications of these ideas provide some important insights into
the work of my other favorite theorist, Jean Baudrillard. The concept of

the real surfaces repeatedly in his writings, posited once more as a mythic point of origin yet again impossible to recover—though here for very different reasons. Baudrillard takes as his topic "the death of the real," focusing on the structures of signification responsible for this slaughter. Thus in many ways he picks up where Lacan left off, continuing the deconstructive critique of representation with his analysis of the simulacrum. However, Baudrillard does not define the concept of the real in the same way as Lacan, and it emerges in his work in rather vague references to an experiential state which, it is inferred, was once accessible at some previous *historical* juncture. In his book *Simulations* he supplies the following schema: "This would be the successive phases of the image: it is the reflection of a basic reality; it masks and perverts a basic reality; it masks the absence of a basic reality; (and finally) it bears no relation to any reality whatsoever: it is its own pure simulacrum."[5] This notion of a "basic reality" and the reference to an original transparency of the sign serve as the rather shaky foundations upon which Baudrillard will build the impressive evidence of his later arguments.

Like Lacan, Baudrillard believes that the system of significations determines the perception of meaning, making it impossible to conceive of any meanings anterior to or outside that system: "This 'world' that the sign 'evokes' (the better to distance itself from it) is nothing but the effect of the sign, the shadow that it carries about...."[6] For both men language exists as a closed order; but while Lacan outlines the subjective stake in this closure, and the price that is paid in the dead end of desire, Baudrillard works backward from the real's resultant loss, emphasizing the inevitability of its capture in the signifying code: "The very definition of the real becomes that of which it is possible to give an exact reproduction.... At the limit of this process of reproducibility, the real is not only what can be reproduced but that which is always already reproduced: the *hyperreal*."[7] This is the point of a crucial contradiction: What Lacan has termed the "resistance" of the real as that which is necessarily outside of and inaccessible to representation has been *reversed* by Baudrillard; here the concept of the real is completely *contingent upon* its reproduction, its existence superceded in the all-consuming logic of its double.

Although at one point he refers to the three terms in Lacan's schema—the symbolic, the imaginary and the real—and suggests the addition of a fourth term, the hyperreal,[8] what Baudrillard has really done is reduce these three elements to two. True to his model of "implosion," he actually collapses these terms together: the hyperreal can be understood

quite simply as *the symbolic mapped over the imaginary* in order to banish forever the unruly ghost of the real. Combining the representational force of both symbolic and imaginary structures, the digitally generated images of computer graphics exemplify the simulated pseudospace of the hyperreal, whose matrix swallows up any extralinguistic subtleties of the image by ordering it exclusively in the rigid terms of the binary code. This mutant mechanical hybrid, the hyperreal, is then played off against the real—an obvious setup since that real is weakened in advance in Baudrillard's theory by its shadowy linkage to the structuralist referent and its resultant impotence in the representational scheme of things. This attempt to fabricate an utterly synthetic and totalizing system which would rival, and ultimately replace, the terrifying fullness of the real itself reveals what Lacan claims the underlying stake of representation really is: the death of the real that it delimits.

My trouble with this model occurs when Baudrillard makes the assumption that the hyperreal has entirely accomplished this aim. As a woman, linked by the system of significations to that repressed other against which it is posed, I mistrust that totalizing logic which would also exclude *me*. For that which is "outside" the order *must* exist as a condition of that order's function, which becomes then the continual staging of its death. As Baudrillard himself would eventually have to admit, "even the most aggressive model must in principle fall short of its object," and he cannot quite elude that excluded force which waits unconvinced at the gates of his system.[9] As a friend once cynically suggested, perhaps Baudrillard will rediscover the real in the same way as Barthes: under the wheels of a moving truck. A fitting epitaph was supplied by one of the entries in the recent "Anti-Baudrillard Show" at White Columns in New York. On a kitsch poster of a lion cub frolicking in an obviously faked "natural" setting was the following caption: "I'm trying to hide from reality but somehow it always seems to find me."

Lacan and Baudrillard have both made a significant impact on what is known as "critical practice" in contemporary art. In the second Dia discussion Douglas Crimp mentioned the show "Difference: On Representation and Sexuality," held at the New Museum in winter 1984, which articulated a reading of Lacanian theory in the visual field, including excellent work by Mary Kelly, Barbara Kruger and Silvia Kolbowski, among others. Although the issues of sexuality and the spectator at stake in this show interest me a lot, I have problems with the way some artists have appropriated impressive-sounding arguments to legitimate their own reductive practice. The idea that a work of art would come

equipped with footnotes underlines the role this work assumes, often illustrating what functions as a master discourse like a book report in rebus form. Using text to discipline the image, this work reflects the sternly logocentric attitude evident in Rosalind Krauss's remark in the third Dia discussion: "whatever is critical, which is to say, non-Imaginary, nonspecular, in contemporary production." The imaginary can in fact be posed against the symbolic order, the domain of "critical distance," as the realm where immersion and fascination are the rule. As anyone who does a few laps in the image pool can attest, the image produces pleasure precisely where it fixes meaning least, and we can see in the phantasmatic structure of spectacle that polysemic plenitude that still bears a faint stain of the real.

Baudrillard's work is also popular with artists, and anyone can find his ideas reduced to absurdity in the degenerate jingles for the neo-geo art which proliferate with viral fury in the press. The notion of the hyperreal has focused on the hype, using the idea of implosion as a final eclipsing of the referent with the same savvy found in the marketing slogan "Don't sell the steak, sell the sizzle." However, this emptying of the sign in the process of simulation does *not* signal any possible restaging of the real; here "the real thing" could only mean Coca-Cola. As Baudrillard has pointed out, it is capital which feeds off this neutralization of meaning, and it is ironic that the commercially successful strategies of this group of artists were derived from a primarily Marxist analysis of the political economy of the sign. Rejecting the visually spartan format of photo and text found in the work of the "Difference" show, simulationists such as Ashley Bickerton, Jeff Koons, Haim Steinbach and Peter Halley indulge their specular consumer, presenting the art object in all its pristine splendor, unveiling the seductive dance of the ultimate fetish in the bright commercial spotlight of desire.

Resisting the dominance of either discourse or the object, certain artists have begun to articulate another set of tactics which attempt to unravel the order from the position of the other held within it, to undermine the barriers of distance and mastery which repress that difference they define. In this respect, the ideas that interest me the most have been developed in the time-based media of video and film by several artists who, probably *not* coincidentally, happen to be women. In her feature film-in-progress *Peggy and Fred in Hell*, Leslie Thornton traces the media's staging of a postsimulacrum subjectivity, emphasizing the disorienting spiral of technology in a disturbing chiaroscuro one could call

"science noir." In the mechanically reproduced printouts of her "Total Recall" series, and in the video shows *Dumping Core* and *Total Recall*, Gretchen Bender has developed a disjunctive style of image editing which deconstructs the synthetic plenitude of corporate spectacle, ripping open the hidden seams of the hyperreal. Finally, Trinh Minh-ha, who will participate in the next Dia discussion, raises the provocative question "Who is speaking?" in the supposedly neutral discourses of knowledge, allowing to emerge in her feature film *Reassemblage* the muted voices of color defined, in our own cultural interests, as "the other of the west."

I have tried to outline what I see as a crucial set of issues embedded in the assumptions of recent critical thought, and to describe in brief some of the more interesting attempts by artists to address these issues in their work. I hope that some of these ideas can be developed further in discussion, if not in this somewhat intimidating context, perhaps later, with a few friends, in a bar.

References

1. Jacques Lacan, *Écrits* (New York: Norton, 1977), p. ix.
2. Ibid., p. x
3. Ibid., p. 265.
4. Ibid., p. 105
5. Jean Baudrillard, *Simulations* (New York: Semiotext(e), 1983), p. 11.
6. Jean Baudrillard, *For a Critique of the Political Economy of the Sign* (St. Louis: Telos Press, 1981), p. 152.
7. Baudrillard, *Simulations*, p. 146.
8. Ibid., p. 157.
9. Baudrillard, *Political Economy of the Sign*, p. 26.

Legacies of Critical Practice in the 1980s

SILVIA KOLBOWSKI

I read aloud in first grade ... and heard the barest whisper with little squeaks come out of my throat. Louder, said the teacher, who scared the voice away again.... The other Chinese girls did not talk either, so I knew the silence had to do with being a Chinese girl. I could not understand "I." The Chinese "I" has seven strokes, intricacies. How could the American "I" ... have only three strokes, the middle so straight? Was it out of politeness that this writer left off strokes the way a Chinese has to write her own name small and crooked? No, it was not politeness; "I" is a capital and "you" is a lower case. I stared at that middle line and waited so long for its black center to resolve into tight strokes and dots that I forgot to pronounce it.

A remarkable peculiarity is that they [the English] *always write the personal pronoun "I" with a capital letter. May we not consider this Great I as an unintended proof how much an Englishman thinks his own consequence?*

You may be wondering why I have chosen to begin my statement by reading these two quotes. The first one is taken from *The Woman Warrior*, a book about the contradictions of growing up as a daughter of Chinese immigrants living in San Francisco, written by Maxine Hong Kingston. The second, the epigraph to Homi K. Bhabha's article "Signs Taken for Wonders" (*Critical Inquiry*, August 1985) on the "insignias of colonial authority ... desire and discipline," is written by Robert Southey, author, under the pseudonym of Manuel Alvarez Espriella, of a book called *Letters from England*. Writing in the early 19th century,

Southey, a liberal English man of letters, makes pretense to being a Spaniard writing on the customs of the English. Why have I chosen to speak the words of a Chinese-American woman and a 19th-century man impersonating a writer from a country with an extensive history of colonization commenting on another culture with a similar history? Neither one is an artist or an art critic or art historian. I have done this not in order to idealize non-western peoples whose cultures are significantly different from my own, or to use a historical quote for the purpose to which quotations are usually put: that is, in the service of evidence or confirmation, to confer authority seamlessly onto myself as speaker. Rather than use them to prove a point, I would like to use them to raise some speculative questions about the production of contemporary "critical" art and critical writing about art—practices that must deal with critical legacies.

I was originally drawn to these quotes as a way of beginning, and then floundered for a week trying to figure out whether they were acting as nothing more than an effective block. Rather than regard the choice as a false beginning, I tried to interpret my attraction symptomatically (after all, don't we often have love affairs with words?). I surmised that I liked the distance they afforded me—they were not quotations taken from specialized contemporary academic writing by white (more often than not, middle-class) writers on art and culture (like myself). That is, they were not borrowed from within the confines of the discipline. And I also derived a certain amount of pleasure from the somewhat undisciplined way in which I was bringing the words of a "marginalized" figure onto a panel restricted to white speakers, rather than leaving them to be confined within the next panel, which is specifically focused on the issue of "other peoples."

These thoughts regarding the relationship between me or "I" and the quotes gave me some idea that this beginning could prove to be a springboard. So as this statement is written in the spirit of an open-ended inquiry, you will have to bear with some of my inconsistencies and meanderings.

I want to interpret the "I" of the quotes as the signifier of the impartment of knowledge, the wielding of a kind of power.

What makes us aware of the different shifting levels of access to the position of the "I"? Of "our" presumptive and unspoken ease of access? I put "our" in quotes because you, as an audience, are differentiated by gender, race and distinctions other than those that can be ascertained by

sight, and therefore have relative stakes and ease in assuming the place of the "I" in relation to institutions and in relation to each other within these institutions.

There is a split between the humanist conception of the "I" and the post- or anti-humanist conception informed by structuralist and psycho-analytic theories. This is not a chronological distinction, for certainly both formulations exist today. The humanist self—centered, unified, fixed; the anti-humanist "I"—mutable, decentered, fractured and fractious. Instead of talking here about a psychical construction of subjec-tivity, a formulation that is not useless to the argument, I would like to take the argument beyond a metaphysics of identity. To simplify this pre-sentation I would like to define my interest here as something more like the acquisition of a place from which to speak, a place that is, in addition to other things, not disembodied, and embedded in historical determin-ations. As in the two opening quotes, the woman who pointedly forgets to pronounce it, and the imposter who inscribes a distance from colo-nization by questioning capitalization.

The psychical assumption of the "I" is a treacherous trajectory for all. But the "I" as it is connected to power, abstract or concrete, seems to be more readily available to some than to others. I find it particularly con-tradictory when critics or artists who do critical, political work do not seek to undermine—in fact, often avoid undermining—the positions of authority from which they themselves speak. Certain institutional dis-courses—such as phallocentric western logic, the rationality of academic or philosophical languages and concepts, the humanist politics of value—are unproblematically used to challenge the insularity and imperviousness of other institutions. For while it is important to directly point out, as some of the panelists in this series have, the conditions of spectacle and alienation and the various structures of presentation in which we are all participating here, few of the speakers have paid atten-tion to the very ideologies that inform their methods of presenting knowledge in order to challenge knowledge. All methodologies are his-torically determined—yet if we do not consider an *approach* to be an institution how can we put it into question?

In the third Dia discussion Benjamin Buchloh asked Michael Fried how, at the time of his writing "Art and Objecthood," he could so willfully have ignored the evidence against his position. Fried replied by accusing Benjamin of sounding positivist, but was unable to articulate a further

response. I found myself wondering whether what he was trying to say to Benjamin was that he, Benjamin, was challenging him within the confines of his, Fried's, own terms of address. I thought that one reason for Fried being dumbstruck was the tautological structure of the exchange, a closed circle which precluded *exchange* on any other level. This interaction stood out in relief because it seemed to highlight what was for me a conflict in Benjamin's very significant presentation. The conflict lies in challenging the institutional role of the critic, as Benjamin did, without questioning the philosophical postures which have historically given, and at present give, the critic a voice—some of these postures being the economies of western masculinist logic, the privileging of Fact and Knowledge, Origin and End. In other words, the critic speaks, but what, in addition to concretely definable institutions such as the university, the philanthropic organization and the publishing industry, allows her or him to assume an authoritative place from which to speak, to redefine? Again, I do not want to belittle Benjamin's contribution to the discussion; I simply wonder what that contribution might have been like if the contradictions of speaking as an authority against authority were brought to light.

Similarly, when Douglas Crimp spoke in the second discussion, I wondered why, even though I agreed with almost all of what he said, I should feel so chastised (even if I do qualify my reaction by acknowledging that I was an exhibitor in the "stunning failure" of the "Difference" show at the New Museum). For although I support the demands for accountability to a largely ignored homosexual spectator or reader, I found these demands difficult to reconcile with the authoritative voice of the father, with an unquestioned relation to academia and the voice of judgment. For me the chastising voice maintains the illusion of speaking from outside the margins of institutions. Can one thus prise content apart from form? Are there stakes in using language as though it were simply a vehicle for communication? And who are kept in their place through this pedagogical fiction?

In a comparable way some art which intends a critical or transgressive position remains blind to the way that transgression is articulated. If conservative work silently reinforces the existing social relations, then some dissenting work posits a correction, a didactic cure to the ills of those relations. In the former case the viewer is placed in the position of the child who is praised and rewarded for being in her proper place; in the latter she is corrected and thus positioned in a new proper place. There

seems to be no place made for the viewer to doubt the centered sources of legitimation, to question who is speaking and the stakes of particular articulations. And by assuming the voice of authority and prescription, the critical artist or writer risks producing as viewer or reader the rebellious child who no longer wants to listen, or an audience that must think about resistance in conventional terms. In both cases—reward for conservatism or punishment and reeducation—the outcome, the cure, is a condition preformulated from the start. On the other hand, a production which makes pretense to the radicality of an infinite availability of readings, a sublime generality, risks drowning the spectator/reader in a sea of indeterminate sensations.

So although we artists and writers on art may subscribe to the idea of an anti-humanist subject, we still seem to be holding on to the fiction of a fully unified position of enunciation: a stance that impedes the emergence of fissures that bring about change.

But what stance have I taken now, what voice have I assumed here? For this text itself has lapsed into teleological argument. As I lose my voice to a more historically determined approach, where does that place you?

We also have to ask whether the stakes of those who are unempowered are such that they would find it strategically difficult to relinquish the unified "I" identified with power in their struggle to forge a voice. For clearly the "I"s have it. I hope this is taken in the spirit of a critique, because it is certainly not my intention to undermine the efforts of critical artists and writers or to place my own work outside the parameters of this problematic.

At the risk of making some additional pronouncements and running counter to my attempt to remain within the realm of inquiry, I would like to raise a few more points. Because of the title of this discussion, "The Legacies of Critical Practice in the 1980s," I spent some time reading on and around Dan Graham's work in the context of exhibition catalogs, monographs and criticism—a process I found illuminating for several reasons. The main reason is that it encouraged me to do something which, as someone who continuously shifts between being a writer on art and an artist, I find to be very difficult: to develop an overview of either discipline. While clearly this is something that cannot be accomplished in one week, I did isolate a theme that seemed to play a significant role in minimalism, pop and conceptual art: the position of the artist within each type of production. (And here I am rather glibly accepting

the very notion of categorization by definitions of style as employed by art history.) Last week Rosalind Krauss pointed to the limits of the spectator produced or assumed by minimalism, the masculine spectator. One could take this further and say: the white, moneyed, heterosexual, masculine spectator assumed by pop, minimalism and some but not all conceptual art—assumed by default, that is. But I would like to turn and look back the other way—at the artist as inscribed within the work— and ask how this inscription also produces a particularized spectator.

The "I"s that I found were either effaced, as in pop and minimalism, or present in excess, as with the phenomenological "I" of much '70s conceptualism, including performance, where the artist inscribes the "I" as though it could be contained, made clear by description, and in a sense also effaced because unparticularized. What sort of spectator does this create? Is the spectator able to discern her or his difference in relation to the address? Is that difference to be experienced only as a lack?

Beginning attempts to inscribe the producer of the written or visual or performed text have been taken. Not solely by registering the individualized "I" of autobiography, but by taking up the challenge of an inscription which would question the social coding of the place of enunciation and the sort of reader/viewer this produces. Not the artist or writer who steps outside the system to comment on it, but the possibility of staging a critique directed outward, which also refracts back onto the place of the "I" as this structures a "you." Not a search for an "I" that is a perfect fit, but an inquiry into the ways it is organized and formed, an inquiry into the ways its order is desired.

Legacies are bequeathed, but surely we can adopt stances other than those of the arbitrary nihilism of iconoclasts or the passivity of inheritors.

Legacies of Critical Practice in the 1980s

DISCUSSION

DAN GRAHAM: I'm always struck by how absolutely different the New York art world is from the world of European culture—or from other places in the U.S. In other words, this is a very parochial situation, and despite our talk about artist/writers there are many who have been forgotten and left out. It might be good to keep those others in mind—if only to shake up our own discourse.

MODERATOR (HAL FOSTER): Dan, I wonder if you want to respond to the charge that Silvia made about the construction of the subject in minimalism and conceptualism—that this subject is not differentiated.

D. G.: Well, my work at the time was about how the phenomenological model that minimalism took up was a failure, about how the phenomenological "I" had been questioned and eroded elsewhere in culture. In art this goes back at least as far as Jasper Johns, who showed the erosion of his "I" in terms of the subliminal influence of advertising and media images.[1]

SILVIA KOLBOWSKI: I wasn't talking about an erosion of the "I"; I was talking about the ways in which the "I" is encoded and inscribed—or the ways in which its inscription is suppressed, and how that suppression affects the construction of both the work and the spectator. My point was that there's a very strong effacement of the position of the "I" both in the production of art and in critical and historical writing.

D. G.: I think that's a misreading of minimalist and conceptual art. The "I" projected by minimalism is like Samuel Beckett's "I"—an "I" invaded, subliminally disintegrated, by mass advertising and corporate clichés.

People like Robert Smithson thought this art got rid of anthropocentrism, but that was not my experience. In "Subject Matter" (written in 1969 and included in my Einhoven exhibition catalog "Articles") I saw minimalsm as a crisis in the subjectivity of the spectator—of his or her consciousness in relation to the intention of the artist. That often became the "content" of the work. Below this content was another ostensive content, of which the relation to the gallery structure was emblematic: the relation of the work to the city and its housing. The work of both Flavin and Judd alludes to architecture and mass architectural containerization, and I read it as both constructivist and expressionist in feeling.

AUDIENCE: Dan and Aimee, how do you propose memory to be used as a revolutionary force? Aimee, you point to some prelinguistic realm of the real which has the status of an origin and is not affected by difference—but theorists like Derrida would say that's impossible.

AIMEE RANKIN: Well, it's only impossible once we enter the system of signification, and this process, which Mary Kelly has recorded in her work, is hardly a simple procedure. I'm not arguing for some return to infancy; I'm interested in the schizophrenic aspects of postmodern culture—which Fredric Jameson has seen not only negatively as a breakdown in the signifying chain but also positively as an experience of hallucinatory brilliance, an iridescent flow of images. The mass media, for example, tries to get at a kind of subliminal memory trace, a kind of phantasmatic plenitude that we can only construct after the fact.

AUDIENCE: More specifically my question was: How do you propose that such memories be employed in a political or discursive way?

A. R.: There's no way to apply them directly. As subjects we retain a sense of loss that goes back to those memories and that colors our relations to discourse with ambivalence.

S. K.: Aimee, I'm curious: Would you say that you try to create a phantasmatic plenitude in your own work? Visually?

A. R.: No, I'm dealing with the *loss* of that plenitude; I don't believe one can recreate it. I'm not trying to get back to the real as such. But I am trying to make a space for reverie, about its loss.

HAL FOSTER: Aimee, I was struck by a point of contact between your statement and Dan's. You use a Lacanian model; he referred to Ben-

jamin—but you both talked about a strategy that would deploy the imaginary against the symbolic. You gave a few examples of what you meant; maybe your own work is an example. My question is for Dan: In your statement you talk about a recovery of the "just-past," and you refer to dreams and childhood . . .

D. G.: My work isn't programmatically about dreams or fairy tales per se; that's what Benjamin's arcades writings were partly about. He attempted to bring the subliminal fixation of the spectactor of film, the dream state produced by the newness of the commodity, surrealism, Freud—all this together with his idea of historical memory. I bring in Benjamin instead of Lacan and Baudrillard in order to suggest an historical, maybe contradictory, way to see our crisis; as (post)structuralists Lacan and Baudrillard seem to float academically in an ahistorical limbo. But I too like to juxtapose people or social groups that don't quite fit, whether it is "President Eisenhower and the Hippies" (in my 1967 article of that title) or Julia Kristeva and Ari Up (of the Slits) or Lydia Lunch (as in my article "New Wave/Feminism," commissioned by *Screen* but rejected for my "misuse" of Kristeva's "semiotic chora").[2] I think that's the only way for an artist to work through theory.

S. K.: How recent is the just-past?

D. G.: Well, for Benjamin it's the last newness before the current newness. In America it seems to come in decades: back to the future, back to the past. For example, when people were drawn to the plenitude of the '50s they jumped over the '60s—jumped over the actual struggle between those periods. I discovered this when I did my videotape "Rock My Religion" and noticed people's interest in the '60s. (My view, by the way, is very negative on the '60s.)

AUDIENCE (BARBARA KRUGER): I'm not sure this is a question, but I'm interested in these words "plenitude" and "open inquiry." I think of Trinh Minh-ha and her persistence in questioning the notion of conflict, the concept of challenge, the idea of hierarchical address—in really encouraging the idea of plenitude and open inquiry. On the one hand, where are those things found if not in the furtherance of one's own desire and in the tolerance of others'? On the other hand, how can we use the discursive space of authoritarian fathers and not be appropriated by their presence? How can we encourage work which is not exemplary but merely different?

A. R.: I'm trying to understand how those spaces or structures come about and what they really mean . . .

BARBARA KRUGER: And not to reenact them.

A. R.: I don't know if we have that choice—but our reenactment can be inflected by an awareness of the stakes of their construction.

AUDIENCE (DOUGLAS CRIMP): Silvia, I feel compelled to respond to your paper. It's very complicated to respond because I don't really recognize "the voice of the father" in what I said two weeks ago—certainly not my father. To clarify my position I need to talk about the response to my statement. There was very little response at the time, but what I heard afterward reflected the general feeling that when a gay person speaks from an explicitly gay position it is taken to be a confessional speech. That's always a risk (in fact it's something I wrote about five years ago in an essay about Fassbinder); and that, it seems to me, was turned against me. On the one hand, what I did was considered confessional; on the other hand, it was treated as a polemic—a polemic based on a kind of personal affront that was part of my confessional speech. Now it doesn't seem to me I was doing that at all. I was talking about issues of the gay community. That is why I assumed, at the moment, the position of a subject unified around being gay. In order to claim a political stake I think one has to assume that kind of position at certain moments. Whatever the rhetoric or theory, if I want to claim there are very great stakes in relation, for example, to the oppression of gay people because of AIDS, I have to assume the risk that this will be misread: A) as confessional and B) as polemical.

S. K.: I didn't read your presentation as either purely confessional or polemical; as a matter of fact I'm not sure I would look negatively on either. I think what you said was very important, but you didn't question the discourses you used in making your accusations. I'm not saying one can't speak with conviction or one can't be accusatory. I'm saying one has to take into account the discourses one employs, and there was nothing in your presentation that really acknowledged your position as critic and historian. What I heard throughout the presentation was the voice of the father—not a literal father but academia as the father.

DOUGLAS CRIMP: I know you don't mean a literal father. But I'm not sure that the voice of the father is called into play in my or any discussion of gay politics.

S. K.: One can speak in the voice of the father and say almost anything—or maybe everything.

DOUGLAS CRIMP: Given your claim that I made certain accusations, can you repeat one?

S. K.: Aside from not questioning the discourses you employed, your points weren't raised in the spirit of inquiry or in the questioning of certain givens. For example, you used a lot of quotes to bolster your argument, and you never once questioned what it meant to use such quotes—from artists, filmmakers, academics . . .

DOUGLAS CRIMP: There were two quotations, both from gay people.

S. K.: It was not clear to me as part of the audience that they were solely from gay people; and besides, I'm not sure I agree that being gay completely undermines the positions of authority that many of them also fill. I don't think that being gay is enough to undermine certain constructs of authority.

DOUGLAS CRIMP: Of course it's not . . . But Pasolini—whom I did quote—devoted his entire life to questioning authority: the authority of the church, of the family, of the Italian state, of the Communist Party. And he was vilified by all of them. He was literally on trial for most of his adult life. So to construct Pasolini in turn as authority is a very strange thing to do.

S. K.: I can't recall your exact quotes, but my general feeling was that your argument was not presented in the spirit of an open-ended or self-questioning inquiry—it was presented as a kind of watertight accusation. You did recognize the conflicts within the gay community—it was not watertight in terms of saying "This is the gay position." Nevertheless, your voice was an unquestioning voice.

AUDIENCE (ROSALYN DEUTSCHE): I disagree. One of the central themes of Douglas's talk was the questioning of the construction of Hans Haacke as an exemplary political artist—which is something Douglas himself was involved in. So there was a questioning.

S. K.: What, in his presentation, would make us question Douglas's authority?

AUDIENCE (WILLIAM OLANDER): As a matter of fact I thought his presentation was quite similar to yours, with the exception of the reflec-

tion about the "I" at the beginning—that it too was in the form of questions.

S. K.: Maybe other people can also comment.

AUDIENCE (ABIGAIL SOLOMON-GODEAU): Silvia, given your preconditions, there's a question whether it's possible to speak at all. Your statement problematized first-person address and acknowledged that this is a position that is assumed. But when the first-person voice is made problematic from one side or the other, it becomes virtually impossible to produce political speech at all, much less to define political stakes.

S. K.: I don't think it precludes speaking; it's about producing a different kind of political speech. There are definitely different levels of access to the position of the "I"—that was the point of my talk. I started out with a quote from a woman—a Third World woman—in a position of aphasia, in which there is a recognition of the difficulty of speaking the "I" at all. But I don't think that difficulty precludes political address; I'm just calling for a different kind of political speech.

ABIGAIL SOLOMON-GODEAU: Could you be more specific about the nature of this political discourse?

S. K.: I don't know for certain, but it's not a self-righteous one. More often than not what is typified as political discourse comes from the myth of a center which is unselfquestioning and unselfconscious.

DOUGLAS CRIMP: Could you tell us, Silvia, how you viewed the recent series on television about the black civil rights movement in the south in the late '50s and early '60s ["Eyes on the Prize"]? What about this movement as an articulation of political discourse?

S. K.: Nothing whatsoever in my talk precluded political activism; I'm not sure why you're interpreting it that way. I'm calling for a difference in the way one articulates such action and for a recognition that one often speaks from a position of power even in challenging power. Without that difference, without that recognition, the spectator or addressee is placed in a passive position.

AUDIENCE (CRAIG OWENS): One of the things I also heard in your talk is the necessity not to accept certain unified "I"s, the necessity to deconstruct notions of identity or the places from which we speak as given to us institutionally. Now the identity of the gay man is an institutionally prescribed position—it is largely constructed by medical

and legal discourses. And one has to question that position when one want to address issues as a gay man—that's what I heard in your talk. Otherwise it becomes a self-referential discourse—to say who I am before I speak. That's also why it tends to be perceived as "coming out" when one doesn't question that identity.

DOUGLAS CRIMP: How does one take an action without assuming an identity?

S. K.: I wasn't suggesting that one not assume an identity. In my talk I questioned whether the unempowered mustn't sometimes attempt to construct unified positions of power. I'm also not calling for a disintegration of the "I." But I agree with Craig that one can't just say "I am this." Instead one could say "Perhaps I am constructed this way" or "I assume this position" or "This position is created for me—and I have to question that position as I speak."

AUDIENCE (MARGARET MORGAN): I felt a certain ambivalence, Douglas, when you talked with the assured voice of the gay man, but more so and more to my chagrin, given this privileged audience, when Barbara Kruger two weeks ago held up her working-class credentials. There seem to be certain views about gayness and working-classness that we're not allowed to transgress. It becomes easy to say "I am like this, so this is what I do."

BARBARA KRUGER: What I said was said not in terms of a class reference but in terms of the structure of the market.

MARGARET MORGAN: I took your point. I just didn't think it was necessary to wear your own badge.

BARBARA KRUGER: Well, variety is the spice of life.

MARGARET MORGAN: I felt foreclosure not variety, and I felt the same foreclosure when Douglas suggested that a particular stake can only be a stake for a particular group. Does that mean I can't speak on his behalf?

AUDIENCE (GREGG BORDOWITZ): It seems to me that strategies for calling into question idealist presuppositions of the subject—as in minimalist or conceptual art—have in turn been called into question. I think of Yvonne Rainer saying she only talks about the personal insofar as it exemplifies social relations—that was one strategy of pointing to the various positions that subjects occupy as social beings. I also think of

Martha Rosler's strategies of questioning idealist subjectivity, and her discourse developed counter to conceptual art.

AUDIENCE (KRZYZSTOF WODICZKO): Why not use all of those strategies? When one has a position of power, maybe that's the moment to question that power; when one does not, maybe then one has the right to speak the word "I." Douglas might speak sometimes from the point of view of the academic professor, but he also might speak as a person whose role is to scream or to use, as Derrida says, bad language.

HAL FOSTER: I wonder, though, what the politics of this plurality of voices would be. In a way this gets us back to the first discussion—the opposition between balkanized audiences and imaginary public.

WILLIAM OLANDER: Silvia, how can you accuse Douglas of assuming the voice of the father when he is trying to challenge institutionalized structures based on that discourse?

S. K.: He is associated with *October*; he has a role that is recognized in the art world . . .

WILLIAM OLANDER: But to characterize the issues which he addresses as "academic" is extraordinary!

S. K.: In no way did I say he was not challenging certain structures. In fact, I acknowledged that he was and that I supported that challenge. My point was that he did not include within that challenge a challenge to his own authority. And I agree with Craig: He was not questioning what constructed him as a gay man. There's a danger in attempting to separate form and content.

DOUGLAS CRIMP: Would you characterize the gist of my speech as "academic"?

S. K.: Yes, in the sense that you didn't question your position except to say "I am a gay man, this is my identity"—I would call that academic to a certain degree. It's aligned with certain philosophical discourses very often employed by academics.

HAL FOSTER: There's obviously a personal difference here, but there's also an important strategic difference—between, on one hand, a deconstruction of discursive positions in the abstract and, on the other hand, work within institutions in order to change them directly and materially. That opposition is too blunt, too simplistic, if posed in these terms . . .

CRAIG OWENS: It is also the mutual exclusiveness of those two things that is in question.

HAL FOSTER: Right.

CRAIG OWENS: That's exactly what Silvia's text was about: that one can't speak as an activist without such questioning.

HAL FOSTER: But it seemed to me that Silvia suggested there was a space outside institutions where one might question discursive "I"s, and I don't know what that space might be.

S. K.: I think I inscribed myself within my presentation in several ways.

DOUGLAS CRIMP: I don't want this to come back to the same thing, but I need to clarify what I said. The motive behind it was that I felt the art world is floating on discourse. For example, in the first discussion, I couldn't tell what anyone's stakes were. What are the stakes, for example, of deconstructive discourse? It seems to me that the stakes of deconstruction have largely been lost in its transportation to the United States. That's why I wanted to be concrete—to talk about a specific show, "Homo Video" at the New Museum, and a specific audience, the gay community. It was an attempt to make concrete and specific one possible political stake—and that keeps getting lost. What are the real political stakes of people in the art world right now?

S. K.: I fully appreciate the fact that you did bring up those stakes in this series. I feel very strongly about that. But I still find it problematic that you could bring up those stakes and yet not question the position from which you spoke—as if to identify yourself in a single phrase was enough. For me the stakes of such questioning are as great as any other; so too the stakes of maintaining the fiction of a voice that speaks from a position of authority—outside—are as great as any other.

D. G.: In an American context always criticizing one's own position is very puritanical—and self-righteous.

HAL FOSTER: What is the alternative to this self-questioning?

D. G.: I was simply bringing up a cultural reference—we're Americans. There are no European artist/writers up here, though we constantly bring in translated quotes from European theorists (often removed from their historical, cultural contexts). Conceptual art is heir to intellectual puritanism (opposed, in the cultural cliché, to the material and sensuous

but corrupt gallery / market art commodity). And one of the forms that
an imported deconstruction takes on is puritanical—I mean a self-refer-
ential questioning of motives and positions, an endless, tautological
examination of self-consciousness and conscience. This idea of the cor-
rect "position," politically speaking, of the "correct" I.

S. K.: I think you're speaking in different terms than I am. What I have in
mind is not puritanical in the least.

D. G.: I'm not negative about puritanism. Self-questioning is what we're
doing now—not only Silvia, everybody. All the questions are about that.
But there's a certain circularity here.

BARBARA KRUGER: To me puritanism is about a desire to pull every-
thing back to one thing: to say "This is not historically grounded, not
politically correct, not properly footnoted ... but that is exemplary."
Puritanism reduces things to a univocal voiceover or dictation of fact.
Why not allow for a number of different voices, a number of different
positions—a horizontal rather than a vertical, hierarchical structure?

S. K.: Voices and positions that might question each other as well.

BARBARA KRUGER: Exactly.

AUDIENCE (JANE WEINSTOCK): Aimee, I was confused by your talk,
especially as it relates to the question of some kind of exemplary practice
in the real, and how that relates to the imaginary ...

A. R.: I know of no such practice in the real, but I think a lot of work
today gets caught up in its own tactics in a way that has backfired. For
me the work in the "Difference" show used Lacanian theory as a kind of
master discourse, as a way of authorizing its own investigation. That to
me is a problem—the kind of repressive attitude towards the image that
came from a late '70s scorched-earth policy in feminist criticism (as in
Laura Mulvey's "Visual Pleasure and Narrative Cinema," where she calls
for "the destruction of pleasure as a radical weapon"). American prac-
tices—minimalism, conceptual art—also had this attitude toward the
image: to interrupt its seductive qualities or distance the spectator. This
is an interesting project, but it often uses language in order to sidestep
the question of how images work—by discussing desire at arm's length
rather than dealing with it in material terms.

Then there's this work related to Baudrillard that emphasizes the
object in a very fetishistic way, that is more about commerce than desire

(exchange in Baudrillard's theory takes the place of desire in Lacan's theory). I would like my own work to fall closer to the third group I mentioned in my paper, but I think it's less complex than theirs because it isn't time-based. I'm interested in questioning suspect structures of spectatorship in imagistic representation through a kind of critical play that's not about a distanced form of mastery but rather about a critical immersion—where one is working within a system of representations and yet trying to deal with what flows through the cracks of that system. This is where the time-based work picks up and goes much further.

JANE WEINSTOCK: You're setting up a hierarchy and reducing a multiplicity to single lines. In the "Difference" show there was certainly a lot of different work on the image and work on the text: to reduce all of it to a pleasureless, scorched-earth policy is extreme.

HAL FOSTER: Also, Aimee, work that you see as simply a replication of theory is often more a questioning of theory—or an extending of theory.

A. R.: I don't mean to question that. Mary Kelly's work is very important for the way it puts the theoretical articulation of the construction of subjectivity in conflict with her own personal narration with all its different layers and voices. She not only appropriates certain discourses but furthers them in her own practice. I was talking about the tendency in other related work not to question language to the same degree that it questions the image. I didn't mean to sound so negative about the work I mentioned.

AUDIENCE (DENNIS THOMAS): Aimee, in your statement you suggested that the prelinguistic is somehow liberatory. I don't see it.

A. R.: No, not liberatory. But the repression of that prelinguistic state, which occurs in the construction of subjectivity, will always load it with a particular kind of nostalgia or sense of loss. I don't think there's any way to get back to this mythic origin of subjectivity, but one might imagine it as yet unformed in a way that might help one see that subjectivity is constructed at very high cost.

Afterwords

DAN GRAHAM (REFERENCES): 1. The essential truth about art of the last thirty-five years, continually erased from consciousness by the ide-

ology of internationalist liberalism, is that fascism didn't die with the cessation of World War II, to be replaced by avant-garde progressive art, but remains the repressed collective unconscious of the present. New techniques of mass psychological or product representation (swastika, national flag, corporation logo) replaced traditional forms of representation in Nazi propaganda and spread to postwar corporate advertising...

In the Cold War advertising merged with patriotism; the subjective desires of the consumer were enlisted by the ad, coercing him/her to consume more goods "for a better life." As the product became inseparable from the advertising image, the corporate trademark, like Coca-Cola, functioned as a psychologically all-pervasive archetype. Advertising techniques merged with those of large-format color photography and film, placing the spectator in a new relation to the overpowering voyeuristic image which, as Laura Mulvey observes in "Visual Pleasure and Narrative Cinema," produced "the alienated subject, torn in his imaginary memory by a sense of loss, by the terror of potential lack in phantasy."

The irony is that at the same moment that abstract expressionism was evolving its oversized, abstractly subjective painting, advertising forms also made a shift toward the oversized billboard, use of the color photograph, the wide-screen film and the picture magazine format (*Life*, *Look*) which plunged the viewer inside the giant images. Like the viewer of an abstract expressionist painting, the viewer of the new publicity form inserted him/herself into a psychologically ambiguous space where the absence of objectively signifying meaning allowed the unconscious self to project a "personal" meaning.... Although the artist still believed that the meaning of his work was determined solely by his uncompromised subjective intuition, market and media forces were giving the work a different meaning—one beyond the artist's control.

Jasper Johns was the first American artist to fully understand that the newly subjectivized advertising icon and the gestures of the abstract expressionist painting (which struggled against the cultural domination of these new forms) were virtually identical. Because Johns's work (and psyche) takes a passive position relative to these phenomena (the opposite of abstract expressionism's active struggle), the advertising/propaganda icon which invades the unconscious, private space of the individual is experienced as unmediated. Johns's work directly confronts the loss of an undivided self to the totalitarianism of mechanical reproduction and a publicity form become all-pervasive, determining

both popular and fine art forms and meaning. This is the unconscious core "truth" which it is liberalism's ideological task to keep concealed. (Adapted from "The End of Liberalism," *ZG* 2, 1981.)

2. Kristeva equates the prelinguistic realm of primary drives and feelings with the time when the child identified with the mother—before the fixed, social, "stable" ego necessitated by symbolic language and produced by the castration complex had forced conscious denial of these primary drives. The movements of the chora are not between positions of the speaking ego, as in rational discourse, but between the fragmented zones of the body, expressed in heterogeneous gestures and feelings—especially in vocal intonations like "the babbling of a child or musical rhythms." In music the feminine is to be found within the vocal expression more than the overtly comprehensible lyrics and melody. Examples can be found in the songs of the Swiss all-female group Kleenex (e.g., the sibilant insertions in "U"), of the Raincoats (e.g., the polyphonic counterpoint in "In Love"), and especially in the music of Lydia Lunch. . . . As the order of social speech is dependent upon the construction of a singular, unified identity for the individual subject, it must deny the shifting and heterogeneous impulses and feelings of the body reflected in Kristeva's "semiotic chora." An art which is "plurivocal . . . heterogeneous [and] polymorphous" can liberate the level of the "chora" and "create a place where the social code is destroyed." (Adapted from *Live* magazine.)

AIMEE RANKIN: I haven't heard so much talk about positions since the last time I played "Twister." To speak, as we have seen, is to assume a certain position. If we call for "a number of voices and positions that might question each other," as Barbara and Silvia agree to do, we are still left with the sticky question of the position one assumes in asking questions. It all goes to show how easy it is to get lost in the labyrinth of language. If, as has been suggested and as I truly hope, the system of logic which models our thinking process is showing signs of wear, soon we might be able to assume whatever positions we wish in an exuberant orgy of mental gymnastics that would freely encourage a fluid interchange of meaning. Until that time, we operate within our broken logic in the only way we know: by tracing patterns on an axis of similarity and difference and trying to make sense of the mosaic. For me, coming to terms with the artistic practices that inspire me posed this challenge. To become aware of one's own position one must situate oneself and others in some way. To question positionality can become the most rigid posi-

tion of all by pointing an accusing finger at the awkwardness of others. Like everything else, this makes me think of sex. Somebody's got to assume a position sooner or later or nothing will get done. It doesn't matter who's on top as long as it feels good. Sometimes discourse fucks me nicely and I don't begrudge myself this pleasure. Sometime I like to use it to fuck it back—discourse as a sort of strap-on prosthetic dick. I like being able to play in more than one position.

In the end it all boils down to power. How do we fight the dynamic of power since in fighting it we place ourselves within it? Rather than avoiding confrontation, which would eliminate the pleasurable rubbing of one idea against another to see what sparks fly, I would suggest a refusal of the stakes. This is why we should never take this discursive game or our places within it too seriously. Whatever happened to that old '70s idea, "the revolutionary power of women's laughter"? Who would want a revolution that didn't allow for dancing in the first place? And what could make the overswollen dick of culture shrivel faster than a woman's well-timed laughter? The sadness of our predicament is so absurd that in the end all one can do is laugh, and encourage the illicit copulations of language to be more and more perverse, more fluid and slick and polymorphous. And then the dancing can begin.

SILVIA KOLBOWSKI: Access, and fictions of access . . . to an "I." Perhaps the most fictitious is the notion of a directly assumable access. And yet the effacement of the difficulty involved is a commonplace. Do we (I/you/they/who?) not need to question the historical legacies of these fictions, these effacements?

Sometimes needing to enact a fiction as though it were not one . . . as a strategic prop. And at other times questioning whether challenging the transparency of the structures surrounding and producing political address is expendable, deferable . . . in a call for change. Might not certain small-scale audiences be seen as a field on which to attempt to create new ground, on several different levels, even in a period of heightened political conservatism? Or precisely because of such a period?

The creation of political models—their perfection—and the perfecting of them: these are processes needful of institutions. Not just the institutions of critical journal or museum, but the elusive—because too familiar—institutions of philosophical discourses. Discourses that reinforce the role of the model—to deny access, yet generate the desire for perfectibility. Perhaps in response we could question . . . not only what is offered to us, but the very politics of articulation—suppressed—of that offering.

THE POLITICS OF REPRESENTATIONS

Of Other Peoples:
Beyond the "Salvage" Paradigm"

JAMES CLIFFORD

The subtitle of this discussion, "Beyond the Salvage Paradigm," may seem cryptic, though to some it will recall early 20th-century anthropology, the "salvage ethnography" of Franz Boas's generation—A. L. Kroeber and his Berkeley colleagues recording the languages and lore of "disappearing" California Indians, or Bronislaw Malinowski suggesting that authentic Trobriand Island culture (saved in his texts) was not long for this earth. In academic anthropology "the salvage paradigm" has an old-fashioned ring. Nevertheless, many ethnographies and travel accounts continue to be written in the style of *après moi le déluge*, with the exotic culture in question inevitably undergoing "fatal" changes. We still regularly encounter "the last traditional Indian beadworker" or the last "stone age people" (though the discovery of the Tasaday, front-page news ten years ago, is now revealed to have been a staged media event). The salvage paradigm, reflecting a desire to rescue "authenticity" out of destructive historical change, is alive and well. It is found not only in ethnographic writing but also in the connoisseurships and collections of the art world and in a range of familiar nostalgias.

In short, the term names a geopolitical, historical paradigm that has organized western practices of "art- and culture-collecting." Seen in this light, it denotes a pervasive ideological complex. I'll sketch some of the paradigm's underlying conceptions of *history* and *authenticity*—conceptions that need to be cleared away if we are to account for the multiple *histories* and *inventions* at work in the late 20th century. What's at issue is a particular global arrangement of time and space.

TIME/space. Our dominant temporal sense is historical, assumed to be linear and nonrepeatable. There is no going back, no return, at least

in the realm of the real. Endless imaginary redemptions (religious, pastoral, retro/nostalgic) are produced; archives, museums and collections preserve (construct) an authentic past; a selective domain of value is maintained—all in a present relentlessly careening forward.

SPACE/time. A dominant "theater of memory" organizing the world's diversities and destinies has been described in Johannes Fabian's *Time and the Other: How Anthropology Makes its Object* (1984). Put schematically, in the global vision of 19th-century evolutionism, societies were ordered in linear sequence (the standard progression from savage to barbarian to civilized, with various, now arcane, complications). In the 20th century, relativist anthropology—our current "common sense"—emerged, and human differences were redistributed as separate, functioning "cultures." The most "primitive" or "tribal" groups (the bottom rungs of the evolutionary ladder) could then be given a special, ambiguous temporal status: call it the "ethnographic present."

In western taxonomy and memory the various non-western "ethnographic presents" are actually pasts. They represent culturally distinct times ("traditions") always about to undergo the impact of disruptive changes associated with the influence of trade, media, missionaries, commodities, ethnographers, tourists, the exotic art market, the "world system," etc. A relatively recent period of authenticity is repeatedly followed by a deluge of corruption, transformation, modernization. This historical scenario, replayed with local variations, generally falls within the "pastoral" structure anatomized by Raymond Williams in *The Country and the City* (1973). A "good country" is perpetually ruined and lamented by each successive period, producing an unbroken chain of losses leading back ultimately to . . . Eden.

In a salvage/pastoral setup most non-western peoples are marginal to the advancing world system. Authenticity in culture or art exists just prior to the present—but not so distant or eroded as to make collection or salvage impossible. Marginal, non-western groups constantly (as the saying goes) enter the modern world. And whether this entry is celebrated or lamented, the price is always this: local, distinctive paths through modernity vanish. These historicities are swept up in a destiny dominated by the capitalist west and by various technologically advanced socialisms. What's *different* about peoples seen to be moving out of "tradition" into "the modern world" remains tied to inherited structures that either resist or yield to the new but cannot *produce* it.

In a moment I'll mention some recent challenges to this global historical arrangement, challenges coming from within anthropological discourse and from the local cultural-political initiatives of non-western peoples. But first I want to give a concrete example, close to home, of the salvage paradigm in action.

My example is the exhibition "Art of the Sepik River," organized by the Tribal Art Center of Basel, Switzerland, and presented in spring 1987 at the IBM Gallery of Science and Art in New York City. Much could be said about the exhibition and the superb artifacts it brought together, but I'll be content with a few quick observations locating the exhibition within the set of "art- and culture-collecting" practices I'm concerned to question.

The dominant presentation was aesthetic: Objects were isolated and lit in ways that emphasized their formal properties. A faint Muzak of voices, chants and flutes added a "tribal" ambiance but did not challenge the hegemony of the sense of vision. No evidence was permitted to compete with the aesthetic context; for example, the sole photography (black and white) of the Sepik milieu was highly enlarged and stylized: bodies, a canoe, silhouettes on a river. "Realistic" photos of objects *in use* would disrupt the "tribal art" context. (Sharp color photos, particularly, tend to break the mood, for they are coded as "actual," "real," whereas black-and-white, sepia or grainy images suggest the "past," atmospheric memory or "imagination.")

At the IBM Gallery the objects tended to be vaguely located in a time period—late 19th to early 20th century—which defines the "ethnographic present" for most authentic "tribal art." (See, for example, the Metropolitan Museum's Rockefeller Wing collection.) Moreover, the show's commentary made clear that Sepik artifacts collected as late as the 1960s were then already *old* objects. There was no inclusion or mention of any recent Sepik work, despite the region's very intense ongoing production and trade. (Presumably such work falls under the general rubric of "tourist art.") Within the show the manifest impact of new materials and influences was passed over in silence. A blue shield, breaking with the otherwise dominant color schemes of red, white and gray, made use of newly available paints; but there was no commentary on this innovation, and the shield remained an anomaly.

The history of collecting was not included in the presentation. While the names of individual collectors were sometimes provided, the circumstances, priorities, funding, institutional and political contexts for the

objects' physical move from New Guinea to Switzerland to New York were deemed irrelevant to their presentation as "tribal art." In their salvaged, aesthetic-ethnographic status they exist outside such mundane historical dimensions.

The ethnographic information provided in the exhibit never decentered the dominant presentation. In part this was due to a shared temporal prefiguration: Sepik culture and art were evoked in similar ethnographic and aesthetic presents—actually pasts rescued as timeless essences. Moreover, the provided ethnographic information tended to feature ritual uses and traditional, religious functions— "sacred" contexts that easily fuse with dominant western concepts of art.

Overall, the complementarity of ethnographic and aesthetic discourses in the Sepik exhibition reflects a tendency to appropriate specific elements of "tribal" culture as enrichments for a desacralized modern aesthetics. (I'm reminded of William Rubin's insistence in the 1984 "Primitivism" show at the Museum of Modern Art that what Picasso learned from African carvings was their "magic," a ritual transforming power.) The last paragraph of the Sepik Exhibition brochure provides a condensed statement of this sort of appropriation:

> Much of Sepik River art was therefore meant to be awe inspiring and even terrifying at times, and the people who used these objects deeply respected the magic power each example contained. Viewed purely as objects of art, these works reveal a rich, vibrant and dramatic style which gains additional power by suggesting an ever present spirit content within its forms.

Ethnographic knowledge merely deepens an essentially aesthetic appreciation.

In academic anthropology a growing body of recent work has begun to unravel the assumptions about tradition, history and authenticity that underlie the salvage paradigm. The result has been to displace global dichotomies long "orienting" geopolitical visions in the Occident. One of these dichotomies sorts the world's societies into peoples *with* and *without history*. The inheritors of Thucydides, Gibbon, Marx, Darwin, etc., are endowed with "historical consciousness"; others have "mythic consciousness." This dichotomy is reinforced by other oppositions: literate/nonliterate, developed/underdeveloped, hot/cold. The last pair, coined by Lévi-Strauss, assumes that, for good or ill, western societies

are dynamic and oriented toward change, whereas nonwestern societies seek equilibrium and the reproduction of inherited forms. Whatever truth this sort of general contrast may contain, it becomes rigid and oppressive when ranges of difference—both within and between societies—become frozen as essential oppositions: "we" have history, "they" have myth, etc.

Anthropologists now challenge the assumption that nonwestern (even small-scale "tribal") peoples are without historical consciousness, that their cultures have scant resources for processing and innovating historical change. I'll quickly list a few important recent works. Renato Rosaldo's *Ilongot Headhunting, 1883–1974* (1980) discovers a distinctive historical idiom among nonliterate Philippine highlanders, a concrete way of narrating real past events and of using the landscape as a kind of archive. Richard Price's *First Time: the Historical Vision of an Afro-American People* (1983) probes an elaborate local historical memory and discourse among the descendents of escaped slaves in Suriname. A strong historical sense is crucial to the group's identity and its continuing resistance to outside powers. Marshall Sahlins's *Islands of History* (1985) argues that 18th-century Hawaiian mythic and ritual structures, far from being timeless and unchanging, were concrete forms through which forces of historical change (like the arrival of Captain Cook) could be locally processed. Work by sociologists like Anthony Giddens and Pierre Bourdieu has introduced an increased awareness of process and inventive agency into formerly synchronic and holistic theories of culture.[1] A seminal work of the mid-1970s by Roy Wagner, a work deeply influenced by Melanesian processual styles, gives its title to a whole new perspective: *The Invention of Culture.*

Of course I'm glossing over a number of important debates. Suffice it to say that for me the importance of the new anthropological attention to historical process has been to reconceive "cultures" as arenas not merely of structural order and symbolic pattern but also of conflict, disorder and emergence. Several of the essentializing, global dichotomies I've mentioned are complicated. For example, Sahlins has spoken of "hot" and "cold" sectors within specific societies: people may in fact be willing to rapidly discard or change whole areas of traditional life while guarding and reproducing others.

Another dichotomy is displaced by Trinh T. Minh-ha in her special issue of *Discourse* (Fall–Winter 1987). In her introduction she writes, "There is a Third World in every First World, and vice versa." (A walk in

many neighborhoods of greater New York easily confirms the first part
of her statement!) Old geopolitical oppositions are transformed into sec-
tors within western and non-western societies. Hot/cold, historical/
mythic, modern/traditional, literate/oral, country/city, center/periph-
ery, first/third... are subject to local mix and match, contextual-tactical
shifting, syncretic recombination, import-export. Culture is migration
as well as rooting—within and between groups, within and between
individual persons.

A significant provocation for these changes of orientation has clearly
been the emergence of non-western and feminist subjects whose works
and discourses are different, strong and complex but clearly not
"authentic" in conventional ways. These emergent subjects can no
longer be marginalized. They speak not only for endangered "traditions"
but also for crucial human futures. New definitions of authenticity (cul-
tural, personal, artistic) are making themselves felt, definitions no
longer centered on a salvaged past. Rather, authenticity is reconceived as
hybrid, creative activity in a local present-becoming-future. Non-west-
ern cultural and artistic works are implicated by an interconnected
world cultural system without necessarily being swamped by it. Local
structures produce *histories* rather than simply yielding to *History*.

What kinds of cultural and artistic histories are being produced? I'll
end with a few examples drawn from the ongoing invention of Native
American culture and art. Perhaps my co-panelists and the audience can
augment and complicate them in discussion.

Anne Vitart-Fardoulis, a curator at the Musée de l'Homme, recently
published a sensitive account of the aesthetic, historical and cultural dis-
courses routinely used to explicate individual museum objects.[2] She dis-
cusses a famous, intricately painted animal skin (its present name: M.H.
34.33.5), probably originating among the Fox Indians of North Amer-
ica. The skin turned up in western collecting systems some time ago in a
Cabinet of Curiosities; it was used to educate aristocratic children and
was much admired for its aesthetic qualities. Vitart-Fardoulis tells us
that now the skin can be decoded ethnographically in terms of its com-
bined "masculine" and "feminine" graphic styles and understood in the
context of a probable role in specific ceremonies. But the meaningful
contexts are not exhausted. The story takes a new turn:

> The grandson of one of the Indians who came to Paris with Buffalo
> Bill was searching for the [painted skin] tunic his Grandfather had

been forced to sell to pay his way back to the United States when the circus collapsed. I showed him all the tunics in our collection, and he paused before one of them. Controlling his emotion he spoke. He told the meaning of this lock of hair, of that design, why this color had been used, the meaning of that feather And this garment, formerly beautiful and interesting but passive and indifferent, little by little became meaningful, active testimony to a living moment through the mediation of someone who did not observe and analyze but who lived the object and for whom the object lived. It scarcely matters whether the tunic is really his grandfather's.

I don't know what's going on in this encounter. But I'm pretty sure two things are *not* happening: (1) The grandson is not replacing the object in its original or "authentic" cultural context. That is long past. His encounter with the painted skin is part of a modern re-collection. (2) The painted tunic is not being appreciated as art, an aesthetic object. The encounter is too specific, too enmeshed in family history and ethnic memory. Some aspects of "cultural" and "aesthetic" appropriation are certainly at work. But they occur within a current tribal history, a different temporality (and authenticity) from that governed by the salvage paradigm. The old painted tunic becomes *newly*, *traditionally* meaningful in the context of a present-becoming-future.

This currency of "tribal" artifacts is becoming increasingly visible to non-Indians. Many new tribal recognition claims are pending at the Bureau of Indian Affairs in the Department of the Interior. And whether or not they are formally successful matters less than what they make manifest: the historical and political reality of Indian survival and resurgence, a force that impinges on western art- and culture-collections. The "proper" place of many objects in museums is now subject to contest. The Zuni who prevented the loan of a War God from Berlin to the Museum of Modern Art in 1984 were challenging the dominant art-culture system. For in traditional Zuni belief War God figures are sacred and dangerous. They are not ethnographic artifacts, and they are certainly not "art." Zuni claims on these objects specifically reject their "promotion" (in all senses of the term) to the status of aesthetic or scientific treasures.

I'm not arguing that the only true home for the objects in question is in "the tribe"—a location that, in many cases, is far from obvious. My point is only that the dominant, interlocking contexts of art and

anthropology are no longer self-evident and uncontested. There are other contexts, histories and futures in which non-western objects and cultural records may "belong." The rare Maori artifacts that recently toured museums in the United States normally reside in New Zealand museums. But they are controlled by the traditional Maori authorities whose permission was required for them to leave the country. Here and elsewhere the circulation of museum collections is significantly influenced by resurgent indigenous communities.

This current disturbance of western collecting systems is reflected in a new book by Ralph Coe, *Lost and Found Traditions. Native American Art: 1965–1985* (1986). It is a coffee-table book: we have not transcended collecting or appropriation. And once again a white authority "discovers" true tribal art—but this time with significant differences. The hundreds of photographs in Coe's collection document recent works, some made for local use, some for sale to Indians or white outsiders. Beautiful objects—many formerly classified as "curios," "folk art" or "tourist art"—are located in ongoing, inventive traditions. Coe effectively questions the widespread assumption that fine tribal work is disappearing. And he throws doubt on common criteria for judging purity and authenticity. In his collection, among recognizably traditional katchinas, totem poles, blankets and plaited baskets, we find skillfully beaded tennis shoes and baseball caps, articles developed for the curio trade, quilts and decorated leather cases (peyote kits modeled on old-fashioned toolboxes).

Since the Native American Church, in whose ceremonies the peyote kits are used, did not exist in the 19th century, their claim to traditional status cannot be based on age. A stronger historical claim can in fact be made for many productions of the "curio trade," for the beaded "fancies" (hanging birds, mirror frames) made by Matilda Hill, a Tuscarora who sells at Niagara Falls:

"Just try telling Matilda Hill that her 'fancies' (cat. no. 46) are tourist curios," said Mohawk Rick Hill, author of an unpublished paper on the subject. "The Tuscarora have been able to trade pieces like that bird or beaded frame (cat. no. 47) at Niagara since the end of the war of 1812, when they were granted exclusive rights, and she wouldn't take kindly to anyone slighting her culture!" (17)

"Surely," Coe adds, "a trade privilege established at Niagara Falls in 1816 should be acceptable as tradition by now."

Coe does not hesitate to commission new "traditional" works. And he spends considerable time eliciting the specific meaning of objects—as individual possessions and as tribal art. We see and hear particular artists; the coexistence of spiritual, aesthetic and commercial forces is always visible. Overall, Coe's collecting project represents and advocates ongoing art forms that are both related to and separate from dominant systems of aesthetic-ethnographic value. In *Lost and Found Traditions* authenticity is sometimes produced not salvaged. Coe's collection, for all its love of the past, gathers futures.

A long chapter on "tradition" resists summary, for the diverse statements quoted from practicing Native American artists, old and young, do not reproduce prevailing western definitions. Let me end with a few quotations. They suggest to me a concrete, nonlinear sense of history—forms of memory and invention, re-collection and emergence, that offer a different temporality for art- and culture-collecting.

"Whites think of our experience as the past. We know it is right here with us."

"We always begin our summer dances with a song that repeats only four words over and over. They don't mean much of anything in English: 'Young chiefs stand up.' To us those words demonstrate our pride in our lineage and our happiness in always remembering it. It is a happy song. Tradition is not something you gab about It's in the doing"

"Your tradition is 'there' always. You're flexible enough to make of it what you want. It's always with you. I pray to the old pots at the ruins and dream about making pottery. I tell them I want to learn it. We live for today, but never forget the past"

"Our job as artists is to go beyond, which implies a love of change, [always accomplished with] traditions in mind, by talking to the elders of the tribe and by being with your grandparents. The stories they tell us are just amazing. When you become exposed to them, everything becomes a reflection of these events. There's a great deal of satisfaction being an artist of traditions."

"We've always had charms; everything that's new is old with us."

References

1. For a good account of the recent trend toward historically sensitive theories of sociocultural *practice* see Sherry Ortner's survey in *Comparative Studies in Society and History* 26 (1984).
2. See the new journal *Gradhiva* 1 (1986) published by the Archives Division of the Musée de l'Homme.

Of Other Peoples:
Beyond the "Salvage" Paradigm"

VIRGINIA R. DOMINGUEZ

A particular awareness of history—of the subjectification and objectification of different peoples, their cultures and social processes in our Euro-American construction of history—makes the very notion of cultural or ethnographic salvage suspect. Salvaging what and for whom? When we assert the need to salvage, rescue, save, preserve a series of objects or forms, we announce our fear of its destruction, our inability to trust others to take appropriate action and our sense of entitlement over the fate of the objects. Our best liberal intentions do little other than patronize those slated for cultural salvage.

As a postcolonial, poststructural conceptualization of the nature and consequences of our construction of history spreads, salvage becomes symbolic of intellectual, aesthetic and institutional practices we seek to bury rather than preserve. But are we indeed burying them? What would it mean to transcend "the salvage paradigm"?

I am pessimistic. While in the narrow sense of the word "salvage" may sound antiquated (passé), in a broader sense I believe it lies at the heart of most forms/practices of representation—visual, audio, literary, expository—in which the representer uses or incorporates material or immaterial objects s/he perceives to be the creation or property of others. Our complementary constructions of otherness and history also manifest themselves in a salvage mode. My argument rests on three fundamental points.

(1) The perception of otherness is not just one of difference but inherently one of hierarchy. Whom do we identify as others? Not those we identify with, but those we believe inferior or superior to us, or potentially subservient or dominant. Others are significant to us, even if our

rhetoric seeks to deny that significance, because it is through our con-
struction of them precisely as significant others that we situate ourselves.
Simone de Beauvoir put this quite eloquently in *The Second Sex* (1949)
in her portrayal of woman as other.

When we acknowledge that an idea, object, history or tradition is not
ours, we distance ourselves from it. When we then proceed to use, incor-
porate or represent it, we arrogate the right to employ what we acknowl-
edge as not ours. It is not something we do *despite* the foreignness of our
subject; it is something we do *because* of our perception of it as other.
The implicit hierarchical nature of otherness invites seemingly innoc-
uous practices of representation that amount to (often unknowing) strat-
egies of domination through appropriation. Edward Said's *Orientalism*
(1978) shows both how extensive those practices can be and how sec-
ond-nature they are even to those genuinely fascinated with the other-
ness of the other.

(2) But it is not just that otherness invites forms of representation that
are inherently appropriative; otherness itself implies representation. The
other *is* a representation. Minimally, the other is always present—at
least implicitly—in patterns of linguistic objectification. Witness the ter-
minological representation of contrastive systems of racial classification,
and its implication for the identification of the category of others.

Students of comparative race relations have long noticed the funda-
mental cognitive, epistemological differences in the construction of
race/color categories in the United States and the Afro-Latin world.
Whereas descendents of Africans and Europeans in the United States,
regardless of miscegenation, are typically allowed membership in only
two racial categories—white and black—the Afro-Latin world (e.g.,
Brazil, Cuba, Puerto Rico, Columbia, the Dominican Republic, Haiti)
has long used miscegenation as a mechanism for the construction of a
new category of people epistemologically separate from both whites and
blacks. Linguistic terminology both signals that difference and contrib-
utes to its perpetuation. The Afro-Latin world not only has dozens of
race/color terms in its linguistic repertoire, but it uses them regularly in
ways that perpetuate a nonbinary perception of racial categories. In the
United States, in contrast, we have and use far fewer race/color terms
and treat them either as synonyms of other racial terms (e.g., black,
Negro, Afro-American) or as labels for subgroups within two racial cate-
gories—white and black—that we constantly differentiate as if they were
biologically pure categories (e.g., light-skinned blacks, olive-skinned

whites). In the binary system there is a clearly differentiated single other to be seen as a threat, a group to dominate or to be dominated, *an* other in reference to which the self is constructed. In the nonbinary system otherness is plural, and sociopolitical relations resemble coalition politics much more than in a dichotomous system of political control.

But clearly the relation between otherness and representation does not stop with linguistic objectification. How much representation of otherness occurs outside language varies with time and place and the sociopolitical relations of societies in which the representer and the represented live and work. I call this *the historicity of appropriative representation.*

Genres of representation come and go, and not just for purely aesthetic reasons. The emergence of anthropology did not come about in the 19th century by accident. The expansion of European colonialism, the growth of an almost unbending faith in science, the combined condescension and universalization inherent in global, all-encompassing theories of biological and social evolution, and the successful domination of much of the world's political economy by 19th-century Euro-American capitalism made the emergence of academic anthropology not only possible but highly likely. It is likewise difficult to imagine that anthropology—the self-styled "science of man" dedicated to the study of humanity by the self-conscious study of others—could have arisen in any other era. The same goes for the rise of public museums, the scramble for ethnographic artifacts and the emergence and popularity of world fairs in the 19th century. They too took the world as their unit, progress as the natural principle of life on earth, and authority, right and responsibility as moral corollaries of superiority. They fostered an active social and cultural movement convinced not just of the possibility of representing others but also of their right and duty to do so.

A more contemporary example of the historicity of appropriative representations is evident in Israel's cultural policies and practices. For years Israel's official cultural institutions—its arts museums, galleries, orchestras and theaters—displayed cultural forms associated with European high culture. Governmental discourse continued to assert the policy of promoting European culture in Israeli society, and not Oriental or Middle Eastern cultural forms. They associated democracy, high technology, economic development and stable political institutions with the west. By extension, they believed in the superiority of western culture despite the obvious history of persistent, and at times genocidal, anti-Semitism in Europe.

That paradox could itself be seen as a form of cultural appropriation, but there is little in the written record to suggest that there was any conscious sense—or politicization—of the adoption of European cultural forms as deliberate appropriation. Instead, the simplest explanation is the most plausible. The vast majority of the Jews in the Yishuv—Jewish society in pre-state Palestine—were themselves European, albeit Eastern and Central European rather than Western. The forms associated with German and Polish *Kultur*—the expressive forms of the German, Hungarian, Austrian and Polish upper classes—were forms which the secularized European Jews had come to perceive as truly cultural.

The mass immigration of hundreds of thousands of North African and Middle Eastern Jews in the fifteen years after the establishment of the state of Israel altered the country's demographic make-up but not its official cultural policy. The Ashkenazim (European-origin Jews) ran Israel's government and its institutions. They pushed for "modernization" but meant by this westernization. Numerous popular and social science books published since then have documented the extent of that policy. But what interest me here are the changes of the last twenty years. A self-identified liberal sector of the Ashkenazi population has responded to growing demands for cultural recognition from the non-Ashkenazi population. As the Oriental/Sephardic population grew to become the demographic majority in Israeli society and a generation of Israeli-born Oriental/Sephardic Jews began to come of age, cultural expression became a major focus of their demands for equality. By the mid-1970s the government had agreed to establish a center aptly named the Center for the Integration of the Heritage of Jewry from the East and made plans to allocate the equivalent of hundreds of thousands of dollars to support its efforts. Its professional staff and grant recipients were to be Oriental/Sephardic Jews in Israel. Though they stated their goal in less grandiose terms, they sought and won a form of cultural reappropriation that could not have been possible earlier.

We should note, however, that parity has not yet been reached. Note, for example, that the aforementioned center is formally charged with integrating the *heritage*, not the culture, of Jews from the east—as if a concession has been made to grant Oriental Jews a heritage but not quite a worthwhile culture. It is the same mixed message that the Israel Museum—the closest thing Israel has to a national museum of art and culture—has given Oriental/Sephardic Jews for twenty years. Its Department of Jewish Ethnography de facto mounts exhibitions of non-

Ashkenazi Jewish communities in the diaspora, prior to their migration to Israel. Here and there they exhibit an object of Ashkenazi origin. But the impression is clearly that non-Ashkenazi Jewish communities warrant representation as proper subjects of ethnographic research, not of art or cultural criticism. The Museum, like the government institutions that created and fund the Center for the Integration of the Heritage of Jewry from the East, has thus responded to political pressure by incorporating a *particular* representation of non-Ashkenazi cultures that does not threaten the continued dominance of Ashkenazi views of culture in Israeli institutional life. The current representation of non-Ashkenazi Jewish communities' cultural life appropriates and controls it by folklorizing it.

(3) So far I have argued that otherness implies hierarchy and representation, that the coexistence of the two invites forms of appropriative representation and that the form and spread of genres of appropriative representations beyond linguistic objectification derive from—and thus reflect—historically-bound sociopolitical relations. But does this necessarily spell *salvage*? I believe the answer lies not just in the historicity of representation but, in fact, in *the representation of historicity*. It is a particular representation of historicity, deeply rooted in cultural/cognitive traditions in the Euro-American world, that makes the representation of others in most genres operate within a salvage mode.

Three characteristics of the dominant representation of history in the Euro-American world lie at the heart of this connection: (1) its presumed linearity; (2) its orientation toward the past; and (3) the sense that its subject matter can and indeed does come from the world as a whole. What do we do when we write other peoples' histories? In developing western scholarship on other peoples' pasts, have we not developed and affirmed *our* belief or conviction that others' histories are *our* concern?

I am certainly not arguing against developing a curiosity about the rest of the world; the point is that historicizing others is also a form of appropriative representation. We normally write *their* history but in *our* terms. We write the history of some peoples, and not of others. The primary example of the latter in the Euro-American tradition is our assumption of the ahistoricity of "primitive" societies. Eric Wolf's *Europe and the People Without History* (1982) argues this point extensively.

In writing some peoples' histories and not others', we imply that some have developed while others have not. Moreover, through these people

we assume we're looking into *our* past: they, who "represent" an earlier stage or mode of human social organization and cultural life, are "living examples" of how we used to be, perhaps not exact replicas but close parallels. Hence the salvage paradigm. Since we expect continued advances in technology coupled with the internal dynamics and forces of capitalism to cause the disappearance of these other ways of life, we are concerned to salvage what we can of their lives for the sake of salvaging our own "past."

I should add that this is a widespread Euro-American representation of historicity, and not exclusively a capitalist one. Museums in Eastern Europe today vary from those in western Europe and North America in minor not major ways. The East Germans continue to display—with pride—the objects, monuments and aesthetic forms "discovered" by German archeologists throughout the Near / Middle East in the 19th and 20th centuries and brought back to Germany for preservation and reconstruction. The Hungarians' Museum of Ethnology in Budapest organizes its material in a straight linear evolutionary sequence, divided by stages taken directly from the works of Marx and Engels on pre-capitalist socioeconomic formations. Its explicit goal is to encompass the world, and represent not just the world's social, economic and cultural history but by implication also the Hungarian people's "past."

Is it then possible to transcend this salvage paradigm, given the continuation of so many of its conditions of possibility? Can experimental, new forms of representation/incorporation transcend it? Is the answer to be found in a shift away from the deliberate representation of others to an explicit emphasis on the representation of the self? Experimental new forms would do little to transcend it if they still work within the framework of otherness shaped by our contemporary representation of historicity. A deliberate shift to self-representation sounds welcome but simplistic. Who is to be delineated as the self? How much change would this bring about? After all, we have implicitly, unconsciously represented our *imperial* sense of self in all of the applications and manifestations of the salvage paradigm. Moreover, the empowered group's ideology so penetrates into the underprivileged sections of a population that there is no guarantee that the representation of self produced by members of the minority population would necessarily differ from the empowered group's representation of their otherness. What better example of this than the continued internalization of femininity as a goal and value among many, if not all, women?

Experimenting with form and pushing for semiotic self-determination will not by themselves lead us to transcend the salvage paradigm, but they might, in conjunction, be jarring enough to call attention to the problem. That in itself is a necessary condition for any possible transformation beyond the salvage paradigm.

Of Other Peoples:
Beyond the "Salvage" Paradigm"

TRINH T. MINH-HA

On the one hand, James Clifford's questioning of the salvage paradigm fostered by ethnography is necessary to open up a critical space within western practices of culture-collecting. It is necessary because it speaks to those who perpetuate such practices in a language they can recognize and either enlist in or "salvage" for their own purposes. A critique from the interior always helps to sow doubts in a way that cannot be merely discarded as "other."

On the other hand, this critique can be opened up further; it should leak from many sides. A range of in-between possibilities might prevent the critique from closing off or stiffening into a potentially prescriptive "politically correct" line. (What is set in motion by initiators is not infrequently transformed into rigid judgments and formulas by partisans.) In any case, an argument in defense of or against practices of culture-collecting should not become another form of censorship for any of us, especially not for non-western culture explorers, retrievers and transmitters. If it is useful to remain alert to the Euro-American–centered context in which definitions of self, culture and others feed on one another, it is crucial to differentiate this context from other contexts so as to clear the ground for one's own undertakings. To make things even more complex and more disposed to critical investigation, "western" and "nonwestern" must be understood not merely in terms of oppositions and separations but rather in terms of differences. This implies a constant to-and-fro movement between the same and the other.

No system functions in isolation. No First World exists independently from the Third World; there is a Third World in every First World and vice-versa. I requote here the line Jim has quoted so as to expand it further:

A Third World in every First World
A Third World in every Third World
And vice-versa.

Again the question of "otherness." The outsider versus the insider. The "clash of cultures." The naming of this contact of races continues, and otherness opposed to sameness facilitates consumption.

In a context that defines identities according to conflicts, otherness is necessarily reduced to a set of fixed values and practices. In the area of Third World filmmaking, for example, there is the necessity to address specific sociopolitical issues and to stay away from an art-for-art's-sake attitude. There is also today an acute wariness, if not fear, of what has been widely and indiscriminately condemned in the west as "nostalgic," "sentimental," "romantic," "apolitical"; or "too ideological," "naive," "propagandistic"; and last but not least, "westernized." But the fact that the west might criticize its continuing racist and ethnocentric legacies— its attempt at anthropologizing "man" and at gathering the world around itself —does not mean that whatever it now considers negative in its own past language should become censored or tabooed for others. Although the west's language of occupation has gone through many stages of refinement, it is always lurking—especially in statements that tend to negate or obscure the actualities of subjects when questioning, for example, the validity of a word such as "Third World" (even or especially when it is used purposely by Third World members) or when resorting to scientific manipulations whose unconscious or unavowed aim is often to grant a little so as to occupy or own more effectively.

"That you may have more" should be understood as "That I may have no less" or "That I may always have more." Even in this age of "decolonization" one frequently encounters situations where the white man still arrogates the privilege to tell Third World individuals, without any hesitation or consideration, that they should be taught to be dewesternized. Or that they are nostalgic or naive toward their own culture, or even that they are racist toward other Third World peoples. For, according to this logic, acculturation means they are more whitewashed than their illiterate peers; or reciprocally, illiteracy means ignorance, and therefore those who suffer such a lack are easy prey to westernisms. Divide and conquer. The west has been, and continues to think it is, in a position to define realities for others, including those of westernization, authenticity and, of course, racism.

All this, as if Third World people, people like you? and me?
Do not know. Are not equipped, to understand what
Rac...i.s...m really is....

I/we are thus pressed to question every single gesture, every single
concept that is likely to be taken for granted. Each detail belongs to a
historical part and whole that needs to be contextualized accordingly. As
notions that serve an analytical purpose, otherness and sameness are
more useful when they are viewed not in terms of dualities or conflicts
but in terms of degrees and movements within the same concept, or bet-
ter, in terms of differences both within and between entities (differences
between First and Third—if such naming serves a temporary purpose—
and differences within First, within Third —if such boundaries can be
temporarily fixed). Otherness *to* the outsider or insider is necessarily not
the same as otherness *from* these positions, and in their encounter the
two need not *conflict* with each other nor merely *complement* each
other. Exploring oneself and one's culture in its interaction with other
selves and other cultures remains a vital process when *understanding is
creating—is creation.*

Every woman is the woman of all women....
What I saw shattered my everyday existence....
I would have to apply myself to translating the
unknown in an unknown language...
what I called "me," without knowing
"me" is a redundancy of myself.

—Clarice Lispector

Nothing in the universe is supernatural. All is natural. The super-
natural is an anti-scientific invention of the West, its incapacity to
grasp the spirit of matter and the soul of beings, to distinguish both
of them from the energy of matter.

—Boubou Hama

Difference is an ongoing process; and to use differently a thought of
Jim's: difference, like authenticity, is produced not salvaged. If the work
of differentiation is constantly engaged and made visible, then even the
notions of accumulation and preservation peculiar to western culture-
collecting take on a different meaning in a different connotational con-
text. The most "nostalgic," "sentimental," "romantic," "apolitical,"

"naively ideological" and "propagandistic" definition of the "political" is precisely, in my view, the one that immediately takes itself for granted—that is to say, as objective and absolute—and the one that excludes all the supposedly nonpolitical dimensions of our lives. If art for art's sake appears mystifying today, so too does information for information's sake. Blindness to the to-and-fro movement between authenticity and inauthenticity in every definition of authenticity leads to a legitimation of a notion of tradition reduced to the past and to a rejection of, or a nostalgia for, so-called lost values. It also leads to an intense fear of an invasion into one's world by the "other"—hence the constant need to reserve access to that world to the "initiated" and the "conformist."

Of Other Peoples:
Beyond the "Salvage" Paradigm"

DISCUSSION

AUDIENCE (ZEV TRACHTENBERG): I have a question for James Clifford. I'm interested in your idea of authenticity, but the word I expected to hear and didn't is "nature." In their 18th-century confrontation with "primitive" peoples Europeans conceived of them as closer to nature. Is your notion of authenticity the successor to the idea of nature as Rousseau and others presented it?

JAMES CLIFFORD: Well, the German word for "primitive" people is *Naturvolker*, nature people, and of course the idea persists that tribal people are closer to nature. This is an idea that's neither true nor false but has to be historicized and politicized in complex ways—for "nature" is an historical entity. In the west nature is usually seen as the starting point—the raw material—of history: To nature comes tragedy, or happily to nature comes culture; to nature comes corruption, or happily to nature comes development. In the west these are all historical processes—there's never any going back. In the Rousseauan mode the idealized natural man can't get back after the fall (except perhaps in the the the ethnographic fictions of a Colin Turnbull, for whom the forest pygmies represent a return to the early primal). In this linear history nature functions as origin, as site of the fall, as raw material, and in this system we are still very much within the "salvage paradigm."

But it's possible to think of the nonhuman environment in different ways, to think of nature and culture in terms neither of progress nor of fall. In this regard I recommend an article called "No Nature, No Culture: the Hagen Case" by Marilyn Strathern (in Strathern and MacCormack eds., *Nature, Culture, Gender*). Strathern is an anthropologist who talks about the symbolic use of the natural by the

New Guinea Hagen people. Their nature/culture distinction is cast very differently from ours; they don't see nature as origin or as raw material for cultural work. There's a richness there that provokes us to rethink our entire western theory of history.

AUDIENCE: Can you explain the nature/culture distinction in a way other than the historical?

J. C.: I like Minh-ha's idea of to-ing and fro-ing, the notion of nature as neither an origin nor a resource for culture but as a sort of alter-culture, if you like. For example, in many places in Melanesia ancestors are felt to be in the landscape in a very concrete way; there's a continual coming and going, a conversation, between worlds. That really problematizes the notion that nature is prior to humanity, a raw material for its use. Others can probably provide lots more examples. But the point is this: Inasmuch as it hides a story, an historical story, the nature/culture opposition needs to be deconstructed, and it's probably from sources outside the west—inasmuch as westerners can imagine them, imperfectly but importantly can imagine them—that this will occur.

AUDIENCE: I think your point's well taken—the nature/culture opposition is an historical myth. But how do we deconstruct it?

J. C.: I would start with feminist writing—that's where the most sophisticated unthinking of the nature/culture opposition occurs now. Because women, like *Naturvolker*, are "others" who have been naturalized; because they too have to question—as well as not totally throw out—the qualities imputed to them as natural creatures, natural bodies. A study like Strathern's does this in terms both of ethnographic practice and of feminist theory.

VIRGINIA DOMINGUEZ: I want to follow up on this idea of authenticity. If it no longer means the natural or implies some natural state, what does it in fact mean—and how is this new meaning different from earlier conceptions? Does it apply only to a traditionality which we perceive some people to have and others not to have? Does it imply a change in our notion of history?

TRINH T. MINH-HA: Why this necessity to come back to the notion at all, as if it can still be this "full center" gathering within its limit a set of fixed values? Why this necessity to identify it when no definition of authenticity can be made without involving the notion of inauthenticity?

AUDIENCE (STEVEN LAVINE): If you take Jim's definition of authenticity as a hybrid creative activity in the present-becoming-future, there's an implicit danger: You may assume that all cultures are in a position to be equally creative; and you may mask the historical fact that we continue to impact on the present of other cultures though our economic power. If you say "Well, they create a response, they make of it what they want" you run the risk of masking our ways of dominating—because that's not the nature of the historical relationship.

J. C.: Your point's well taken. One has to look at culture-conflict situations with at least two narratives in mind. One just can't go in with stories about progress or corruption; one has to try to become self-conscious. I go in with a story that's all too familiar: the story of western destruction, neocolonial loss, the impact of our economic or media empire on local traditions. This is real. But I also go in with the story of people resisting and reinventing, reappropriating and parodying—producing new culture. The question is: How to find a form of history that can accommodate both stories?

I feel that to-ing and fro-ing between those stories is necessary; that's how I start. Maybe I need a third or fourth story, or maybe one should ultimately do away with narrative entirely. Yet I'm a storytelling animal and I'm a westerner—I want to line things up. But at least I can try to go in and out of a couple of lines, each of which might undermine the other. The *Tristes Tropiques* story—of cultures turning to dust, of differences being destroyed—that story is powerful and true. It's also much, much too simple. So is the story that goes: "Oh yeah, there was all that colonial violence—maybe 80 percent of the population was killed off—but, really, look how inventive and resilient folks are!" I need narratives that both account for and deconstruct those two stories. That's as far as I get. But I agree with you: the risk of masking the brute power of impact is real, always real.

STEVEN LAVINE: Is Yvonne Rainer here? I wonder if she thinks there's a relationship in terms of different forms of representation to her work in feminist cinematic narrative?

YVONNE RAINER: Yes and no. . . . For me—I guess, like Viriginia—it's a question of pessimism: one's doomed to be either the oppressed or the oppressor. But I have a question about pessimism: You point to an inability to transcend hierarchy and yet you also point to the Caribbean—to the many more differentiations that are made there. That seems hopeful to me.

V. D.: I hate to be pessimistic, but just because people of the Caribbean have more racial categories doesn't mean they're not racist. I'm from the Caribbean, have studied it, and throughout most of the region—throughout most of Latin America too—white is on the top and black is at the bottom. People can play with identities more and they do, but there is a racial hierarchy, and it is an idealization of a status which reflects the history of the classes in the area. There are more others, and so perhaps a finer sense of placement of people than there is here (with our enormous dichotomy between black and white), but all that means is that there are different boundaries. In each case there's an objectification, a signification of people based on color.

YVONNE RAINER: When I think about representation—narrative ways to represent others—the notion of a decentered subject becomes very relevant...

V. D.: Right. After all, the other doesn't have to be ten thousand miles away. If the other is the female world it's right next to you. It has nothing to do with geography; it has to do with conceptualization and power relations. What would happen if we could really represent ourselves? We'd still have the self/other opposition, and it'd still imply not only difference but hierarchy within difference. I feel we're caught in this bind.

T. M.: You said the other doesn't have to be very far away, it can be very close. Why not include this other within the self? Of course, as you said, one might still reproduce the model of opposition—but not necessarily if one opens the space to not representing, to difference, which is a notion that, when not reduced to a question of separation between entities, has the potential to undermine both hierarchy and opposition.

V. D.: What would "not representing" amount to? I can't conceive of a world in which we're not representing self and others, at least within language. How far beyond language can we go in this business of representation?

T. M.: Well, it's certainly a question that needs to be opened so as to invite each of us to rethink representation. Is language only limited to communication? If so, it is bound to representation; but if not, then one can talk about "not representing" also. What that might be will only come from a questioning of representation.

AUDIENCE: You spoke about a Third World in the Third World. What does that mean?

T. M.: It's related to what we just said about the self and the other. It's very easy to separate the First from the Third World. So my first step is to say there is a Third World in every First World and there is a First World in every Third World. But within this Third World a Fourth World is now constructed—the "gentle" Third World, more gentle than the "aggressive" Third World.

Some people associate the Third World with economic underdevelopment; others use it mainly in terms of political affinity. Which means that there is no such thing as a Third World that is separated geographically—the Third World is everywhere. So when one deals with oneself in terms of the First World, one also has to deal with the other in oneself that is Third World.

AUDIENCE: I'd like to address two questions specifically to Virginia Dominguez. Could you elaborate on your concept of pessimism? Do you mean among First World people or Third World people—or do you include both in the term? I guess I'm disturbed by its fatalism. For example, we are now at least aware of the problems of the "salvage paradigm," and that's a beginning to moving beyond it. Groups like us have started to challenge that kind of structure. Do we really have to wait for changes in the production of social relations before we even think about transcending it?

My second question has to do with models of history. Many of us do want to get away from this notion of a universal history—but what replaces it? Obviously not the notion of a fragmented history in the sense of a totally unstructured form. It's very important to move away from universal history to local histories —but what do we do then? Do we move back to a kind of transnational perspective so that we don't end up, on the one hand, with a universal history dominated by western male biases or, on the other hand, with an array of Middle Eastern history, Latin American history, African history . . . ?

V. D.: On pessimism: I'm pessimistic about transcending this salvage paradigm. Can people in the Third World escape what they've never been part of? My pessimism is mostly about us here. As a woman I'm in a sense your Third World; I'm also Third World in terms of my national origin. How much we as women or Third World people can represent

ourselves apart from the way we've been represented as Others with a capital O—I'm still not sure. The whole issue here is one of power. I don't think that pushing for self-representation will give us political or economic power in other realms. How successful can we be when the other conditions in the political economy don't change? That's partly where my pessimism comes in. But it's not total.

Your second question: What to substitute for universal history? When we write the history of a people, by what right do we do this? It certainly comes in the form of a representation and/or a collection. What I object to is our modern tendency to appropriate other peoples' presents as if they were parts of our own past. That's what we've done with subject peoples whose material cultures we represent in ethnographic museums. Why were we interested? Why did all these people run around the world in the 19th century and a good part of the 20th century madly collecting items to put in museums? Why do we care? I think the reason is that we see them as part of our own history—and that's what really concerns me. It's the same thing whether it's the writing of a history, the mounting of an ethnographic exhibition or the incorporation of non-western motifs in visual art. The whole issue is whose representation is it, and what does it tell us about the relative power relations.

J. C.: Many of you in the audience are artists, and many of you may be inspired by non-western sources, materials or perspectives in your work. Does the salvage or representation paradigm apply to your own appropriations? Are there practices that can be presented as models? We've talked mostly about anthropology, museums, old and dusty modes. How do these issues resonate—or not—with actual artistic practices? For example, I just saw the van Gogh show at the Met and was again struck by the presence of Japan in his work. In postmodernism there's even more permeability. So my question is: Do those influences occur in ways that are not appropriative—that are not raw materials for our own avant-garde history? This of course was an issue that came up over the 1984 "Primitivism" show at the Museum of Modern Art

MODERATOR (HAL FOSTER): People in the art community are aware of this ideological process of appropriation. It arose first in an investigation of documentary modes of representation of others as precisely not neutral; then came the whole poststructuralist/postmodernist critique of representation. But in a way this awareness has produced a new problem. I was struck by what Minh-ha said about the white western intellec-

tual: that today he presumes to tell his other what racism really is. In this way we fall right back into the old role of the intellectual, artist or critic as consciousness or conscience—which is the very ideology of universal reason, of the Enlightenment, that helped to justify conquest and colonialism in the first place. I was also struck by your perception, Virginia, that this process of appropriation is not limited to capitalist society: that in the advanced east as in the advanced west, in "socialism" as in capitalism, others are presented as residual figures of our own past. So, again, what are the possible roles for the artist, critic or intellectual other than this problematic one of consciousness or conscience, and what are the possible models other than this problematic process of appropriation or collection?

AUDIENCE: Why can't Third World people begin to do what the First World has always done—that is, represent its other, represent the First World?

V. D.: From what place?

J. C.: A small point: Many museum basements contain images of white colonists that are normally not displayed. There's a book by Julius Lips called *The Savage Hits Back*, printed in 1937 with a preface by Bronislaw Malinowski, that presents African images of white people. Lips directed the Rautenstrauch-Joest museum of Cologne, before he fled the Nazis. Working with African sculptures since known as "Colonfigures," he produced a whole book of counterethnography *avant la lettre*. Granted, it's a limited gesture, but including such objects in ethnographic exhibitions might constitute a displacement.

T. M.: For me it's not enough to say that now the Third World can "oppose" the First World—it's still a reactive position. Why should the Third World be preoccupied with representing the First World when so much needs to be done in terms of presenting and re-representing the Third World? One may want to point to the First World in passing, but one need not limit oneself to such a task, which ultimately still puts the First World at the center of one's preoccupation. I would prefer that the position opened up be one of a continual to-and-fro movement. After all, one can never point to the other without pointing to oneself, and a superficial understanding of the other always entails a superficial understanding of oneself.

v. d.: This reminds me of a recent exhibition at the Israel Museum on Kurdish Jewry. The curator, a relatively young woman trained in anthropology and folklore art, wanted to make the exhibition really come alive—to bring in Kurdish Israeli Jews into the show with lectures, poetry readings, etc. But there was great opposition from within the younger sections of the Kurdish Jewish community. They felt it was an attempt to coopt them. The show wasn't their idea; they didn't make the decisions about the objects or their presentation; to participate in these activities, they felt, was to legitimate a misrepresentation. And I agree: That's not my idea of creating space—presenting relatively disempowered people as objects. If that's all we can do I'd rather not do it.

AUDIENCE: But then you're left with women representing women's histories, blacks representing blacks' histories (and black men can't represent black women).... You end up representing only yourself.

v. d.: Right, how far do you go with these qualifications? There's a real problem there. But put it in context: Women are still politically and economically a minority; same with blacks. So as minorities they gain from self-representations even if they are not totally perfect or pure self-representations. I personally can justify pushing for more self-representations of people who are unempowered.

AUDIENCE (MAUD LAVIN): I'd like to go back to the relationship of representation and power and get away from this idea of self-representation as a kind of mirroring, of presenting a self-image. That's not a particularly effective strategy unless it's connected to issues of power and institutions. The strongest example in this regard is journalistic practice; I'm interested specifically in the white press's coverage of black teenage mothers. Here you have examples of real ethnographic thinking: there's a lot of writing on the so-called bizarre practices of this group. Now there are a couple of options. One is black teenage mothers telling their own stories. That's desirable in some ways but not as helpful as a consideration of the journalistic institution that encourages the focus on such stories instead of reports on Reagan's welfare cuts. This gets back to the comment about the Third World representing the First World: these black teenage mothers are one of our Third Worlds, and so to take up their position against the First World powers of Reagan, the welfare system, journalistic practice and so on is to link issues of representation to issues of power.

J. C.: Let me just add in relation to this question of power a sort of modest local utopia; my example is again concerned with museums and their collections. Some very interesting things are happening to museums in the Pacific Northwest Coast, especially in Vancouver. Those cultures that Edward Curtis said were vanishing didn't vanish: Northwest Indian art, especially Kwakiutl art, of superb quality is being produced right now. There's a museum in Vancouver involved with the native communities around it—sculptors working in the museum from models, older objects circulating out for use in potlatches, etc. Half of this is a liberal extension on the part of the curators, but the other half comes of pressure from native artists who go to museum not simply to admire old work but to make new work. So new tribal works go into the ethnographic museum, old tribal works circulate out. The objects came to the museum in the first place to be preserved against all decay—the old salvage mode of ethnography. Now in some new historical moment a new pattern of reappropriation occurs.

Museums shouldn't be destroyed—there should be more and different kinds of museums in complex relations to their local communities. I don't mean this as a panacea. Our institutions of appropriation are massive, but in small, local ways they can be budged, especially when they are put in contact with local non-western communities. The Maori art show which came to New York a couple of years ago was a fantastic case of mutual appropriation. It was bankrolled by Mobil, which wanted to curry favor with the New Zealand government in order to build a gas refinery; the New Zealand government put the show together to curry favor with the resurgent Maori tribal elders, who wanted in turn to move these objects out of museums in New Zealand in order to present Maori culture to the world—to show its continued liveliness. Everybody using everybody; nobody pure; and the objects move into new places and old contexts. Now there's plenty of hierarchy here, plenty of representation, plenty of appropriation. I agree—there's no way now to escape these processes into some new nonviolent, nonrepresentational, nonhierarchical world. But those institutionalized positional contexts can move, and that seems to me worth encouraging.

Of Bodies and Technologies

ALICE JARDINE

Our machines are disturbingly lively and we ourselves frighteningly inert.

—Donna Haraway, "A Manifesto for Cyborgs"

We must take hold of the enigma of technology and lay her on the table....

—Paul Virilio, *Pure War*

The fields of theories and practices covered by the words "the body" and "technology" are enormous. In some sense, therefore, I will be here as but an expeditor of the obvious, laying out some territories for discussion. First of all, I will describe a book I'm working on, *La Femme automate: Woman and the Machine*, and secondly, a special issue of the journal *Copyright* titled "Technobody." I will emphasize two things.

First, questions of gender and women, especially to the extent that both are very often left out of discussions of technology and the body— as if men's and women's bodies had been represented in the same way throughout our philosophies and histories in the west, as if women (as historically constructed bodies) had had control over technology. Technology always has to do with the body and thus with gender and women in some form. For example, gender is present when we investigate technology at the level of *male fantasy*: as with "The Virgin and Vamp" where technology is represented either as a virgin, an asexual virgin mother who is neutral, obedient and subservient to man, or as a vamp, threatening and out of control. Gender is present as well at the level of *philosophy*, especially in analyses of the various permutations under-

gone by *technē* and *physis*. Questions of *poiēsis* (as bringing forth) and
alētheia (revealing) link technologies as first and foremost challenges to
mother nature. Gender is relevant *etymologically* too: it is clear that
somewhere in the past *tek*—the etymological root of both technology
and tecnology—had to do not only with fabricating and weaving but
also with begetting and giving form. Finally, gender is relevant *psycho-
historically*: the maternal has been a crucial stereotype in the psycho-
history of male technological fantasy and also in the more recent histo-
ries of the ways in which machines and women have come alive and to
identity at approximately the same time.

The second thing I will emphasize is the conjunction today between
Michel Foucault's use of the word "technology" and our everyday sense
of the word "technology"—a conjunction on or in the flesh. Various his-
tories and geneologies of technology (from the Greek *technē* through
Heidegger's "Question of Technology" to contemporary "high tech-
niques") have brought us to the point where what Foucault described
"metaphorically" as techniques of techno-bio-power have merged with
our everyday sense of the term of technology as "mechanical" (from the
Greek *mechanos*)—although a lot of people insist Foucault wasn't being
metaphorical. This has produced a series of megamachines which are
disciplining and punishing the body—by which I do not mean some
abstract entity but *the flesh*—in new and sometimes overwhelming
ways.

Foucault has left us with a powerful description of how bio-technico
power emerged in the 17th century as a coherent political technology.
The concern with the human species became a concern with the body to
be manipulated, with new techniques of discipline (prisons, schools,
hospitals). He has shown us how in the 19th century the classical con-
cern with the species and the body united with a concern for sex, pro-
ducing new disciplinary technologies and techniques of power, sur-
veillance and punishment.

These Foucaultian political technologies have today met up with the
still anthropological and instrumental sense of technology as both
mechanical and cybernetic within a technologic run by technocrats who
(as we know) consider rationality only in terms of efficiency. We are
being programmed for new and sometimes frightening megamachines.
And I am concerned with their effects on the flesh....

So, with these two general concerns in mind, I will briefly describe
these two projects, and then, even more briefly, I will talk about

responses to these issues. Finally, I will raise a few questions. I should just add that the book project is more "historical" than the journal project: the book deals with a set of historical geneologies of discourses and media over time, whereas the journal involves a more topological mapping of our present.

The book, *La Femme automate: Woman and the Machine*, is concerned primarily with questions of gender and representation. Among the main territories there are, first, the *philosophical* discourses, philosophy considering technology as a true dark continent (a lot of contemporary philosophies actually name technology "the dark continent"). Of particular importance in this territory are Descartes, La Mettrie (author of *L'Homme machine*), through Freud and Marx (with the whole concept of the "apparatus" in Freud and Marx's insight that "the essential function of technique is to make nature work for free"), to Heidegger. In his important essay "The Question Concerning Technology" Heidegger showed that the essence of technology is not technological but rather a way of *revealing* "the totality of being through attempts to enclose all being in utter availability and sheer manipulability." I end my survey of philosophical discourses with Gilles Deleuze and Felix Guattari's machinologies which take us up to 1972—I really don't try to go past that date.

The second major field is that of *literary* discourses, most of which involve "bachelor machines," described a long time ago by Michel Carrouges as an entire set of artistic and literary practices beginning at the end of the 19th century and extending through dada and surrealism to the present time. All of these bachelor machines are anti-coupling, anti-totalizing machines. They are about solitude and death without procreation. They do not deny eroticism, only procreation—often turning love into death. Some of the most familiar writers involved include Villiers de L'Isle-Adam, E. T. A. Hoffmann, Poe, Melville ("The Maids of Tartarus"), Alfred Jarry, Kafka.... I am adding to those a set of contemporary authors grouped by David Porush under the heading "cybernetic fiction"—male writers of the last twenty-to-thirty years like Thomas Pynchon, John Barth, Samuel Beckett and William Burroughs, all of whom write through a kind of bachelor-machine logic.

The third territory is that of the *plastic arts*—I'm sure that many of you here know more about that than I do. Duchamp, Max Ernst and Richard Linder have been particularly important for me.

There are also the images and discourses of *film*—from Fritz Lang to

Modern Times to *Bladerunner*. There is the field of *cybernetics* and
robotics (e.g., the new books on "sexy robots"). And finally there is of
course the realm of *popular culture*: from domestic machines to geo-
graphics (with special attention to Southern California).

The issue of *Copyright* titled "Technobody" concentrates less on the
historical and more on the present, less on the question of representation
and more on the conjunction of Foucault's political technologies and the
everyday sense of technology. The issue is being special-edited by Rosi
Braidotti, a philosopher in Paris; what follows is only a working table of
contents.

For the moment we've divided the material up into a set of topologies.
The first is "medico-technologies," for example, the enormous field of
reproductive technologies: in vitro, artificial insemination, surrogate
mothers, embryo transfer, and now (almost) male pregnancy, artificial
wombs and successful cloning experiments. Also in this medico-tech-
nology field are what some people refer to as "rituals for future bodies"—
having to do with organ transplants (technology actually attached to the
body) and genetics. There are also of course eugenics and all of the new,
multimillion-dollar bio-industries.

The second major topology is "war," not only because (as Virilio puts
it) war is the source of technology but also because (as Donna Haraway
puts it) war is a cyborg orgy. We will look at several specific things: for
example, the notion of logistics in modern warfare (where there are no
more bodies at all); the question of speed in war (measured according to
metabolic rates in the body); the issue of modern surveillance (in-
creasingly in a nuclear situation where everything depends on deter-
rence, the human body is only there in case something breaks down;
what happens then is that the human becomes the police and thus but
another element in the surveillance network).

Another thing we will look at in this more scientific realm is "space
research"—all of the new industries involved in finding ways of tran-
scending our environment and our bodies, since in terms of space our
human bodies are absolutely obsolete. Within the topologies of space
and war research (which of course run our western economies) there are
lots of sub-categories that deserve consideration too, although I won't go
into them here: labor and economics (women in the integrated circuit,
homework economics in the so-called Third World), robotics and all the
"tele-technologies" that have to do with moving bodies through space
and time.

Some of the less scientific and more cultural manifestations of this link between technique as disciplining and punishing and technology as mechanical must also be emphasized. First, there are the new and various ways of simulating and actually becoming machines. One way of becoming a machine is to hook yourself up to one: video games, media, television, the new nonumbilical telephones (that transmit through walls), etc. This technology is described by some as an external nervous system connected to us by a variety of devices that radically change our sense of time and space. Another way to simulate a machine is to look like one: there have been several analyses of punk culture as a phase of this strategy, where the object is to be as pale as possible and wear nothing but grey and black and metal. Another version of that is the "Grace Jones look"—make yourself as square and angular as you possibly can.

Other cultural manifestations of this connection between technique and technology occur anywhere "discipline," "repetition" and "precision" are key terms. One example is what Rosalind Coward has called "food pornography," having to do with the denaturalized high-tech presentation of food; this appears to be connected to one of the sets of diseases affecting shocking numbers of women: anorexia and bulimia. Another cultural mode of this connection are the new forms of self-testing. We are no longer in the system of the panopticon described so accurately by Foucault. As Bob Somol has put it, we are rather in a mode of self-surveillance: we watch ourselves as someone else. The new technologies and media of advanced capitalism have set up the test as producing reality through a discourse of choice: whether you are testing yourself in the "comfort of your own home" for pregnancy, or answering a poll (a form of test) to see how much you really know about Reagan's White House—these things determine what the "reality" on the next day's news will be. There are many other categories which I can't go into here: for example, the large category of sexuality—telephone sex, answering machine sex, etc. There are also the new cults of the body: yuppie body maintenance, where one plugs the body directly into the machine so as to "fix" it, to plug it directly into capital. . . .

The final category we'll try to address in the issue is "art"—particularly music and the voice (Laurie Anderson being one of the more popularized versions of this) and film (Virilio once said that cinema is war pursued by other means).

This, then, is the very general shape of these two projects. There have been a lot of reactions and question surrounding both historical and

contemporary issues. As far as I can tell, there seem currently to be four kinds of responses by both men and women. One is an *anti-technology* response: one from the left, one from the right. From the left it feels like ec(h)o(e)s from the 1960s (back to nature, nature is good, the new ecologies, etc.). From the right one gets all kinds of anti-tech embedded in puritan ethics: anti-abortion, anti-reproductive technologies, etc. Another response, logically, has been *pro-technology* (when not technophilia): go ahead and be a cyborg, it's great. However, some people—primarily theoreticians—feel that the anti-pro syndrome has lost its power. There is a third position, close to that of Rosi Braidotti, which is that science and technology were in fact invented to liberate men from real women and that the reproductive technologies, for example, are simply the last desperate attempt, at the stage of nature's final exhaustion, to drain the female human body of "the feminine" (in Juliet Mitchell's strong sense of "otherness," since both men and women have it). This position wants to concentrate, among other things, on documenting the new male hysteria around these issues....

Now there is a fourth position or approach (close, I think, to mine) which absolutely agrees with the "paranoia" of the third position—technology always has been about the maternal body and it does seem to be about some kind of male phantasm—but, more, it perceives that the machine *is* a woman in that phantasm. According to this perception we need to find some access to this phantasm, and it seems that one of the few ways is through two particular kinds of discourses: myth and psychoanalysis. Virilio has said that myth is an analyzer and a tendency, a radical imaginary and a founding belief. Concentrating on the image of the sun god Apollo from the paper balloon flight of 1783 to the Apollo space flight of 1969, Michel Carrouges has also spoken of the power of "mythical energy" in our cultural imaginary.

For me the capital myth for thinking about women and technology is that of Pandora. Jean-François Lyotard calls her the first "auto-mate," the first machine, forged by Hephaestus, aided by Athena (the patroness of the mechanical arts), as a body to confound the boundaries between the animate and the inanimate, the divine, the human and the bestial. Pandora was always at a distance from the maternal and there seems to have been some investment in denying Pandora's motherness, even though men had to go through Pandora to reproduce. Of course we cannot rely on just one myth here; we would need in fact a genealogy of the entire mythological suppression

of the maternal throughout Hebraic and Hellenistic mythologies. . . .

Psychoanalysis, as tiresome as it can be, is still there with some very powerful analyzers and tendencies, the most powerful one for me being fetishism—which is about displaceable and artificial parts. (Who cannot help but think of the hide-and-seek games played by the superpowers with bombs, these latter having strangely retained their oblong shapes while still being called "The Ladies" as they were at Los Alamos?) Other useful tools of psychoanalysis are the "repetition compulsion" and, in particular, work on the relation between production and reproduction—this may help us to think about why the celibate priests and soldiers of modern technology continue to wage their sacred wars in order to remain impenetrable. Jacques Lacan said once that perhaps psychoanalysis could help us discover the ways in which the machine is a lot freer than the human. . . .

I will end now by just throwing out a few questions:

(1) The first big, obvious question is about ethics. The binaries in modern thought are breaking down, and the bottom-line binary of traditional ethics—life and death—is falling out from under us. The technobodies I have been describing do not allow the distinction between life and death—nor the distinction between the organic and the synthetic—to operate fully. These technobodies also confuse our notion of originals and copies (as with Baby M: will the real mother please stand up?).

(2) How do those of us who consider ourselves feminist want to deal over the next few years with the various *impensés* or unthoughts of feminism itself, two of those being technology and the maternal? I think feminist theory is making a lot of progress in thinking about other kinds of unthoughts: for example, the whole question of objectification—is resistance to being objectified only valid when the "object" is then commodified or are all forms of erotic objectification at issue?

(3) A related question: Do we want to reinvent the natural? Do we want to create a new reservoir of being? Some say there is no more nature, or there won't be very soon. At the moment it appears that the word nature is performing three functions; it is seen: as a normative horizon fixing universalist ethical limits to technical activity ("that's against nature, it's unnatural"), as an horizon of technical exploitation and as *ecos*, as ecology, which sometimes links up with the desire to create some other kind of nature.

(4) What and how are the major new megamachines being produced? ("Megamachine" is Lewis Mumford's term for any enormous machine where the human becomes an indispensable part of a larger mechanical complex, the army being an obvious example. There the body is turned into a micromachine or automaton in order to fit into the larger mechanical structure.) What are the megamachines today and—for those of us still committed to the human—which ones do we need to worry about most immediately?

(5) A question of particular interest to me: Is the evolutionary model out of date? If it is not out of date, is it adequate? Can we still use it? If it is adequate, are machines evolving faster than humans? Some think they are.

(6) Is "art" still an answer? Heidegger said it was. He said it is the only place for *poiēsis* and *alētheia* to bring forth differently.

(7) And, finally, there is a political question (not that everything else hasn't been political): Do those of us who still hang on to some kind of commitment to, at the very least, a progressive or liberal politics have a strategy for what some call the coming "body backlash"? Actually it's already here, but it will no doubt get worse, produced as it partly is by an unconscious terror of the mother finally and actually being replaced by male technology. (If you have read Margaret Atwood's *The Handmaid's Tale*, you may have a sense of what I mean by "body backlash.") I'll stop there and leave you with these thoughts.

Of Bodies and Technologies

MICHEL FEHER

The questions raised by Alice are the great ones concerning the body today, but how we approach them is an important question in its own right. How can we arrive at what Foucault calls "a thick perception" of the present? I too am preparing an issue of a journal—in my case *Zone*—on the body, with special emphases on its historical regimes. This history concerns neither the evolution of the species nor the biological process of the individual; it is neither a history of scientific knowledge about the body nor a history of the ideologies that (mis)represent the body. Rather, it is a history of "body building," of the different modes of construction of the human body. The body perceived in this way is not a reality to be uncovered in a positivistic description of an organism nor is it a transhistorical set of needs and desires to be freed from an equally transhistorical form of repression. This body is instead a reality constantly produced, an effect of techniques promoting specific gestures and postures, sensations and feelings, and so forth. Only in tracing these modes of its construction can one arrive at a thick perception of the present "state of the body."

Such a history is both political and ethical, though the two perspectives have a relative autonomy. The project of a political history of the body, initiated by Nietzsche, is taken up by Foucault, Kantorawicz, Norbert Elias and others; it is a history of "body building" apprehended through relations of power. Now a relation of power is not purely repressive or violent, nor is it primarily a matter of ideology or (mis)representation. Rather, as defined by Foucault, it is an action upon an action—it is what promotes action. Power is real but relational; virtual, it needs to be actualized, and our bodies are the objects, the terms, of its

relations. A certain combination of these relations of power—a certain promotion of practices and techniques—can be called a political regime of the body.

This definition of a political regime of the body raises a series of questions. The first question concerns the system of differentiations that characterize a given regime—in terms both of values (normal/abnormal, pure/impure, active/passive, etc.) and of roles (masculine/feminine, master/slave, teacher/student, confessor/penitent, etc.). Even when the terms are the same, the differentiations may be different, which means that the relations of power will also be different. For example, from the 2nd to the 18th century the basic differentiation between man and woman rested on this: Woman was seen as a lesser, or not fully developed, man. Her genitals were taken to be inversions of his. Supposedly they remained inward because woman lacked heat: a little warmer and she'd be a man. (Hermaphroditism in the 17th and 18th centuries was often explained as an accident of heat that turned a female into a male.) Thus in this regime there was both an homology between man and woman and a hierarchy of superior and inferior roles. And this order had strange consequences; for example, because of the homology between man and woman it was thought that in order to procreate the woman as well as the man must have an orgasm. However, at the turn of the 19th century a new regime emerged, precipitated among other events by the discovery of the process of ovulation (it must have been a great relief to Victorians that female orgasm was not necessary to procreation). What ensued was a completely new differentiation between man and woman based not on hierarchy but on difference; and the domination of women by men was reinscribed and reformulated accordingly.[1] Here then we have a transition from one set of differentiations to another and from one regime to another.

The second question raised by this definition of a political regime of the body concerns the functions and objectives of relations of power within a given regime. To borrow an example from Foucault (*Discipline and Punish*): the punishment of the criminal in the ancient regime of Louis XIV was supposed to restore the sovereignty of the king's body which he, the criminal, had partially tainted, whereas the incarceration of the delinquent in the 19th century was supposed to restore the social body which he, the delinquent, had partially sickened—a completely different function, a completely different objective, is set forth in each instance. The third question, after the system of differentiations and the

set of functions and objectives of a particular regime, concerns the specific techniques and practices that actualize the relations of power. Again, to take Foucault's example, incarceration is a technique for the function of surveillance whose motive is to watch without being seen. It is entirely different from the very public and violent torture inflicted on the criminal of the ancien regime, which again is supposed to restore the glory of the king's body. Then there is the fourth question, the question of the institutions which integrate these practices: the jail, the hospital, the state, the family, etc. These institutions do not cause or create relations of power; they integrate them. Such institutions as the state and the family are thus also subject to change from one regime to another—they are not historical invariants.

The fifth question concerns the formation of knowledge which describes the reality produced by a given regime of power and which raises the problems immanent to that reality. Such knowledge is neither a transcendental science nor an ideology at the service of the ruling class: it is a set of ideas adequate to the mechanisms of power. This means that the mechanisms of power and the forms of knowledge of a given regime always presuppose one another but also enjoy a relative autonomy. For example, the notion of delinquency and the jail system have completely different origins: delinquency is an offshoot of the whole medical and legal theory of the Enlightenment, whereas the jail apparatus originates in systems developed previously for hospitals and factories. But a political regime is created only when the two—the forms of knowledge and the mechanisms of power—come together. And as they come together they always presuppose each other, despite the fact that there is no real anteriority or causality between them.[2]

So the body is at once the object of power—or better the actualizer of power relations—and that which resists power. But again it resists power not in the name of transhistorical needs but because of the new desires and constraints that each new regime develops. The situation therefore is one of permanent battle, with the body as the shifting field where new mechanisms of power constantly meet new techniques of resistance and escape. So the body is not a site of resistance to a power which exists outside it; within the body there is a constant tension between mechanisms of power and techniques of resistance. This, then, is a brief sketch for a political history of the body in the genealogical framework designed by Nietzsche and Foucault.

But there is another approach to the history of the body—an ethical

approach. On the one hand, there is the political question of the body as a battlefield of power relations; on the other hand, there is the ethical question of one's relation to one's own body and how that relation shifts. So intertwined with the political regime of the body is an ethical typology defined by the relationship of people to their bodies. Let me give an example of how the two—the political regime and the ethical typology—meet. Ergonomics is the "science" of work processes; it distinguishes between second-generation machines—machines that are semi-automatic, still manipulated by workers—and third-generation or automatic machines in which the relationship between worker and machine is one of mutual control and communication. The second-generation machine is very much in tune with classical capitalism, with its two flows of capital and labor. The worker is subjected to the machine as a "free" worker: he is supposedly free to rent his labor power. This is part of the humanism of classical capitalism—never to confuse man and machine. However horrid the conditions of work were, the capitalist could always say of the worker: He is here freely, he is not a slave, he even actualizes his freedom by manipulating his machine. With third-generation machines this difference disappears because the machine has the same status as the worker: they are equally controlling and controlled. And this reciprocity creates a difference in political regime between subjection—the creation of the free subject—and incorporation—the production of the worker as part of capital, as part of the machine. What does it mean to go from the status of a free subject, subjected and subjectifying in relation to a machine, to the status of a piece of human capital, a mere relay in a megamachine? It calls for seeing own one's body as capital (a transformation that has been traced in an important book by François Ewald called *L'État Providence*[3]), and this in turn requires two things: the development of a type of knowledge, quantitative, sociological, statistical, that is concerned with risk and forecasting; and the development of insurance as a practice that allows people to consider their body as a piece of capital that can be somehow guaranteed.

Thus through the development of both quantitative sociology and insurance it became possible to see one's body as capital. Yet how does one live—the ethical question—if one sees oneself in this way? (An answer of sorts is offered in our own day by neoconservative theorists like Milton Friedman and Gary Becker, who push to an extreme the model of the body as capital.) This question raises the general question of a history of ethics or of ethical types: What do we take our bodies for?

What are our bodies capable of perceiving and doing? This ethical question can in turn be developed into four further questions.

The first question concerns the regions of the body considered problematic in any given regime—that is, the gestures, postures and attitudes which are in need of disciplining or styling. For example, the perceptions of sexuality—the way it affects different regions of the body—are completely different for a pagan Roman of the first century and for Augustine. For the pagan Roman sexuality is a question of the act; it is a sexuality (defined by and for men) of penetration. It is also a sexuality of self-rule, for if the goal of the Roman free man is to rule over others he must also rule over his own body—be in full control of his instincts and desires. In this sexuality of act and self-government, the great negative value is passivity or softness (which is often expressed in the form of a warning against too great an attachment to a person who produces pleasure). Augustine, on the other hand, considers sexuality in terms of libido, as a current that runs from the most minute thought to orgasm; for him there is no qualitative difference between the two. What one has to regulate or even eliminate is not so much the act as the whole current from prurient thought to erection. So Augustine's is a sexuality of erection rather than a sexuality of penetration—a completely different region.[4]

So much for the first question concerning an ethical typology of the body. The second question that arises is: In the name of what are bodily activities disciplined or styled? Here an example of different principles is suggested by a book written by Erasmus (his last) on the education of children. It is a rather mundane book of manners, but it was republished many times. The strange thing is that when it was published in humanist Germany a preface by Erasmus presented its code of manners and mode of disciplining in the name of a human nature which was considered basically good: the rules simply actualized what already existed potentially in children. However, when the book was published in Protestant Holland a few years later the moral code was exactly the same but the preface was changed. And this time the reason why children should be educated was not so that they might implement and express their human nature but so that they might fight against its intrinsically evil nature.[5] So the same set of rules was proposed in the name of entirely different principles.

The third question is: What are the specific techniques that are developed to achieve a particular self-styling? Here there is a nice example in

the same regime given in a book by Caroline Bynum on late medieval
women and food, a beautiful comparative analysis of male and female
mysticism in the late middle ages. Both men and women mystics tried to
approach Christ immediately:this was called *imitatio Christi*, imitation
of Christ. But it meant completely different things for men and women.
Imitation for men meant the abandonment of power and privilege—just
as Christ had given up his powers to embrace the human condition. For
women this ascetic abandonment of power and privilege was impossible
for the simple reason that they didn't possess them in the first place, so
they imitated Christ through suffering. At work here was another cul-
tural assumption of the time: that women were flesh par excellence. And
since they were flesh and since Christ in the incarnation on the cross was
also flesh, it was through flesh, through its suffering—fasting, self-
flagellation, etc.—that this immediate approach to Christ might be
achieved. So within the same political regime one sees different practices
in pursuit of the same goal.[6]

The fourth and last question concerning an ethical typology is then:
What are the assigned goals of these ethical practices of the self-styling of
the body? To take the most obvious examples: For a classical Greek the
goal was to keep his good reputation even beyond death; for a Christian
it was personal salvation. But there are much more minute differences in
any given regime. For instance, in the court society of the 17th century
there were at least two types of aristocratic behavior: In the first, mainly
French, the courtier was supposed to learn a very precise code of man-
ners; the idea was to achieve perfect civility—a perfect adaptation to
obligations, styles, etc.—considered as a profession and an acquired
skill. In the other aristocracy, mostly Spanish and Italian, the idea was to
achieve not perfect civility but perfect grace or gracefulness—a quality
that aristocrats were supposed to have innately. In short, while the
French courtiers displayed how much they learned, the Italians tried to
hide the fact that they had learned anything at all.

Another example of this difference in ethical goals concerns the differ-
ent ascetic quests of western Christians and eastern Christians in late
antiquity. The goal for a western Christian like Augustine was of course
to get to paradise; but even though sexuality was the sign of the fall,
paradise for Augustine was not a sexless place. Adam and Eve before the
fall were sexualized, active beings; the difference was that then their sex-
ual life was perfectly willed, i.e., there was perfect adequacy between
their wills and their desires. (Augustine puts it this way: Every part of

their bodies was like their fingers, perfectly under the pressure of their wills.) Because man went too far with his will and challenged God, the fall effected the creation of the flesh, which was then agitated by desire that was not controlled. So to get to paradise is to get back to this adequacy of will and desire. For eastern monks of the same era—in Alexandria or Byzantium—the question is once again completely different. Chastity was very important but only as a first step: if one eliminated sexuality one was on the way to eliminating all other mundane feelings such as greed, wrath and pride. Paradise for the Byzantines was much closer to an eastern idea of nirvana, ecstatic yet perfectly sexless.[7]

So to summarize these four points: the problematic regions of the body; in the name of what the body is disciplined or styled; the practices of disciplining and styling; the goals assigned to these practices. Together they form an ethical typology of the body which is at once intertwined with and autonomous to the political regime of the body. The two—the ethical and the political—work together. After all, it is not that ethics is the realm of freedom while politics is the realm of power; the ethical affects the mechanisms of power as much as the political, and there is as much resistance in the political as there is in the ethical. This intertwining of the ethical and the political—this genealogy of the regimes and this succession of the types of relations to the body—is the framework with which I want to approach the history of the body.[8]

References

1. Thomas Laqueur, "Orgasm, Generation, and the Politics of Reproductive Biology," in *Representations* 14 (Spring 1986).
2. Gilles Deleuze, *Foucault* (Paris: Minuit, 1986).
3. François Ewald, *L'État Providence* (Paris: Grasset, 1986).
4. Michel Foucault, in *Humanities in Review*, volume edited by Richard Sennett.
5. Jacques Revel, "Les Usages de la civilité," in *Histoire de la vie privée III* (Paris: Seuil, 1986).
6. Caroline Bynum, *Holy Feast and Holy Fast: The Religious Significance of Food for Medieval Women* (Berkeley: University of California Press, 1987).
7. Foucault, op. cit., and Peter Brown, "Late Antiquity," in *A History of Private Life*, volume I, ed. Paul Veyne (Cambridge: Harvard University Press, 1987).
8. As this last sentence suggests, this paper is but a rough beginning; I have remained close to the transcript of my talk.

DISCUSSION

ALICE JARDINE: Michel, for you, how do the metaphorical sense, the Foucaultian sense and our everyday sense of technology come together to discipline and punish the flesh today? For me there are at least three discourses involved: historical, mythical and psychoanalytical—probably lots more. How do you see the place of these discourses in thinking about these issues? For example, I talked about delirium and you didn't. For me when the psychoanalytical and the mythological are bracketed, the sexual also gets bracketed—the sexual in the sense of delirium, in the sense of fantasy. The phantasm gets left out.

MICHEL FEHER: I have a problem with generic structures like psychoanalysis because they tend to reduce differences rather than to multiply them. And to want to multiply differences rather than to reduce them to a generic structure is, in a way, an ethical objective—ethical in the sense that life is richer when it is based on differences rather than identities or resemblances. Besides, I'm not sure how accurate psychoanalysis is for a lot of historical regimes—that's my other problem with it. I have the same problem with theories of ideology. Ideology is always either too little or too much: it's too little—it's a mere product—when seen only in terms of class struggle, and it's too much when it becomes equated with the Lacanian imaginary for then there's no way out of ideology.

MODERATOR (HAL FOSTER): I have a question for Michel and one for Alice. Michel, you said that the body both actualizes and resists power—that's a Foucaultian formulation. But can the body still "resist" when it is penetrated by so many different technologies and disciplined by so many different techniques as it is today? All that suggests a postnatural per-

spective, which is where my question for Alice comes in. If we are indeed in a partly postnatural moment, might not the natural regain a certain radicality? This question arose for me through recent feminist art: it seemed that its critique of naturalism or essentialism regarding the representation of women had pushed it into the other extreme—the treatment of women as so many signs to fetishize. A certain ideology of the postnatural is pervasive today, and I wonder if the natural might not be recovered in a critical way. After all it's not always a historically regressive or reactionary term.

M. F.: Resistance, it is true, is an ambiguous term. Resistance is not reaction. When the body resists it does not react to an action; it merely responds. That's where there is a problem with the Foucaultian formulation of resistance; one has to speak of insistence as well. Modes of resistance are already modes of invention and modes of escape. It's not simply that the body must claim its freedom against the machine; the body must invent, out of its new conjunctions with new machines, new possibilities, new connections, which are not the ones promoted by the system. One must take advantage of the possibilities of each new reality. For instance, if our bodies are now treated as capital we must ask not only "what are we subject to?" but also "what are we free from?" If we are now not so much subjects with interiority as we are relays in a megamachine—well, it can be very trying but it can also be very exciting. In the same way, in the late '60s and early '70s, there was a rebellion against the whole process of work, against the pervasive integration of everything and everybody into capital. This rebellion created new strategies of resistance which were strategies of escape, not just of reaction.

A. J.: I wonder whether one can resist and insist at a time when recuperation is instantaneous. In my optimistic mood I too believe there are new kinds of affirmative resistance that don't operate through negation. But it does feel like new forms of resistance are recuperated instantly. That's why the distinction between the body and the flesh is so important for me. After all if you have to take ten different tests based on bodily fluids and tissues before you can even get an interview for a job...

M. F.: It's a shifting process: as the strategies of power change, their strengths change also and so do their weaknesses. For the past twenty or thirty years the strategy of capitalism is to pass from a society in which the time for work, the time for leisure and the time for reproduction are perfectly delineated, to a society in which every second is productive,

where boundaries between workplace, home and whatever are completely removed. In this condition if all time becomes productive each moment you waste is a moment of resistance. It's quite nice when you think about it.

A. J.: Hal, I don't know how to answer your question about a postnatural phase. There are lots of "posts" around, and some are danger posts because they allow us to think that binary oppositions are deconstructed when in fact they remain in place in very powerful ways. There are, for example, a lot of male theorists who talk about a postnatural phase—that technology has becomes our second nature. And I get very seduced by those arguments until I come back to the question of subjectivity—and whether there is any space in a postnatural or postmodern era for a female subject with interiority. You see, we've never had it, and we'd like to see what it feels like.

M. F.: We've had it.

A. J.: I know. And we're told "Don't worry about it; it's not very interesting; in fact, it's all worn out."

M. F.: We'll tell you all about it.

A. J.: Right. Thanks. In terms of a feminist practice which wants to invent some new kind of female subjectivity—a complex subjectivity, not a humanistic one—that project may involve, interestingly enough, a reradicalization of what patriarchy has called "nature" as opposed to "culture." Not to go back to nature but to play with it somehow—to reradicalize it through a complex female subjectivity that is partly recovered from the oblivion of history and partly invented out of practices in the present.

AUDIENCE: Neither of you spoke specifically about the mind in relation to the body. Can you comment on the greater and greater symbiosis between our minds and our machines?

A. J.: For feminist theorists the mind/body split is obviously a problem. In the last several regimes the mind has been gendered male and the body female—it's one of the most transhistorical genderizations. That's why I insist upon the flesh—to get away from the mind/body opposition, which is as insidious as the nature/culture opposition. (The distinction between flesh and body is elaborated brilliantly by Hortense Spillers, a black feminist theorist who is examining regimes of discipline and

punishment with regard to blacks and slavery.) The body is already so highly coded as female that as a female subject I don't really know how to talk about the mind/body split. But one way to begin to rethink it today might be to look at the history of the actual physicality of machines: first they have shapes that refer to the body; now with computers they relate to the mind.

AUDIENCE (ERIC DAVIS): I'd like to ask Michel a question about typologies. I found many of your comments very provocative. My question about your scheme is: How do we move from, say, Louis XIV to the 19th century to today? The writings of Foucault are very attractive; they help us get away from sealed and deterministic (or, as you say, "generic") structures. But there's still the problem of causality. We need to address it; we need to historicize without a determinism where everything's linear and there's no subjectivity. You mentioned capitalism: Would a modified marxian model fit into your mode of discourse? For what is it, after all, that attacks us? For me the attack on the body is a way of dividing and conquering, especially among subordinate classes. In this regard I think we need to go beyond typologies.

M. F.: You're right. My idea is not to turn these typologies into a mere collection—to go from a history which is linear or dialectical to a history which is a boutique of different typologies. Genealogy calls for a very precise, very distinct perception of threshold. How in a specific way does one regime pass into another? Where does a regime start to break down? Which type of knowledge develops problems that the regime is not able to deal with? And which type of practice encounters activities that it cannot control, that it cannot survey or master? So for each regime you have to look at the threshold, at the crackups. And the crackups can come from certain formations of knowledge; they can come from certain mechanisms of power; they can come from whole sets of things which aggregate—and when they do aggregate that's when one regime passes into another. So my analysis is not a list of detached regimes or types; it's a genealogy which looks for the specific reasons for the collapse of one regime and the specific reasons for the invention of another. It does not try to superimpose one mode of construction and destruction on every stage, as the dialectical model of history does. And it's always geared toward a "thick perception" of the present—to see what are the weak and strong points of the current regime—so that when we resist we can at least make little holes or little scratches in the right spots.

AUDIENCE: To what end do you do this?

M. F.: It's a question of use; it's a question of relay. I don't think there's a final end; it's purely pragmatic.

AUDIENCE (ANNE GIBSON): Alice, have you come across any strategies of the flesh that have successfully controlled technology?

A. J.: Not yet. Are there any in art maybe? . . . I think there are strategies which haven't been named or elaborated as yet.

ANNE GIBSON: So your choice of the female flesh end of the resistance dichotomy is a fantasy or a desire on your part and maybe our parts?

A. J.: Somewhere between a fantasy and a strategy. I would like to see women claim and affirm various procedures and distinctions located in female subjectivity. But the reaction scares me: as soon as these things are compacted in female subjectivity differences and fissures are created in structures, and that gets people very upset and the reaction can be very strong.

AUDIENCE: When you said that the maternal is an *impensé* of feminism, what did you mean? Which feminism?

A. J.: It's an *impensé* of what the French call existentialist feminism—the feminism inherited from Beauvoir, for example.

AUDIENCE: But there are feminisms that do engage this . . .

A. J.: Absolutely. But it's still very tenuous and not very well articulated, and given the current political climate one hesitates to continue with the exploration.

M. F.: I have a question for the person who asked about the mind/body relationship. What do you think are the current changes in this articulation? Do you see any specific new shifts or problems?

AUDIENCE: The dialogue at the scientific level has begun to shift beyond the body; it's no longer an issue that the body is a machine. The question now is whether our minds are machines as well. To what extent are they anachronistic? To what extent do they have a mystical element that is beyond definition? The dialogue now is concerned with creating a terminology for mental processes.

M. F.: But are machines necessarily mechanistic?

A. J. Not anymore.

M. F.: The mind might be a machine, or the mind/body complex might be a machine—but does that make them mechanical?

AUDIENCE: There's a certain confluence of those terms . . .

AUDIENCE: Computers aren't mechanical in the sense of a natural body, but they are mechanical in the sense of the brain as a schematic organization. In that sense the computer is a replication of a natural object. I think the difference between the mind and the brain of a machine has to do with the difference between mind and body or brain and machine.

A. J.: In my brief exploration of artificial intelligence it appears to me that the mind/body split is reproducing itself in the realm of high technology between artificial intelligence and robotics. For example, if you look at descriptions of robots the language is very highly gendered toward the female, whereas almost all the language descriptive of artificial intelligence is male connoted. High technology is reproducing the split somehow, and this is why delirium is so important to me—you have to be a little delirious to figure all this out.

HAL FOSTER: I want to ask a question which needs to be asked in the present. Michel, you talked about different historical relationships between ethical types and political regimes of the body. In our own moment it is hard not to think of AIDS. Is there any precedent for this new configuration of ethical types and political regimes that might help us work through the discipline that is everyday evermore in place regarding AIDS?

M. F.: The first thing one thinks about, of course, are the great epidemics in the west and how they provoked shifts in regimes. There again to rely on Foucault, leprosy and then the plague reshaped relations of power.

HAL FOSTER: But the plague cut across all sexual categories.

M. F.: It's true, but so increasingly has AIDS.

A. J.: A lot of these ethical and political regimes will come together in self-surveillance; not all of it will be imposed from the outside. There is already a big industry here—all kinds of self-tests, in both senses of the word, that you can do in the privacy of your own home. Soon no one will be able to touch anyone else, and I think it's going to be everyone. That's

what's so scary: the technology is small and portable and invisible in the literal sense, and it'll hook up with the larger Foucaultian techniques of power—it already has.

M. F.: I agree. First, surveillance—surveillance in the name of protection, efficiency, a new notion of health, of diet and its importance. You can already see a hinge, a new connection to a new ethical typology and a new political regime, which will push the system of surveillance into a qualitative leap—into self-surveillance.

A. J.: And unfortunately the "goal," in your sense, will be nostalgic—to go back to very rigid nature/culture and male/female distinctions. Eventually this field of self-surveillance will lead to a very powerful reimposition of the notion of male and female—and a reduction of the bodies that incarnate those notions to their traditional functions. On the woman's side it'll be about reproduction; on the man's side production. And if you don't fit into those traditional categories then you won't have any place to exist. That's my pessimistic mode. There may be some way out of it through affirmative resistance, but often I have trouble seeing it.

HAL FOSTER: One last question. You mentioned a "body backlash." What exactly is at stake?

A. J.: For me it means all this stuff, this unconscious fear of categories messed up—male/female, nature/culture, of maternity transformed. Discourses on the right feed a lot on those fears—and may eventually push people into a regime of total autonomy in which touch is all but prohibited.